CANON REBEL T5/EOS 1200D

THE EXPANDED GUIDE

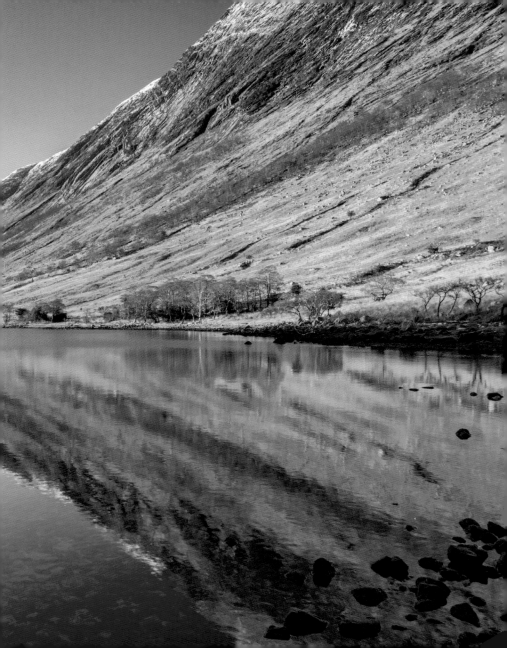

CANON REBEL T5/EOS 1200D
THE EXPANDED GUIDE

David Taylor

AMMONITE
PRESS

First published 2014 by
Ammonite Press
an imprint of AE Publications Ltd
166 High Street, Lewes, East Sussex, BN7 1XU, UK

ISBN 978-1-78145-106-9

British Library Cataloging in Publication Data: A catalog
record of this book is available from the British Library.

Editor: Chris Gatcum
Series Editor: Richard Wiles
Design: Belkys Smock

Typefaces: Giacomo
Color reproduction by GMC Reprographics
Printed in China

« PAGE 2
Glen Etive, Scottish
Highlands, UK

» CONTENTS

1 OVERVIEW

The Rebel T5/EOS 1200D is the latest entry-level camera in Canon's digital EOS range. It can be described as many cameras in one: not only can it be used as a point-and-shoot camera in its automatic modes, but it can also be controlled manually for more creative photography.

The Rebel T5/EOS 1200D was announced in February 2014 as the replacement for the three-year-old Rebel T3/EOS 1100D. Indeed, the two models are quite similar, so it's easy to think of the Rebel T5/EOS 1200D as an evolutionary camera, rather than a revolutionary one.

While this is partially true, it does the Rebel T5/EOS 1200D a slight disservice. The headline change is the resolution increase from 12MP to 18MP, coupled with Canon's highly capable DIGIC 4 image processor. Another improvement over the Rebel T3/EOS 1100D is the camera body itself. The quality of the materials used in the body of the Rebel T5/EOS 1200D is a definite improvement over its predecessor.

Canon has also launched a new app specifically for Rebel T5/EOS 1200D users detailing features of the camera; the app is available for both iOS and Android devices.

iPod 🛜 15:45 ▣

≡ Get to know...

■ Basic Button ■ Intermediate Button

Swipe left or right to rotate the camera 360°

APP «
Canon's free Rebel T5/EOS 1200D app running on an Apple iPod.

FAMILY »
The Rebel T5/EOS 1200D is the junior member of the EOS family, but it is still compatible with every lens made for that system. That includes telephoto lenses, as used for this shot.

» MAIN FEATURES

Body
Dimensions (W x H x D): 5.12 x 3.94 x 3.07in. (130 x 100 x 78mm)
Weight: 16.9 ounces (480 grams) with battery
Body materials: Composite structure
Lens mount: Canon EF/EF-S
Operating environment: 32–104°F (0–40°C) at 85% humidity maximum.

Sensor and processor
Sensor: 22.3 x 14.9mm APS-C format RGB CMOS sensor
Resolution: Approx. 17.9 megapixels
Image processor: DIGIC 4 with 14-bit output
Automatic dust removal: No

Still images
JPEG resolution (pixels): 5184 x 3456 (L); 3456 x 2304 (M); 2592 x 1728 (S1); 1920 x 1280 (S2); 720 x 480 (S3).
JPEG compression: Fine; Normal (except when S2 or S3 are selected)
Raw resolution: 5184 x 3456 pixels
Raw format: .CR2 (14-bit)
Raw + JPEG shooting: Yes

Movies
Movie format: .MOV
Compression: H.264 (image); Linear PCM (audio)
Movie resolution: Full HD (1920 x 1080 pixels at 30, 25, or 24 frames per second); HD (1280 x 720 pixels at 60 or 50 fps); SD 640 x 480 pixels at 30 or 25 fps)

LCD monitor
Type: TFT LCD
Resolution: Approx. 460,000 pixels
Size: 3.0in./7.7cm diagonal
Live View: Yes
Brightness levels: 7 user-selectable levels

Viewfinder
Type: Eye-level pentamirror
Coverage: Approx. 95% coverage
Eye point: 21mm
Diopter adjustment: $-2.5-+0.5m^{-1}$

Focusing (viewfinder)
Focus modes: One-Shot; AI Servo AF; AI Focus AF; Manual
Type: Phase detection
Focus points: 9 AF points that can be selected individually
AF assist beam: Yes

Focusing (Live View)
Focus modes: FlexiZone-Single; Face detection Live; Quick mode; Manual
Type: Contrast detection (FlexiZone-Single; Face detection Live); Phase detection (Quick mode).
Magnification: 5x and 10x magnification of the Live View image available

Exposure

Basic Zone modes: Scene Intelligent Auto; No Flash; Creative Auto; Portrait; Landscape; Close-up; Sports; Night Portrait; Movie
Creative Zone modes: Program (P); Shutter Priority (Tv); Aperture Priority (Av); Manual (M)
Metering patterns: Evaluative; Center-weighted; Partial
Exposure compensation: ±5 stops in ⅓- or ½- stop increments
Automatic exposure bracketing: ±2 stops in ⅓- or ½- stop increments
ISO: 100–3200 in Basic Zone modes (ISO 100 in Portrait mode); 100–6400 (expandable to H/12,800) in Creative Zone modes

Shutter

Shutter speeds: 1/4000–30 sec. plus Bulb (mode dependent)
Drive modes: Single shot; Continuous
Max. frame rate: 3 fps
Max. burst depth: 69 frames (JPEG); 6 frames (Raw); 4 frames (Raw + JPEG)
Self-timer: 2 sec. or 10 sec.

Flash

Built-in flash: GN 30ft (9.2m) at ISO 100
Hotshoe: Yes (compatible with Canon EX Speedlite flashes)
Sync speed: 1/200 sec.
Flash modes: Auto; Flash On; Flash Off; Red-eye reduction; 1st/2nd curtain sync

Flash exposure compensation: ±2 stops in ⅓-stop increments

Memory card

Type: SD (up to 2GB), SDHC (up to 32GB); SDXC (32GB+)
Eye-Fi compatible: Yes

Supplied software

EOS Utility; Digital Photo Professional (DPP); ImageBrowser EX; PhotoStitch; Picture Style Editor

1 » FULL FEATURES & CAMERA LAYOUT

FRONT OF CAMERA

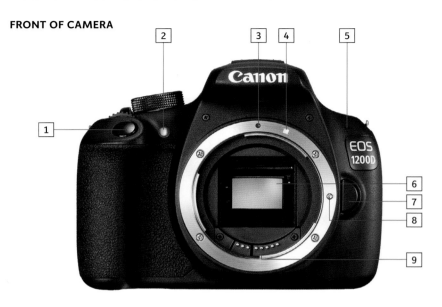

1	Shutter-release button	**5**	Microphone
2	Red-eye reduction /	**6**	Reflex mirror
	Self-timer light	**7**	Lens release button
3	EF lens mount index	**8**	Lens locking pin
4	EF-S lens mount index	**9**	Lens electrical contacts

BACK OF CAMERA

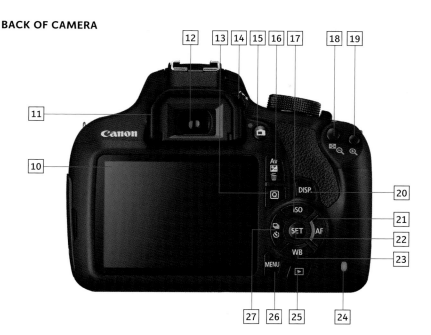

10	LCD monitor	**19**	AF point selection / Magnify button
11	Viewfinder eyecup	**20**	Display button
12	Viewfinder eyepiece	**21**	► / AF mode selection button
13	Quick Control button	**22**	(SET) button
14	Diopter adjustment knob	**23**	▼ / White balance selection button
15	Live View / Movie shooting button	**24**	Access lamp
16	Aperture / Exposure compensation / Erase image button	**25**	Playback button
17	▲ / ISO selection button	**26**	MENU button
18	AE/FE lock / Index / Reduce button	**27**	◄ / Drive mode selection button

1 » FULL FEATURES & CAMERA LAYOUT

TOP OF CAMERA

LEFT SIDE

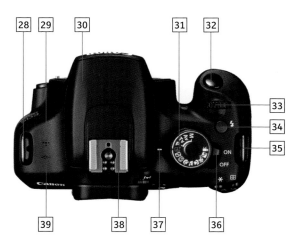

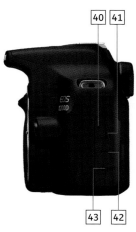

28	Strap mount	34	Flash button
29	Speaker	35	Strap mount
30	Built-in flash	36	On/Off switch
31	Mode dial	37	Mode dial index mark
32	Shutter-release button	38	Hotshoe
33	Main dial	39	Focal plane indicator

40	Terminal cover
41	Remote control terminal
42	Digital terminal
43	HDMI mini out terminal

BOTTOM OF CAMERA

RIGHT SIDE

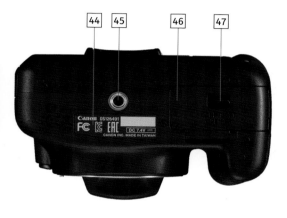

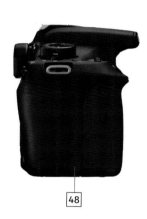

44 | Serial number / Information panel

45 | Tripod socket

46 | Battery / Memory card cover

47 | Battery / Memory card cover lock

48 | DC cord hole

1 » VIEWFINDER

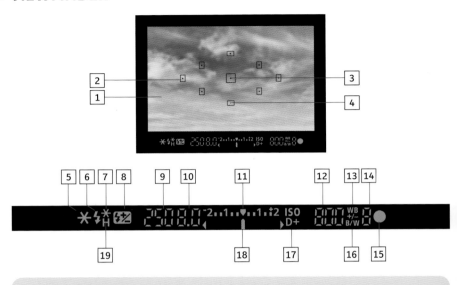

1	Focusing screen	**11**	Standard exposure index
2	AF point	**12**	Selected ISO speed
3	AF point activation indicator	**13**	White balance correction indicator
4	Active AF point	**14**	Maximum burst indicator
5	AE lock / AEB activated	**15**	Focus confirmation indicator
6	Flash ready indicator	**16**	Monochrome shooting indicator
7	Flash FE lock / FEB activated	**17**	Highlight tone priority
8	Flash exposure compensation	**18**	Exposure level indicator / Exposure compensation amount / AEB range / Red-eye reduction lamp-on indicator
9	Shutter speed / FE lock (FEL) / Busy (buSY) / Built-in flash recycling (⚡ buSY) / Card full warning (FuLL) / Card error warning / No card warning		
		19	Hi-speed sync
10	Aperture setting		

› SHOOTING SETTINGS

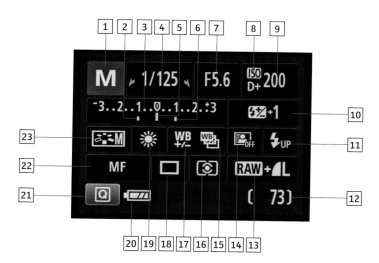

1 Shooting mode	**12** Number of shots available
2 Exposure bracketing mark (underexposure)	**13** Image recording quality
3 Exposure level indicator	**14** Auto Lighting Optimizer
4 Shutter speed	**15** White balance bracketing
5 Standard exposure index	**16** Metering mode
6 Exposure bracketing mark (overexposure)	**17** White balance correction
7 Aperture setting	**18** Drive mode
8 Highlight tone priority	**19** White balance setting
9 ISO	**20** Battery status
10 Flash exposure compensation	**21** Q icon
11 Raise built-in flash	**22** Focus mode
	23 Picture style

1 » PLAYBACK SCREEN

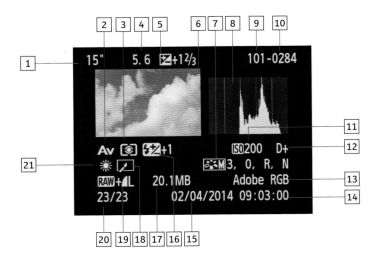

1 Shutter speed	**13** Color space
2 Shooting mode	**14** Time of image capture
3 Metering mode	**15** Date of image capture
4 Aperture setting	**16** Flash exposure compensation
5 Exposure compensation	**17** File size on memory card
6 Image thumbnail	**18** Creative filter (replaces Image recording quality when set)
7 Picture Style details	
8 Histogram (Brightness)	**19** Image recording quality
9 Current folder number	**20** Image number / Number of images on card
10 File number	
11 ISO	**21** White balance setting
12 Highlight tone priority	

LIVE VIEW

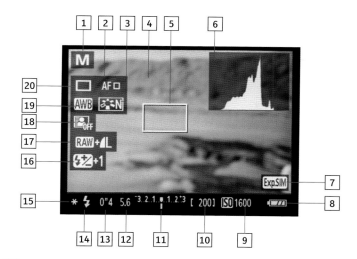

1 Shooting mode	**11**	Exposure level indicator / AEB range
2 AF mode	**12**	Aperture setting
3 Picture Style	**13**	Shutter speed
4 Live View image	**14**	Flash
5 Focus point	**15**	AE lock
6 Histogram	**16**	Flash exposure compensation
7 Exposure simulation	**17**	Image recording quality
8 Battery status	**18**	Auto Lighting Optimizer
9 ISO	**19**	White balance setting
10 Possible shots	**20**	Drive mode

2 FUNCTIONS

In keeping with the Rebel T3/EOS 1100D DSLR that it follows, the Rebel T5/EOS 1200D is an entry-level camera. However, this doesn't mean it is lacking in features.

The Rebel T5/EOS 1200D can be used in one of two ways: either as a fully automated point-and-shoot camera or as a manual camera that you have complete control over. There's no shame in using your camera the first way—although it's useful to understand the basic principles of photography, the creation of successful images is ultimately more important.

READY TO USE ⌄
If you bought your Rebel T5/EOS 1200D with a kit lens, you have everything you need to begin your photographic journey.

The automated side of the Rebel T5/EOS 1200D takes the form of a suite of scene modes (known collectively as Basic Zone modes) that are designed to help you achieve a perfect shot in a variety of photographic situations. The scene modes are fun to use and are easily selectable, making the Rebel T5/EOS 1200D a simple camera to use.

However, if you do want to go further with your photography, there are other modes (known as Creative Zone modes) that will give you greater control over your camera. These modes allow you to set functions such as exposure, metering, and focus to achieve the desired effect. This chapter will begin by explaining the basics of using your Rebel T5/EOS 1200D before moving on to show how it can be used as a powerful creative tool.

FLEETING »
Some photographic opportunities are fleeting. Understanding how your camera works will allow you to make the most of those moments.

2 » CAMERA PREPARATION

› Attaching the strap

Once you've attached the supplied strap, you can wear your Rebel T5/EOS 1200D around your neck or wrap the strap around your wrist to help keep your camera secure.

To attach the strap to your Rebel T5/EOS 1200D, pull one end of the strap out of the attached buckle and plastic loop, and then feed it through either the right or left strap mount on the side of the camera. Feed the end back through the plastic loop and under the length of strap still in the buckle. Pull the end of the strap so that it fits snugly in the buckle. For safety, allow at least 2 inches (5cm) of strap to extend beyond the buckle. Repeat the process on the opposite side of the camera.

› Using the viewfinder

There are two ways to compose an image with your Rebel T5/EOS 1200D: you can either use the LCD screen and Live View or you can look through the camera's optical viewfinder. Both methods have their advantages and disadvantages (we'll explore Live View later in this chapter).

The two big advantages of using the viewfinder are that it conserves battery power and it is easier to hold a camera steady against your face than when held at arm's length. Unfortunately, the Rebel

ADJUSTING THE VIEWFINDER DIOPTER ⌃
The focus (or diopter) of the viewfinder can be adjusted to compensate for individual variations in eyesight. To adjust the diopter, look through the viewfinder and turn the adjustment wheel until the information displayed at the bottom of the viewfinder appears crisp. Adjusting the diopter will not affect the focus of the camera.

T5/EOS 1200D's viewfinder only shows you 95% of what will be captured when an exposure is made (Live View shows you 100%). For this reason, images will contain more of the scene than anticipated.

To counter this, you can either crop the image during postproduction to create the desired composition, or to compensate at the time of exposure, you could zoom in slightly with your lens once you have your composition worked out.

›› POWERING YOUR CAMERA

› Battery charging

The supplied LP-E10 battery must be fully charged before using it in your Rebel T5/EOS 1200D. To charge the battery, first remove its terminal cover and then slide the battery in and down into the supplied LC-E10 or LC-E10E charger (the word "Canon" should be in the same orientation on both the charger and battery).

Connect the LC-E10E charger to the AC power cord and insert the plug into a wall socket or plug the LC-E10 charger directly into a wall socket after flipping out the power terminals. The "charge" lamp will glow orange.

When charging is complete, the "full" lamp will glow green. You can now unplug the charger from the wall socket and remove the battery by pulling it up and out from the charger using the tab on the right side of the battery. It will take approximately 2 hours to fully charge a depleted battery.

Note:
The battery charger can be used abroad (100–240v AC 50/60hz) with a suitable plug adapter and does not require a voltage transformer.

CONTINUITY
The LP-E10 battery is the same battery that was supplied with the Rebel T3/EOS 1100D.

Approximate number of shots per battery charge

Composition method	Shooting style	Ambient temperature	
		73°F (23°C)	32°F (0°C)
Viewfinder only	No flash	600	500
	Built-in flash (50% usage)	500	410
Live view only	No flash	190	180
	Built-in flash (50% usage)	180	170

› Inserting and removing the battery

To insert the battery, switch your Rebel T5/ EOS 1200D off and turn it upside down. Push the memory card/battery cover release lever toward the front of the camera—the cover door should open easily. With the battery contact terminals facing down and to the front of the Rebel T5/EOS 1200D, push the battery into the compartment with the side of the battery pressing against the gray locking lever as you do so. Once the battery has clicked into place, close the cover.

To remove the battery, push the lock lever away from the battery and gently pull it out.

Battery charge indicator

🔋	Battery adequately charged
🔋	Battery less than half charged
🔋	Battery almost depleted (flashes)
🔋	Battery depleted/ requires recharging

› Battery life

The battery supplied with the Rebel T5/ EOS 1200D is a rechargeable lithium-ion unit. Lithium-ion (or li-ion) batteries are remarkably small and lightweight for their power capacity. However, as with all batteries, they will deplete with use. How quickly this happens will depend on how efficiently you use your camera. Using the LCD is particularly draining, so try to keep the use of the screen to a minimum. Using Live View is even less efficient, since the sensor needs to be active, which puts a further strain on the battery.

Environmental conditions can also affect the efficiency of a battery, especially cold conditions, which will cause your battery to deplete more quickly. At normal operating temperatures (without using Live View), the LP-E10 should last for approximately 600 shots or 500 if using flash roughly 50% of the time. If you shoot in freezing conditions, the battery will last for 500 and 410 shots respectively.

Notes:
The battery only fits one way, so don't force it if it doesn't slide smoothly into the compartment.

The battery charge indicator is shown at the bottom left of the LCD.

› Using AC electricity

The Rebel T5/EOS 1200D can also be powered by the optional ACK-E10 AC adapter kit, which provides a constant power supply to your camera. This is useful when you're using your camera for a long period of time, such as when displaying images on a TV, when transferring a large number of files to your computer or printer, or when cleaning the sensor.

To use the adapter, turn the Rebel T5/EOS 1200D off and then plug the power cord of the AC adapter into the coupler. Open the battery cover on the camera and slide the coupler into the camera as a replacement for the standard battery. The coupler should click into place. Close the

battery cover, slotting the power cable into the DC coupler terminal cover.

Plug the power cord into the AC adapter and connect it to a convenient wall socket. Turn the camera on and use as normal. When you are finished, turn the camera off and reverse the process above to remove the AC adapter.

DEPLETING ⌄
Freezing ambient temperatures make batteries less efficient. In these conditions, it's worth having a fully charged spare battery handy (ideally kept warm inside your jacket) so your photography session isn't curtailed.

2 » BASIC CAMERA FUNCTIONS

The Rebel T5/EOS 1200D fits neatly into Canon's DSLR camera range. If you've used other models in the range and are familiar with basic Canon camera tasks, you can skip this section.

› Fitting a lens

Always switch off your Rebel T5/EOS 1200D before adding or removing a lens. Hold the camera so that the front is facing you, and remove the bodycap by pressing in the lens-release button and turning the bodycap to the left until it comes free.

Remove the rear protection cap from your lens. If you want to fit an EF-S lens, align the white index mark on the lens barrel with the white mark on the camera lens mount (the 18–55mm kit lens that may have come with your camera is an EF-S lens). Hold the solid part of the lens, gently push it into the lens mount until it will go no further, and then turn the lens to the right until it clicks into place.

To remove the lens, reverse the procedure. The process is the same if you're fitting an EF lens, except you need to align the red mark on the lens with the red mark on the camera lens mount. Replace the bodycap on the Rebel T5/EOS 1200D and the rear cap on the lens if neither is to be used again immediately.

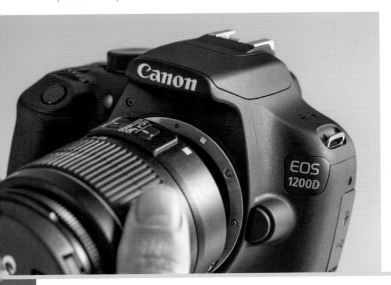

ALIGNING AN ❮❮ EF-S LENS
The procedures for aligning an EF lens and an EF-S lens are subtly different.

› Switching the camera on

The camera's power switch is to the right of the Mode dial. Switched to **OFF**, the Rebel T5/EOS 1200D is entirely inactive. Switched to **ON**, the access lamp will flicker briefly and the LCD will light up.

› Buttons and dials

To use the Rebel T5/EOS 1200D's features to the full, you need to be familiar with the positions and meaning of the various dials and buttons on the camera body. Although the sheer number of dials and buttons may look daunting initially, they're arranged in a reasonably logical way—with practice, it doesn't take long to become familiar with them. We'll be referring to the dials and buttons throughout the rest of the book by using a variety of shortcuts.

The controls you'll be using the most are the Main dial ⚙️ just behind the shutter-release button and the directional keys at the right of the LCD (Left ◄ / Up ▲ / Down ▼ / Right ►). If any of the directional keys can be used (such as when moving the focus point around the LCD),

✛ will be shown—then it will be up to you to decide which button is pressed.

The directional keys are arranged around the Setting button, which will be shown as ⑤. ⚙️ and the directional keys can sometimes be used interchangeably; any exceptions to this will be noted when necessary. Finally, words in **bold type** are options visible on a menu screen, while specific buttons on the camera are referred to by their name or relevant symbol.

Pressing DISP. when in shooting mode will toggle the LCD on or off; press DISP. repeatedly in Live View mode and you'll skip through different levels of shooting information overlaid on the Live View image. However, if you're using the LCD to compose a shot, it's a good idea to turn off the shooting information (if only temporarily), as the less visual distraction there is on the screen, the easier you will find it to compose effectively.

POWERING DOWN　　　　　　　**»**
The power switch should always be in the **OFF** position when fitting a battery or memory card.

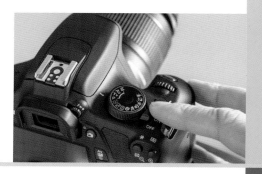

🔆 is used to set the aperture value and shutter speed respectively in Aperture Priority (**Av**) and Shutter Priority (**Tv**) modes. In Program (**P**) mode, the 🔆 can be used to "shift" the exposure values. In Manual (**M**) exposure mode, turning 🔆 changes the shutter speed. To change the aperture value, you need to hold down 🗑 / Av🔲 at the same time as turning 🔆.

Tip

*By default, the Rebel T5/EOS 1200D will power down automatically after 30 seconds if no controls are pressed. **Auto power off** can be deactivated (or the time altered) via the ♀ menu. When the camera has powered down automatically, pressing down lightly on the shutter-release button will reactivate it. In many ways, letting the camera power down automatically is better than repeatedly switching it on or off (although you should always switch it off if you don't intend using it for a long period). This is because the camera doesn't use much power when it's "asleep" and will be ready to use more quickly than if it's switched off entirely.*

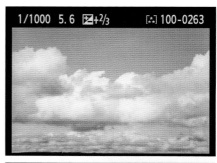

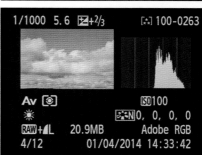

PLAYBACK

Pressing the DISP. button in playback mode will cycle through a series of screens. These screens display different levels of information about the images stored on the memory card.

Quick Control menu

The Rebel T5/EOS 1200D's menu system is very comprehensive (arguably too comprehensive for use on a regular basis). Fortunately, there's a useful shortcut in the form of the Quick Control menu, which is displayed when you press the ⬛Q button. The options shown vary depending on whether you are in a Basic or Creative Zone shooting mode, and whether you are viewing images or movies in playback.

There are two ways to use the Quick Control menu. The first is to press ✚ to highlight the required option and then press ⬛SET to view a detailed settings screen where the required changes can be made.

Alternatively, with the option highlighted on the main Quick Control menu screen, turn 🎛 to make the desired changes (when 🎛 is displayed at the bottom right corner of the LCD).

Shooting functions	Comments
Shutter speed	**Tv** and **M** modes only.
Aperture	**Av** and **M** modes only.
ISO	Not available in Basic Zone modes.
Exposure bracketing	Not available in Basic Zone modes.
Exposure compensation	Not available in **M** or Basic Zone modes.
Flash exposure compensation	Not available in Basic Zone modes.
Picture Style	Not available in Basic Zone modes.
White balance	Not available in Basic Zone modes.
White balance shift	Not available in Basic Zone modes.
Auto Lighting Optimizer	Not available in Basic Zone modes. Disabled when Highlight tone priority is activated.
Metering mode	Not available in Basic Zone modes.
AF mode	Not available in Basic Zone modes. MF only when lens is set to manual.
Drive mode	Single shot: selectable in all modes except 🌸 and 🏃. Continuous: selectable in all modes except Aᵀ, 🌸, 🏔, 🌷, and 🌃. Self-timer: selectable in all modes.
Image quality	Not available in Basic Zone modes.
Ambience-based shots	CA, 🌸, 🏔, 🌷, 🏃, and 🌃 only.
Light/scene-based shots	🌸, 🏔, 🌷, and 🏃 only.
Blurring/sharpening background	CA only.

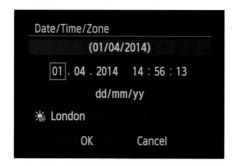

Date/Time/Zone
(01/04/2014)
01 . 04 . 2014 14 : 56 : 13
dd/mm/yy
☼ London
OK Cancel

Setting the correct time and date on your Rebel T5/EOS 1200D is the first task you'll be prompted to do when you first switch on your camera (if you don't set the time and date, the Rebel T5/EOS 1200D will continue to prompt you to do so every time you turn it on subsequently).

It is important to set the right time and date, as this information is embedded into the image file when it's created. When it comes to keeping track of your photos, the time and date information can be a valuable method of sorting your images into order or finding a particular image.

Note:
If you want to alter the date and time settings at any time, press MENU and navigate to the ♥⁺ tab. Highlight **Date/Time/Zone** and then press ⟨SET⟩. Repeat steps 2 to 7 above right.

Setting the date and time

1) Turn on your Rebel T5/EOS 1200D.

2) Press ◄ / ► to highlight the date or time value you want to alter. A yellow box surrounds the highlighted value. Press ⟨SET⟩.

3) Press ▲ to increase the value shown or ▼ to decrease it. Press ⟨SET⟩ once more to confirm your choice.

4) Set the way that the date is displayed on your Rebel T5/EOS 1200D. You can choose from **dd/mm/yy, yy/mm/dd**, or **mm/dd/yy**.

5) Highlight ☼ to set whether daylight saving needs to be adjusted. Press ⟨SET⟩ and then ▲. When ☼ is displayed, the time is advanced by one hour. Press ⟨SET⟩ again.

6) Highlight the time zone option. Press ⟨SET⟩ and use ▲ / ▼ to find your current time zone. Press ⟨SET⟩ to select the time zone.

7) Highlight **OK** and then press ⟨SET⟩ to continue, or highlight **Cancel** and press ⟨SET⟩ to exit without saving.

Operating the shutter-release button

There are two separate stages to the Rebel T5/EOS 1200D's shutter-release button. If you press down lightly halfway, the camera's autofocus and exposure metering systems are activated (if the camera is in playback mode this is canceled automatically).

How the Rebel T5/EOS 1200D focuses is determined by the focus mode you've chosen; if you've chosen to manually focus the lens, the camera won't begin focusing, although it will start metering the scene to calculate the required exposure. The various AF modes are described in more detail later in this chapter.

To take a shot, press down fully on the shutter-release button. However, the Rebel T5/EOS 1200D won't let you do this until the AF system has focused the lens (it will fire when the lens is set to MF, though).

What happens next is determined by the drive mode the camera is set to. When set to Single, one photograph will be taken when the shutter-release button is pressed down fully. To take another shot, the shutter-release button must be released fully and then pressed down again.

Set to Continuous, the Rebel T5/EOS 1200D will continue firing at the maximum possible frame rate until either the memory card or the image buffer is full, or you release the shutter-release button.

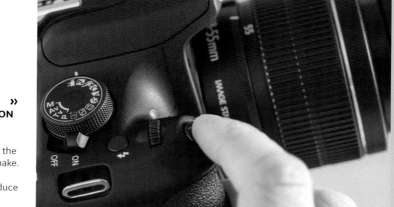

**THE SHUTTER- »
RELEASE BUTTON**
Stabbing at the shutter-release button increases the risk of camera shake. Pressing it down smoothly will reduce this risk.

The Rebel T5/EOS 1200D is compatible with Canon's Remote Switch RS-60E3. This is essentially a second shutter-release button for your camera at the end of a 2ft/60cm cable that plugs into the remote control socket (🎙) under the camera's terminal cover. The RS-60E3 can be used to activate the exposure meter and autofocus, and then fire the shutter to make an exposure—all without you needing to touch the camera body.

Remote releases aren't particularly useful when you're handholding your Rebel T5/EOS 1200D, but they are invaluable when you mount your camera on a tripod. Tripods are typically used to keep a camera steady, usually when light levels are low and the risk of camera shake is high. However, if you use the main shutter-release button there's still a risk that you'll knock the camera or transmit unwanted vibrations, negating the benefits of using a tripod. Firing the shutter remotely allows you to keep a slight distance from the camera, which helps to keep it steadier during the exposure.

Another useful function on the RS-60E3 is the ability to lock the shutter open (until you unlock it, of course). This is particularly useful when shooting very long exposures in Bulb mode, as it saves keeping your finger held down on the shutter-release button during the exposure.

DUSK «
The combination of a tripod and remote release will give you the greatest chance of shooting sharp images in low-light conditions.

MEMORY CARDS

You can use your Rebel T5/EOS 1200D without a memory card, but for everyday shooting you'll need to have a memory card in your camera to save your images.

The SD standard

The Rebel T5/EOS 1200D uses an SD memory card to store movies and still images. The technology of SD memory cards has evolved considerably since its introduction in 1999. The latest variant, SDXC, was announced in 2009 and is currently available in sizes up to 256GB (the specification of SDXC allows memory cards with a capacity of up to 2TB, but to date these have not been developed).

Apart from storage capacity, the biggest difference between SD cards is the speed at which they can read or write data. This is often not an issue when shooting still images, unless you regularly shoot sports/action or are particularly impatient (the read/write speed affects how long it takes to copy images from the memory card to your computer, which can be frustrating if this process is slow).

However, shooting movies definitely requires the use of a fast memory card—there's a lot of data that needs to be written to the memory card as a movie is recorded. Unfortunately, fast memory cards are more expensive than slower cards

of the same capacity, but if you intend to shoot a lot of video, it's wise to buy the largest and fastest SD card you can afford.

An SD memory card's speed is often shown as a Class Rating: the higher the Class Rating, the faster the card. The speed of a card is also sometimes shown as a figure followed by an "x." This figure refers to the speed of the card in comparison to the read/write speed of a standard CD-Rom drive. Canon recommends a Class 6 (40x) memory card or faster for shooting video.

Speed	Read/write speed (Mb/s)	Class Rating
13×	2.0	2
26×	4.0	4
40×	6.0	6
66×	10.0	10

Note:
The Rebel T5/EOS 1200D can also use Eye-Fi memory cards. These are proprietary SD memory cards that feature a built-in Wi-Fi transmitter. This allows you to copy files wirelessly from your camera to a computer.

Fitting and removing a memory card

1) Make sure your camera is switched **OFF**, then open the battery cover door.

2) If your memory card has a write-protect tab, slide the tab to the "unlocked" position. If the card is locked, **Card's write protect switch is set to lock** will appear on the LCD screen and you will not be able to take any photographs.

3) With the memory card contacts facing down and to the front of your Rebel T5/EOS 1200D, push the card into the slot until it locks with a click. Close the battery cover.

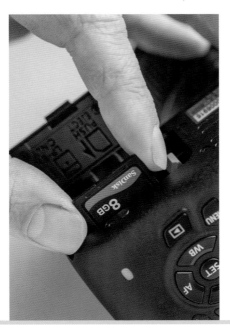

4) To remove the memory card, push it down slightly until you hear a click. The card should now come free. Pull it out gently and close the battery cover door.

Warning!

When the access lamp on the back of your Rebel T5/EOS 1200D is flashing, it means the camera is either reading, writing, or erasing image data. Do not open the battery cover door, or remove the card or the battery when the lamp is flashing. Doing this may cause data on the card to be corrupted and it could potentially damage your camera.

Note:
If there's no memory card in the camera, it's still possible to shoot photos by setting **Release shutter without card** to **Enable** on the ⬛ menu. However, even though you can fire the shutter, your photos will not be saved.

ADDING MEMORY «
An 8GB memory card should allow you to store approximately 970 ◢L JPEG or 270 Raw files.

Formatting a memory card

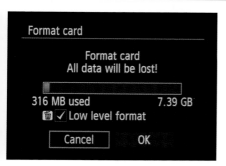

Format card

Format card
All data will be lost!

316 MB used 7.39 GB
🗑 ✓ Low level format

Cancel OK

Most SD memory cards are preformatted, using Fat 32 (SD and SDHC) or exFat (SDXC) formatting. Windows and Mac computers can read both format types, although older PCs may need an update before SDXC cards can be read correctly.

Although the memory card should be ready for use immediately, it's still good practice to format a card the first time you use it in your Rebel T5/EOS 1200D. This is particularly true if you've used the card in another camera previously. Any files saved by another camera may not be visible to the Rebel T5/EOS 1200D, so you will have less space on the card than you expect. If this is the case, make sure you've copied any images stored on the card somewhere else first!

1) Press MENU and use ◄ / ► to highlight the 🍴 tab (if it's not highlighted already).

2) Use ▼ to highlight **Format card** and press (SET).

3) Highlight **Cancel** and press (SET) to go back to the 🍴 menu without formatting. Select **OK** by pressing ► followed by (SET) to format the card.

4) As the card is formatted, **Busy...Please wait** will be displayed on screen. When the card has been formatted, the camera returns to the 🍴 menu.

> **Notes:**
> Usually, when you format a memory card, only the list of contents is erased. The original files remain on the card, but because the camera doesn't know they are there it gradually replaces them with new files, building up a new contents list as it does so. Because of this, it's often possible to recover your files with file-recovery software if you accidentally format a card—provided you don't use the card before doing so.
>
> A low-level format erases everything on the card, not just the list of contents. To use low-level formatting, press 🗑 / Av⊠ when you first enter the **Format** screen. A ✓ will be shown next to **Low Level Format** to indicate that you've chosen this option.

2 » MODE DIAL

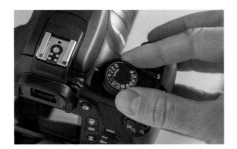

To select the desired mode, turn the dial until its icon is aligned with the white mark at the left of the dial. The mode dial has 13 settings: 12 still image modes, plus Movie for shooting video. The various shooting modes are described in more detail later in this chapter.

The mode dial controls the shooting mode your Rebel T5/EOS 1200D is set to. The shooting modes are grouped by Canon into two types: Basic Zone and Creative Zone. Basic Zone shooting modes are designed to help you successfully make images in specific shooting situations, such as portraiture or landscape. The downside to this help is that the Basic Zone modes are highly automated, which means that the range of adjustments you can make to the camera is very limited.

The Creative Zone modes are far less automated, which means you have to think more carefully when shooting—if an image isn't successful it's more likely to be your fault than the camera's. However, get it right (and there's no reason why you shouldn't) and the sense of achievement will be greater than if you had used a Basic Zone mode.

Basic Zone modes

Scene Intelligent Auto	A⁺
Flash Off	🚫⚡
Creative Auto	CA
Portrait	🧍
Landscape	🏔
Close-up	🌷
Sports	🏃
Night Portrait	🌃

Creative Zone modes

Program	P
Shutter Priority	Tv
Aperture Priority	Av
Manual	M
Movie	🎬

◆ DRIVE MODE

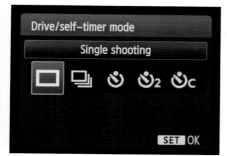

The Rebel T5/EOS 1200D's drive mode specifies whether the camera shoots one image each time you press down the shutter-release button (Single) or whether it shoots repeatedly (Continuous). You can also set a self-timer to fire the shutter automatically after a short delay.

Set to Continuous, the Rebel T5/EOS 1200D has a maximum shooting speed of 3 frames per second (fps). However, this is the very best frame rate possible, and it may not necessarily be achieved: the frame rate depends on the write speed of your memory card, as well as the ambient lighting conditions.

One factor that may bring your continuous shooting to a premature halt is the size of your memory card—if you run out of card space, shooting will stop. However, there's another more subtle factor that you need to be aware of: the Rebel T5/EOS 1200D's buffer.

The buffer is the camera's built-in memory, where images are stored temporarily until they've been written

MOVING OR NOT? »
The drive mode and AF mode you choose will often depend on whether your subject is moving or has the potential to move before you take your shot.

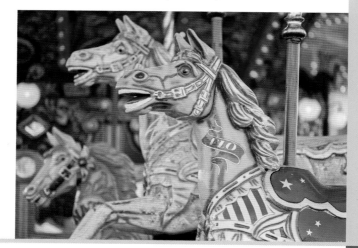

2

to the memory card. When shooting continuously, the buffer will gradually fill to the point that the camera can no longer continue shooting. When this happens, the maximum burst indicator at the right of the viewfinder will show **0** and **buSY** will flash at the left. At this point, you won't be able to shoot any more images until the frame buffer is sufficiently clear and the files are written to the memory card.

Therefore, if you're shooting fast-paced events, it doesn't pay to fire your camera continuously in the hope of catching the peak of action. Frustratingly, you may find your camera choking on this barrage of images and stopping at just the wrong moment. When shooting JPEGs, this happens after 69 shots (when using **◢L**); Raw reduces this to six shots; Raw+JPEG causes the frame buffer to fill after four frames. Correctly anticipating events and

then firing more conservatively will usually lead to a higher success rate.

All of the drive modes are selectable when shooting using a Creative Zone mode, but each Basic Zone mode determines automatically whether you shoot using either Single or Continuous (Self-timer is available in all of the Basic Zone modes). To adjust the drive mode, press ◄ and select the desired option from the drive mode screen. Alternatively, highlight the currently selected drive mode symbol on the Q screen and alter the setting, as described on page 27.

Note:
When **Self-timer continuous** is selected, press ▲ / ▼ to choose the number of shots to be taken.

Drive mode	Action	Symbol
Single	One shot fired per press of the shutter-release button.	☐
Continuous	Shutter fires continuously until memory card/frame buffer fills.	⤷
10-sec. self-timer	Shutter fires after a 10-second delay.	↻
2-sec. self-timer	Shutter fires after a 2-second delay.	↻2
Self-timer continuous	Shutter fires between two and ten shots after a 10-second delay.	↻c

Using the Single shot drive mode wouldn't be the immediate choice for a moving subject, but that's exactly the mode used for this shot. The key is to follow the movement of the subject with the camera in a smooth arc and fire roughly halfway through the arc. It takes practice to get it right, but panning—as the technique's called—can effectively add a sense of speed to a shot.

Settings
> Focal length: 60mm
> Exposure: 1/10 sec. at f/8
> ISO: 800

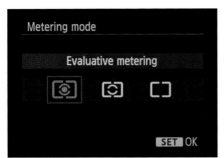

Exposure is the art of allowing the right amount light to fall onto the sensor inside a camera to create a satisfactory image. If there is not enough light, an image will be dark and underexposed; too much light and the image will be light (overexposed).

There are two steps to achieving a correctly exposed image. The first is to measure the amount of light illuminating the scene being shot. This is done using the exposure meter built-in to your Rebel T5/EOS 1200D (although if you're feeling adventurous, you could use a handheld meter instead). There are three different metering modes available, each with advantages and disadvantages.

By taking a meter reading, the shutter speed, aperture, and ISO can be set to allow the correct amount of light to reach the sensor. This is done automatically in Basic Zone modes, or you can control the process yourself in Creative Zone modes.

› Metering modes

To select one of the three metering modes on your Rebel T5/EOS 1200D, press Q and highlight ⊙ (the default metering mode). Turn 🐾 until the required metering option is displayed.

Evaluative metering ⊙

Evaluative metering calculates exposure by dividing the scene being metered into 63 separate zones. Each zone is assessed individually and the overall exposure is calculated by combining the results, taking into account where the focus point is. This system is generally accurate, even with unusual lighting situations. However, it's not infallible and can be thrown by where the camera focuses. If the camera focuses on a lighter-than-average subject, for example, evaluative metering can result in underexposure. Conversely, focus on a

darker-than-average subject and evaluative metering can lead to overexposure (for the reasons why, see chapter 6)

Partial metering

Rather than assess the image in its entirety, partial metering evaluates a small area at the center of the image. Partial metering is most useful if you want to measure the exposure of a particular part of your scene (typically this would be something with an average reflectivity). With exposure lock, you can set the exposure for something outside your intended composition and then recompose to take the shot.

Center-weighted metering

As with Evaluative metering, the exposure for the entire scene is read, but is biased toward the center. The one possible advantage that ▢ has over ◉ is that it's arguably more consistent, as it isn't affected by where the camera is focusing. However, Evaluative metering has largely superseded this metering mode.

› Exposure compensation

As good as the exposure meter in your Rebel T5/EOS 1200D is, there will be times when it gets the exposure wrong. Exposure compensation allows you to override the camera's suggested exposure in ½- or ⅓-stop increments, up to ±5 stops. Applying negative exposure compensation will darken the image, while positive exposure compensation lightens the image. This means you can adjust for any exposure

errors the camera may make, or even for creative effect. The simplest way to set exposure compensation is to hold down 🗑 / Av⊠ and turn ⚙ at the same time. The alteration can be seen on the standard exposure index in the viewfinder or on the LCD screen.

The downside of this method is that the viewfinder standard exposure index only shows exposure compensation up to ±2 stops. Dial in a value greater than this, and underexposure or overexposure are shown as ◀ or ▶ respectively at the side of the standard exposure index.

A more accurate way of viewing the level of exposure compensation is to use the ⓠ screen, highlight the standard exposure index, and turn ⚙. You can also set exposure compensation by selecting **Expo. comp./AEB** on the 📷 menu. Press ◀ / ▶ to apply exposure compensation, followed by ⑤ to confirm the setting.

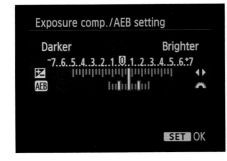

applying AEB, the first shot is exposed at the "correct" exposure setting, the second shot is darker, and the third shot lighter. The bracketing sequence can be across ±2 stops in ⅓-stop increments.

AEB is set on the **Expo. comp./AEB** screen by rotating ⚙: turning to the right will increase the difference in the exposure of the bracketed sequence, while turning to the left decreases it. As with exposure compensation, press ⑤ to confirm the new setting.

> ## Exposure bracketing

Bracketing is a term used to describe the technique of shooting two or more images at different shooting settings. This is done as a "safety net" if you're not sure what the correct settings for an image should be. Bracketing is usually synonymous with exposure, but the Rebel T5/EOS 1200D also allows you to bracket white balance.

Canon refers to exposure bracketing as Auto Exposure Bracketing (AEB). When

Notes:
AEB can be used in conjunction with exposure compensation.

To turn off AEB, turn ⚙ to the left until only the standard exposure index is shown.

If you apply exposure compensation as well as AEB, the bracketing values will be centered on the compensated exposure value.

Backlit subjects are often difficult to expose for: do you expose for the background and risk silhouetting the subject, or expose for the subject and overexpose the background? In this instance, Partial metering was used to determine the exposure of the large leaf at the top right, and then AE lock was used to hold the exposure while I recomposed.

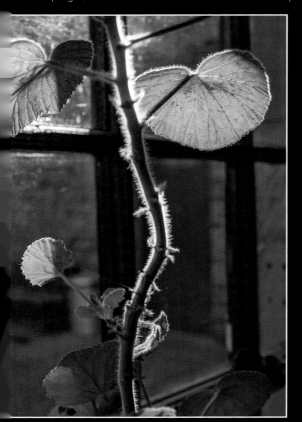

Settings
> Focal length: 40mm
> Exposure: 1/80 sec. at f/5.6
> ISO: 100

It's quite common to measure the exposure from one area of a scene, and then reframe your shot. The simplest way of doing this is to press the shutter-release button down halfway to lock exposure and then recompose.

However, this also locks focus, which may be undesirable. A better solution is to use the Rebel T5/EOS 1200D's exposure lock facility, which is known as AE lock. With the touch of a button, AE lock will hold the shutter speed, aperture, and Auto ISO value (if set) until you take a shot. If no shot is taken, it is canceled automatically after the time set using **Metering timer** on the 📷: menu.

A good example of when you might want to meter and recompose is when you have an off-center subject that is spot-lit against a dark background. Using 🔘 will allow you to move your camera to meter from your subject without the background influencing the exposure reading. Setting AE lock will then let you reframe the shot without the set exposure changing.

Activating AE lock

1) Press the shutter-release button down halfway to activate the exposure meter in the camera.

2) Press ✳. ✳ will light in the viewfinder to show that AE lock has been activated (or on the LCD if you're using Live View).

3) Recompose and press the shutter-release button down fully to take the shot.

4) AE lock is canceled automatically after you've taken the shot. If you want to keep the exposure locked, hold down the ✳ button as you shoot.

Metering mode	AF point selection method	
	Automatic	Manual
⊡	Exposure is determined and locked at the AF point that achieved focus (AE lock is applied to the center AF point if the lens is set to MF).	Exposure is determined and locked at the selected AF point. (AE lock is applied to the center AF point if the lens is set to MF).
🔘 / ☐	Exposure is determined and locked by the center AF point.	

ISO

The shutter speed and aperture chosen by you (or automatically by the Rebel T5/EOS 1200D) determine how much light reaches the sensor to make an image. The third exposure control—ISO—determines exactly how much light is needed to make that image. The default ISO range on the Rebel T5/EOS 1200D is ISO 100–6400: the higher the ISO value, the less light the camera needs to make an image. Think of it as turning up the volume on the sensor.

Unfortunately, there's a price to pay for increasing the ISO: image noise. Image noise is seen as a reduction in fine detail and an increase in "grittiness": the higher the ISO, the "grittier" the image will be.

The optimal ISO setting for a digital sensor is usually the lowest setting available, which is ISO 100 on the Rebel T5/EOS 1200D. If you want the very best image quality, this is the option to choose. However, the ability to alter the ISO is

one of the most useful aspects of a digital camera. If you're handholding your camera in low light, for example, you may not be able to keep the camera steady because the shutter speed is too long.

Increasing the ISO will allow you to use a faster shutter speed, so in this instance an increase in image noise will be preferable to losing shots because of camera shake. A certain level of noise can be removed either in-camera (by setting **C.Fn II-4 High ISO speed noise reduct'n**—see chapter 3) or in postproduction. The downside is that there will be some loss of fine image detail, but at least you'll have the shot.

Noise is most visible when an image is viewed on screen at 100% magnification. However, when you reduce the resolution of an image, noise becomes less visible. Using a higher ISO setting therefore is less of an issue if you know that the image will be reduced in size later.

The Rebel T5/EOS 1200D offers you the choice of either selecting a specific ISO value or setting **Auto**, which sets the ISO automatically according to the ambient light levels (this is the default when shooting in a Basic Zone mode and can't be altered). Auto ISO is most useful when you're shooting with the camera handheld and are moving between scenes with varying levels of ambient light (such as between outdoors and indoors).

2

There are several ways to set the ISO. The simplest method is to press the ▲ / **ISO** button and then set the required value on the LCD. ISO can also be set on the ⓠ screen. You can expand the ISO range and use H, which is equivalent to ISO 12,800: this is set using **C.Fn I–2 ISO expansion** on the 𝖄ⁱ menu. This option is not recommended for everyday shooting, though, as image quality is extremely low at this setting.

Notes:
Increasing the ISO reduces the dynamic range that the camera can capture. When shooting a scene that contains bright highlights and dark shadows, you will have a greater chance of capturing the full tonal range if you use a lower ISO setting.

If your camera is mounted on a tripod, use ISO 100. You won't need to worry about long shutter speeds enough to warrant an increase in ISO.

Don't use Auto ISO when using ND or polarizing filters.

ISO 100 ⌄⌄
The image on this page was shot at ISO 100.

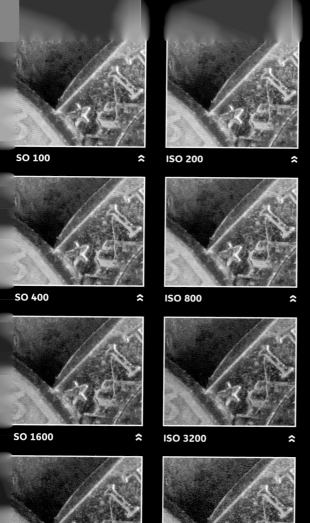

SO 100 ≫

ISO 200 ≫

SO 400 ≫

ISO 800 ≫

SO 1600 ≫

ISO 3200 ≫

SO 6400 ≫

ISO 12,800 ≫

ISO INCREASE

The images on this page are 100% crops of the main image, shot using the full range of ISO settings. At ISO 12,800 (H), detail is severely compromised, but for some uses (such as creating low-resolution images for web sites), the results can be useful.

2 » FOCUSING

In the most basic sense, the lens fitted to the front of your Rebel T5/EOS 1200D focuses light to form a sharp image on the sensor. Focus can either be achieved automatically, with the lens elements moved by motors within the lens barrel, or manually by physically turning the focus ring on the lens. All Canon lenses have an AF/MF switch, which allows you to switch between the two focusing methods.

When you look through the viewfinder, you will see nine rectangles arranged in a flattened diamond shape. These are focus points and show the relative position of the AF sensors built into the camera (Live View AF uses a different system that will be covered shortly). When autofocus is activated, one or several of the points will determine the camera-to-subject distance and focus the lens accordingly.

Although AF is convenient, there may be times when you need to switch to MF for reasons other than personal preference. The camera's AF system can struggle when light levels are low, for example, or when light-sapping filters are fitted to the lens. It can also fail when there is insufficient contrast in a scene. In these situations, the lens may start to "hunt" and fail to lock focus. When this happens, the green ● focus confirmation indicator in the viewfinder (and on the LCD in Live View) will blink. To solve this, either move the AF focus point or switch the lens to MF.

REACTION 《
This is the sort of subject that's easier to shoot when using the viewfinder. Switching to Live View and then focusing the lens using Live AF takes time— time during which the bird may fly away.

Note:
The Rebel T5/EOS 1200D actually has two AF systems. The switch occurs automatically when you swap between using the viewfinder and Live View. The viewfinder AF system uses technology called "phase detection," while Live View uses "contrast detection." Although you don't need to understand how they work, it's important to note that the two systems have different advantages and disadvantages. Phase detection is by far the faster of the two, but this speed comes at the expense of accuracy (although this slight inaccuracy will only be noticeable in certain extreme situations, such as using long focal length lenses at maximum aperture). Contrast detection is slower (you wouldn't use Live View AF for sports), but it is also very accurate, so is ideal for static subjects. Live View AF is described in more detail in the Live View section of this chapter.

can see the exact distance focused at in both meters and feet. When the lens is focused at ∞, it is said to be focused at infinity, which is the furthest possible focus distance (lenses without a distance scale still focus at infinity, there's just no visual confirmation on the lens barrel).

If you hold down the shutter-release button as you focus, the focus confirmation indicator (●) is lit and the camera beeps (if sound is switched on) when your subject is in focus—assuming your subject is under one of the viewfinder's nine focus points.

MANUAL FOCUS ⌄
It's all too easy to forget that the lens is set to MF if you've previously switched to manual focus. It's good practice to get into the habit of switching back to AF once you're done with MF.

Using MF

To focus manually, set the focus switch on the lens to MF, look through the viewfinder, and rotate the focus ring on the lens. Turn the focus ring to the right to focus on subjects that are closer to the camera, or to the left to focus on subjects further away. On lenses with a distance scale, you

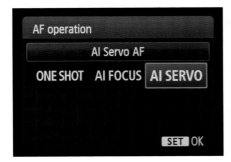

When the focus switch on the lens is set to AF, your Rebel T5/EOS 1200D will focus automatically as soon as you press the shutter-release button down halfway. However, there's more to AF than that. You have the choice of three subtly different AF modes that control whether AF stops at this point or whether it continues to update focus until the final moment of exposure. To choose the AF mode, set the lens to AF and either press the ▶/AF button or change the AF mode using the Q screen.

> **Note:**
> The AF mode is selected automatically when the camera is set to a Basic Zone mode.

One Shot

With One Shot selected, focus is locked by pressing the shutter-release button down halfway (with focus confirmed by the ● focus confirmation indicator lighting green). This means One Shot is only suitable for focusing on static subjects that won't move before you fully depress the shutter-release button to take the shot.

The exposure will also be locked at this point (when using Evaluative metering), which means you can keep the shutter-release button held down and move the camera without it refocusing or taking a new meter reading.

AI Servo

If you're shooting a moving subject, AI Servo is a better option than One Shot. AI Servo tracks moving subjects, adjusting focus (and exposure) until you press the shutter-release button down fully to take the shot. AI Servo is a predictive AF system, as it tries to predict how your subject is moving to keep it in focus. It works, but it's not infallible and can fail if your subject is moving too fast.

With AI Servo selected, hold down the shutter-release button halfway. If **AF point selection** is set to **Automatic selection** (see next page), the central AF point is used initially to determine focus. If the subject moves out from under the central

point, focusing automatically switches to one of the other eight AF points, as long as the subject stays within the AF points diamond.

When **AF point selection** is set to **Manual selection**, focus will still update using the selected AF point, but tracking will stop once the subject moves out from under that AF point. ● does not light in AI Servo mode and no sound is made when focus is acquired.

AI Focus

AI Focus is essentially a combination of One Shot and AI Servo. Focusing initially behaves exactly like One Shot, but switches automatically to AI Servo if your subject begins to move (as long as the shutter-release button is pressed down halfway).

When focus has switched to AI Servo, the beeper will continuously sound very softly as focus is tracked. Although this may seem the best of both worlds, AI Focus isn't quite as quick to begin continuous focusing as AI Servo, so if you know for certain that your subject will move it is better to use AI Servo from the outset.

MOVEMENT »
If your subject is moving, AI Servo will keep track of that movement to maintain focus.

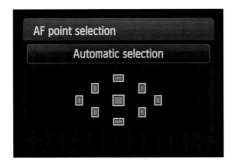

By default, your Rebel T5/EOS 1200D is set to **Automatic selection** of the AF points. This means that your camera automatically selects one (or more) of the nine AF points to focus with. Typically, the Rebel T5/EOS 1200D focuses on the closest point in the scene to the camera (when more than one AF point has been selected, the AF system has found and focused on several areas of the scene that are exactly the same distance from the camera).

Automatic selection generally does a reasonable job at deciding where to focus, but as with other areas of AF, it is not foolproof. One of the ways it can fail is when you're shooting an off-center subject (particularly if there's something else in the scene that's central and closer to the camera). Fortunately, you can switch to **Manual selection** of the AF points to specify exactly which AF point should be used to focus.

Switching AF point selection mode
1) In shooting mode, press ⊕ / ▞▞ , followed by (SET) to toggle between the **Automatic selection** and **Manual selection** options.

2) Look through the viewfinder or at the LCD screen in Live View and press ✛ to select the desired focus point. In the viewfinder, the selected AF point is lit red; on the LCD, the selected AF point is the one with an orange center. ⚙ can also be used to quickly jump around the nine focus points.

3) Once all the focus points have been highlighted in turn, point selection will automatically return to **Automatic selection** (all of the AF points on the LCD will have an orange center or will light red in the viewfinder).

4) Press down halfway on the shutter-release button to return to shooting mode once you've selected the desired AF point. When you next focus, only the selected focus point will be used.

Although there are nine AF points, they aren't all equal in their capabilities. The most sensitive AF point is the one at the center, so in low-light conditions the central AF point will be able to focus more accurately than the other eight. If your dimly lit subject isn't central, point the camera at the subject, focus, and recompose, keeping the shutter-release button held down halfway.

Settings
> Focal length: 200mm
> Exposure: 1/8 sec. at f/14
> ISO: 100

2 » LIVE VIEW

Live View allows you to compose your shots using the LCD screen. To achieve this, the Rebel T5/EOS 1200D flips the reflex mirror inside the camera up, blacking out the viewfinder as it does so. The shutter is then opened and a live feed from the sensor is sent to the LCD screen.

The advantage of Live View over the viewfinder is that you can see exactly how functions such as Picture Style will affect the look of your image before you take the shot (the panel below shows which functions are reproduced). You will also see a reasonable simulation of the final exposure when **Exp. SIM** is shown in white on the LCD. If the image on the LCD is displayed at a different brightness to the final exposure, **Exp. SIM** will blink. If the final exposure cannot be simulated (when using flash, for example), **Exp. SIM** is grayed out.

The main disadvantage of Live View is that it's far less power efficient than using the viewfinder, so the battery won't last anywhere near as long.

Pressing **Q** displays the Quick Control options available when using Live View.

Function	Comments
Exposure	Not available when using flash.
Peripheral illumination correction	Selected lenses only.
Aspect ratio	Black borders are used to define image shape.
Highlight tone priority	Not available when Auto Lighting Optimizer is enabled.
Depth of field preview	Available when C.Fn IV-9 is set to 4.
White balance/WB correction	–
Lighting/scene-based shots	Certain Basic Zone modes only.
Ambience-based shots	Certain Basic Zone modes only.
Auto Lighting Optimizer	Not available when Highlight tone priority is enabled.
Picture Style	–

These are shown overlaid on the Live View image. You can also choose how much (or how little) shooting information is shown on screen by repeatedly pressing DISP. One useful piece of information is the live histogram, which shows the tonal range of the image. Skip to chapter 6 to find out more about how to use a histogram.

Using Live View

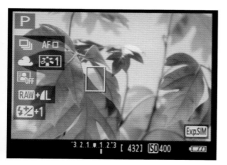

1) With the power switch set to **ON**, press ▣. The mirror inside the camera will rise and after a short delay the Live View image will be displayed on the LCD.

2) The AF mode is set to **AF** ▢ /FlexiZone-Single by default. To move the white focus point rectangle around the LCD, press ✛. To recenter the AF point, press (SET).

3) Press the shutter-release button down halfway to focus, and then down fully— once focus has been achieved—to take the shot.

> **Note:**
> You can magnify the Live View image by 5x or 10x: press ⊕ to magnify the Live View image 5x, again to magnify 10x, and then again to restore the display to normal. Magnifying the Live View image is particularly useful for checking critical focus in the scene (such as when shooting macro subjects). Use ✛ to pan around the magnified image if desired.

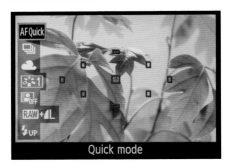

Quick mode

There are three AF modes available when using Live View. The simplest is **AF** □ / FlexiZone-Single. Although there is only one AF point compared to the nine in the viewfinder, **AF** □ has one major advantage: you can move the AF point over a greater area of the image, so you're not restricted to a relatively small diamond shape at the center. This makes **AF** □ ideal for static subjects that are close to the edge of the image space.

The second AF mode, **AF** □ /Live mode, is designed to detect faces within the image space and focus precisely on them. A white ⌐ ⌐ AF point is drawn around an automatically detected face. If there are multiple faces in the shot, ⌐ ⌐ will be displayed instead. By pressing ◄ / ►, you can move the AF point to the desired face. Press the shutter-release button down halfway to focus. Once focus has been achieved, the target box will turn green

as confirmation (or orange if AF can't be confirmed). Press the shutter-release button down fully to take the shot. If a face isn't detected, the **AF** □ point will be displayed instead and focus will be set at the center of the image.

The final mode, **AF** Quick /Quick Mode, uses the Rebel T5/EOS 1200D's standard viewfinder AF sensors to achieve focus. To do this, Live View is turned off temporarily. Press down halfway on the shutter-release button to focus—the Live View image will briefly disappear while the camera focuses. When focus has been achieved, the Live View image reappears and the focus point that achieved focus will turn green. Press the shutter-release button down fully to take the shot. If focus cannot be achieved, the focus point will turn orange and blink.

Tip

If the lens is completely out of focus, Face Detection will be less efficient. Turn your lens to MF and achieve a rough focus, then switch back to AF.

WHITE BALANCE

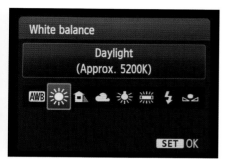

Most light sources have a color bias. This is usually either a red bias (resulting in the light being "warm") or a blue bias ("cool" light). Our eyes usually adjust, so often we don't realize that the light is not neutral in color. It is only when the color

bias is extreme (such as the warmth of candlelight) or when two different light sources are mixed that we really notice a difference. The variation in the color bias of light has been quantified and is known as the "color temperature," which is measured using the Kelvin scale (K).

White balance (WB) is a function on your Rebel T5/EOS 1200D that allows you to adjust for this color bias. You can set the WB either by using one of the presets built into the camera or by specifying a Kelvin value. The preset you choose is the one that most closely matches the light you're shooting under. So, if you were shooting under domestic incandescent lighting, for example, you would choose ☀ Tungsten. For greater accuracy, you can also create a custom white balance or refine the selected preset (see chapter 3).

Setting white balance
1) Press the ▼/WB button.

2) Highlight the desired white balance preset and press (SET).

> **Note:**
> You can't change WB in the Basic Zone modes, but some of these modes allow you to alter **Light/scene-based shots**, which has a similar effect.

WB settings	
AWB	White balance is set automatically
☀	Daylight/5200K (sunny conditions)
🏠	Shade/7000K (shadow conditions)
☁	Cloudy/6000K (overcast light)
☀	Tungsten/3200K (domestic incandescent lighting)
▩	White fluorescent lighting/4000K
🔦	Flash/5500K
◪	Custom white balance

2 » IMAGE PLAYBACK

As soon as you've shot an image, your Rebel T5/EOS 1200D will automatically display it on the LCD for two seconds. You can turn off this facility or alter the display time by adjusting the **Image review** settings on the ◻ menu.

If you want to view images you have shot previously, you first need to press ▶. The first image shown is the last image you viewed previously (which if you've just shot an image will be that one). Both still images and movies can be viewed on the LCD, with movies distinguished from stills by a 🔲🎞 icon at the top left of the LCD.

You can skip backward or forward through your still images and movies by pressing ◀ / ▶ respectively. Turning 🗘 skips through your images using the jump method selected via **Image jump w/**🗘 on the ▶ menu.

Pressing DISP. repeatedly toggles between four different ways of viewing still images and movies. The default is a simple display showing only the still image or the first frame of the movie. The second option shows the still image or movie with a restricted amount of shooting information. The third screen shows detailed information with a brightness histogram. The final screen removes some of the shooting information to display both brightness and RGB histograms.

› **Playback Quick Control**

If you press 🔲 during playback, you can set the following functions: ⌐ Protect images, 🔲 Rotate, ★ Rating, ◐ Creative filters, ⬚ Resize (JPEG only), or ⬚ Jump method. Options in gray are not available when viewing movies.

To select one of the controls, press ▲ / ▼ to highlight the desired control and then ◀ / ▶ to choose the required option. ◐ is the exception to this procedure, as you need to choose the strength of the

> **Tip**
>
> *One neat feature of detailed shooting information playback is that overexposed areas of an image (where the pixels in the image are completely white) will blink white/ black as a warning.*

required filter. With the option highlighted, press (SET) and ◄ / ► to choose the strength of filter. Press (SET) and select **OK** to set the strength and return to the ☒ screen, saving a new image with the ◐ applied.

> ## Magnifying images

You can magnify still images in playback up to 10x. This facility can be used to check critical focus.

This is particularly useful when using longer focal length lenses at maximum aperture, as depth of field will be minimized (so focusing accurately is more important). A good example of when this is useful is if you are shooting portraits. In this instance, it's important to make sure that your subject's eyes are in focus. Magnifying the image after shooting will either confirm this or quickly show that you need to reshoot.

Magnify images
1) Navigate to the image you want to view.

2) To zoom into an image, press ⊕. Use ✛ to move around the zoomed display. A white box within a small gray box, at the bottom right corner of the LCD, will show your position in the image.

3) To zoom back out, press ▦ / ⊖ .

> ## Image index

As well as magnifying a single image, you can also view four or nine images on screen at any one time. If you have a large number of images on your memory card, using the image index view is an effective way of speeding up the task of scanning through them.

Using image index

1) In single image playback mode, press ▓ / ⊖ once to view an index of four images, and again to view nine images.

2) The image you originally started from will be highlighted with an orange box. Use ✦ to select another image on the screen, or turn ⚙ to move up and down pages of images on the memory card (assuming there are more than four or nine on the memory card).

3) When the image you wish to view is highlighted, press ⊛ to revert to single image display.

› Erasing images

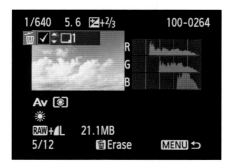

As soon as you've shot an image, you can erase it immediately by pressing ⅲ /Av☒ and selecting **Erase** (or **Cancel** if you change your mind). The same method of erasure can be used when reviewing pictures shot previously, unless the image is protected.

Deleting multiple images

1) Press MENU, navigate to ▶, and select **Erase images**.

2) Choose **Select and erase images**.

3) Press ◀ / ▶ to skip through the images on the memory card. To view three images on screen simultaneously, press ▓ / ⊖ ; to restore single-image view, press ⊕.

4) When the image you want to delete is displayed, press ▲ / ▼ to toggle the erase marker. A ✓ will be displayed in a box at the top left corner of the LCD to show that the image has been marked for deletion. The number of images marked for deletion is shown to the right of the ✓ icon. Mark more images for deletion as necessary.

5) When you're done, press ⅲ / Av☒ to erase all of the marked images. Select **OK** to erase the selected images, or **Cancel** to return to step 3.

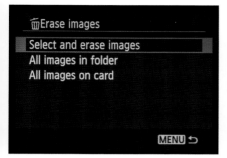

Other deletion options
1) Press MENU, navigate to ▶, and select **Erase images**.

2) Select **All images in folder**. Press ▲ / ▼ to choose the folder you wish to erase images from and press (SET). Select **OK** to continue, or **Cancel** to return to the folder selection screen.

3) To erase all the images on the memory card (except those that are protected), select **All images on card** at step 1. Select **OK** to continue, or **Cancel** to return to the main **Erase images** menu.

› Protecting images

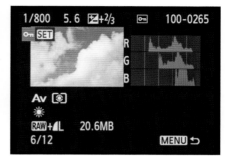

Accidentally deleting an image that you want to keep is easily done. Fortunately, you can add protection to images to avoid this happening. Once an image has been protected, the only way to erase it is either to remove protection or to format the entire memory card (which will clear the card, removing both protected and unprotected images alike).

Protecting multiple images
1) Press MENU, navigate to ▶, and select **Protect images**.

2) Choose **Select images**.

3) Press ◀ / ▶ to skip through the images on the memory card. To view three images on screen simultaneously, press ▦ / 🔍 ; to restore single-image view, press 🔍.

4) When the image you want to protect is displayed, press ⑤ to toggle the protection marker ⚬⊓. This marker will be displayed at the top of the LCD to show that the image has been protected.

5) Repeat steps 3 and 4 to protect other images as required.

6) When you're done, press MENU to return to the main **Protect images** menu.

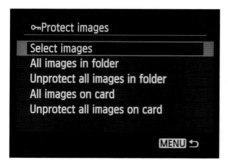

Other protection options
1) Press MENU, navigate to ▣, and select **Protect images**.

2) Select **All images in folder**. Use ▲ / ▼ to highlight the folder you wish to protect, and then press ⑤. Select **OK** to continue, or choose **Cancel** to return to the folder selection screen.

3) To protect all the images on the memory card, select **All images on card**.

Select **OK** to continue, or **Cancel** to return to the main **Protect images** menu.

4) To remove protection, follow steps 2–3, but this time select either **Unprotect all images in folder** or **Unprotect all images on card**.

DELETING ⧯
Don't be tempted to delete as you shoot (unless you need to free up card space). Even if you make mistakes, it's easier to learn from those mistakes looking at images on your computer than on the camera's LCD screen.

BASIC ZONE MODES

The Basic Zone exposure modes are designed to let you achieve satisfying shots immediately, without the worry (and stress) of setting a variety of different camera functions. The two simplest Basic Zone modes are [A]⁺ Scene Intelligent Auto and [⚡] Flash Off. There are no options to change in these modes, other than using self-timer or raising the flash in [A]⁺.

The other Basic Zone modes are slightly more sophisticated. These can be altered by setting **Ambience-based shots**, or when using 🐕, 🏔, 🌷, and 🏃 modes, you can set **Light/scene based shots**.

[CA] Creative Auto is the most flexible of the Basic Zone modes, as it gives you some control over the depth of field of the image by setting **Background blur**.

› Scene Intelligent Auto [A]⁺

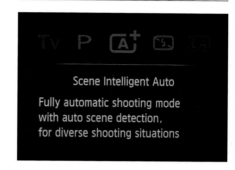

Scene Intelligent Auto

Fully automatic shooting mode with auto scene detection, for diverse shooting situations

[A]⁺ is very much the Rebel T5/EOS 1200D's "point-and-shoot" mode. Virtually all the shooting functions (including exposure, white balance, and Picture Style) are set automatically and cannot be altered. The only functions you can change are the drive mode and flash (both of which can be altered by pressing the [Q] button and selecting the relevant option), which leaves you free to compose your images without worrying about technical details.

The downside to [A]⁺ is that a number of creative decisions are taken out of your hands, but if you just want to shoot and have a better-than-average chance of success—at social or sporting events, for example—[A]⁺ is ideal.

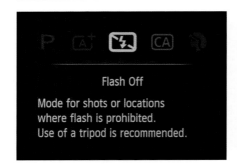

Flash Off

Mode for shots or locations where flash is prohibited. Use of a tripod is recommended.

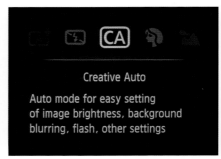

Creative Auto

Auto mode for easy setting of image brightness, background blurring, flash, other settings

This shooting mode is essentially the same as A⁺, although you can't raise the built-in flash and an external flash (if fitted) won't fire either. You'd typically use this mode when flash might not be creatively appropriate or is simply not allowed.

⚡️ increases the ISO automatically to try to maintain a fast shutter speed to avoid camera shake. You can help by activating Image Stabilization (if your lens has it). Using a wide-angle lens will also reduce the risk of camera shake compared to a telephoto lens. If the shutter speed is low enough that camera shake is a possibility, the shutter speed display in the viewfinder will flash.

Q options: Drive mode

Creative Auto is similar to A⁺, but with four shooting options that can be altered by pressing Q before you shoot.

The first—**Ambience-based shots**—allows you to tweak the look of your images. You can choose from a range of different presets, such as Monochrome, which then can be refined.

The second option, **Background blur**, allows you to roughly adjust the amount of out-of-focus areas in an image. When set to 🔳, depth of field will be minimized and the background area will be softer; 🔲 maximizes depth of field, making the image sharper overall.

The drive/self-timer mode can be changed (as described on page 35) and you can also control the flash by selecting **Auto flash**, **Flash on**, or **Flash off**.

Q options: Ambience-based shots; Background blur; Drive mode; Flash

Ambience-based shots options

Setting	Options	Comments
Standard	None	The standard image setting for the chosen shooting mode.
Vivid	Low; Standard; Strong	Increases the saturation of the colors in an image, although the effect can appear cartoon-like if shooting a scene that is already highly saturated.
Soft	Low; Standard; Strong	Reduces contrast, producing a softer effect.
Warm	Low; Standard; Strong	Adds red, increasing the warmth of the image.
Intense	Low; Standard; Strong	Contrast is increased to add drama to an image.
Cool	Low; Standard; Strong	Adds blue to cool the image down.
Brighter	Low; Medium; High	Brightens an image for a "high-key" effect. Can lead to burnt-out highlights in high-contrast lighting.
Darker	Low; Medium; High	Darkens an image for a "low-key" effect. Can lead to dense, black shadows in high-contrast lighting.
Monochrome	Blue; B/W; Sepia	Removes the color from your images, turning them into black and white (or with an optional blue or sepia tone).

Light/scene-based shots options

Setting	Result	Comment
Default	Image stays relatively true to the light source.	Good for general-purpose photography.
Daylight	Colors are correctly balanced for shooting during the middle of the day under sunlight.	Images will appear too warm when shooting indoors under artificial lighting.
Shade	Colors are rendered true when shooting in open shade.	Shade light is very blue. This option adds red to the image to correct for this tendency.
Cloudy	Colors are rendered true when shooting under cloudy conditions.	As with shade, overcast light has a tendency to blueness, although not as dramatically.
Tungsten light	Corrects image color when shooting under household lighting.	Tungsten lighting is biased toward red. This option adds blue to compensate for the tendency. Not available when shooting using ▲.
Fluorescent light	Corrects image color when shooting under white fluorescent lighting.	White fluorescent is warmer than daylight, but not as warm as tungsten lighting, so less blue is added to compensate. Not available when shooting using ▲.
Sunset	Keeps the warmth of the sunlight at sunrise and sunset.	Direct sunlight at either end of the day is very warm in color.

Portrait 🙎

Portrait

For portrait shots. Backgrounds are blurred,subjects stand out. Smoothes skin tone and hair.

› Landscape 🏔

Landscape

For landscape shots. Wide DOF (foreground–background in focus), sharp images.

As the name suggests, 🙎 mode is designed to help you create pleasing shots of people's faces. To achieve this, the Rebel T5/EOS 1200D biases the aperture setting so that depth of field is minimized. This means that backgrounds will be relatively soft and in turn less distracting; the longer the focal length of the lens, the greater the effect. Using a telephoto lens has the happy result of creating a more natural perspective for your subject as well.

However, as depth of field is minimized, focusing needs to be accurate, so it's recommended that you ensure that your subject's face is within the AF focusing area when using the viewfinder.

🔲 options: Ambience-based shots; Light/scene-based shots; Drive mode; Flash

🏔 mode is designed to enhance your landscape shots by boosting the saturation of greens and blues, and increasing the sharpness of the image by maximizing depth of field when possible.

The true landscape photography aficionado will be out either early in the morning or late in the afternoon. The warm, low light at these times of day helps to produce attractive landscape images.

However, there are some subjects that benefit from the softer light found on overcast days. Woodland is one of these, as soft light reduces the contrast range, making it easier to record detail in both shadow and highlight areas.

🔲 options: Ambience-based shots; Light/scene-based shots; Drive mode

Close-up

For close-ups of small subjects such as flowers. Shoot as close to subjects as possible.

🌷 mode will be confusing if you've migrated to the Rebel T5/EOS 1200D from a compact camera. Compact cameras generally have excellent close-up modes that allow you to get within inches of your subject. When switched to 🌷, the Rebel T5/EOS 1200D is optimized to shoot close-up images: the aperture and shutter speed are set to minimize depth of field and reduce the risk of camera shake. However, the closest distance you'll be able to focus will depend on the lens fitted.

The ultimate close-up photography lens is a macro lens (see chapter 7). The 18–55mm kit lens that is commonly sold with the Rebel T5/EOS 1200D does not have a macro facility, but with a minimum focusing distance of 10 inches (25cm), it will allow you to capture reasonably close-up images.

Q options: Ambience-based shots; Light/scene-based shots; Drive mode; Flash

KIT LENS «
Canon's 18–55mm "kit" lens can focus close enough to let you take interesting detail shots.

Sports 🏃

Sports

For shooting subjects in motion. Continuous shooting with subject kept in focus.

🏃 mode gives priority to fast shutter speeds. The ISO is also increased, up to a maximum of ISO 6400, making your action images potentially "noisy."

Capturing fast action successfully isn't just about shooting wildly and hoping that at least one frame works. Successful sports photographers can anticipate when the peak of action will occur and be ready to shoot at that point. This discipline was often honed by shooting on film, when exposing multiple rolls of film would incur unnecessary expense. Obviously digital images are essentially free, but it's worth training yourself to think this way, as it takes time to work through hundreds of near-identical images.

[Q] options: Ambience-based shots; Light/scene-based shots; Drive mode

> Night Portrait 🌃

Night Portrait

For portrait shots with illuminated night scenes in the background

Night Portrait automates the process of shooting subjects in low light. The trick with 🌃 is that although the flash fires automatically to illuminate your subject, the shutter stays open long enough to correctly expose the background (which won't be illuminated by flash).

Because the shutter speed will be longer at night, mounting your camera on a tripod (or other support) is recommended. If the shutter speed drops below 1/4 sec., ask your subject to keep as still as possible during the exposure. If they move during the exposure, they will be recorded as a ghostly double image; the first (sharp) image lit by flash, the second (more blurred) by ambient light.

[Q] options: Ambience-based shots; Drive mode

2 » CREATIVE ZONE MODES

If you want to take full control of your photography, you'll need to use one of the Rebel T5/EOS 1200D's Creative Zone modes. To use the Creative Zone modes successfully, you'll need to understand some of the basic concepts of photography, as described briefly on the following pages and in more depth in chapter 6.

SETTINGS AVAILABLE IN THE CREATIVE ZONE MODES

Focus settings
One Shot AF; AI Servo AF; AI Focus AF; AF point selection; AF-assist beam; Manual focus (MF)
Live View only: 🖐 Live mode; FlexiZone-Single; Quick mode

Image settings
Quality: JPEG (Fine/Normal; Compression levels: L; M; S1; S2; S3); JPEG+Raw; Raw
Other: Aspect ratio; Peripheral illumination correction

Exposure settings
Metering: Evaluative; Partial; Center-weighted average
Settings: Program shift (**P** only); Exposure compensation (not **M**); AEB; AE lock (in **M** with ISO Auto, you can set a fixed ISO); Bulb (**M** only); Long exposure noise reduction

Tone settings
White balance (AWB; Preset; Custom; Correction/Bracketing); Auto Lighting Optimizer; Highlight tone priority; Color space (sRGB; Adobe RGB); Picture Style

Drive mode
Single; Continuous; Self-timer (2 seconds; 10 seconds; 🕐c)

ISO settings
ISO Auto; Manual selection (100–6400); Maximum for Auto; High ISO speed noise reduction

Built-in flash settings
Auto; Flash on; Flash off; Red-eye reduction; FE lock; Flash exposure compensation

External flash settings
Function settings; Custom function settings

This looks like a relatively simple image (and compositionally it is). However, it required careful control of the exposure to ensure detail wasn't lost in the sky. This was achieved by using exposure compensation, which is only available in the Creative Zone modes.

Settings
> Focal length: 100mm
> Exposure: 1/8 sec. at f/11
> ISO: 100

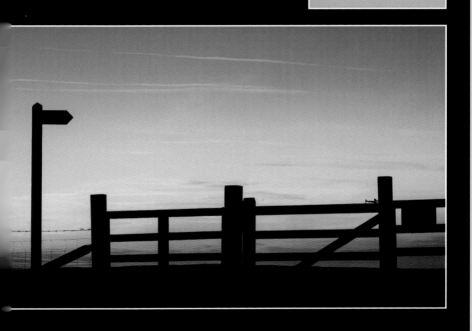

Program AE

Auto setting of shutter speed and aperture. Other settings can be configured manually.

At first glance, you could argue that **P** duplicates the functions of A⁺, as both are essentially "point-and-shoot" modes in which the Rebel T5/EOS 1200D sets the exposure automatically. However, **P** is far more sophisticated than that, as you can override the exposure decisions made by your Rebel T5/EOS 1200D, so you have the final say.

The exposure can be adjusted either by applying exposure compensation or changing the ISO. You can also use a function known as "Program Shift." Although Program sets both the shutter speed and aperture, you don't have to settle for the selected combination of values. Program Shift allows you to adjust (or shift) the shutter speed and aperture combination. This means that you can have a wider aperture and faster shutter speed or a smaller aperture and longer shutter speed than the original settings selected by the camera.

To set Program Shift, turn once you've pressed the shutter-release button down halfway to activate the camera's exposure meter. After you take your shot, Program Shift will be canceled.

P also lets you freely choose from the full range of image options, such as Picture Styles, so although it's an automatic mode, it's better to think of it as a halfway point between A⁺ and the semi-automatic **Tv** and **Av** modes.

Using P mode

1) Turn the mode dial to **P**.

2) Press the shutter-release button halfway down to focus and activate exposure metering. If **30"** is displayed, and both it and the lens' maximum aperture value are blinking in the viewfinder or on the LCD, this indicates underexposure. You'll need to increase the ISO or add extra illumination to the scene (potentially by flash).

Conversely, overexposure is likely if **4000** and the lens' minimum aperture value is displayed and blinking in the viewfinder or on the LCD. You will need to decrease the ISO or reduce the amount of light reaching the sensor (either by shading your subject or fitting a light-blocking filter, such as an ND filter).

3) Turn to alter the shutter speed and aperture combination if required, and then press halfway down on the shutter-release button again. When focus has been achieved, press down fully on the shutter-release button to take your shot.

4) The captured photograph will be displayed on the LCD screen for 2 seconds, unless the review time has been adjusted.

DAYS OUT »
P is ideally suited to fun days out when you don't want to think about technical issues as you shoot, but still want high-quality results.

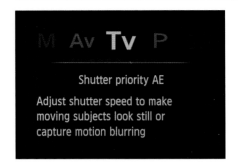

M Av **Tv** P

Shutter priority AE

Adjust shutter speed to make moving subjects look still or capture motion blurring

Tv and **Av** are both semi-automatic exposure modes: you set one aspect of the exposure and your camera sets the other automatically. When you use **Tv**, you set the shutter speed you want to use and the camera sets the aperture for you. When you hold down the shutter-release button, the shutter stays open for the period of time set using **Tv**. This (in conjunction with the aperture) controls how much light reaches the digital sensor to make an image. For more information about how the shutter speed and aperture control exposure, see chapter 6.

The shutter speed you choose is important for two reasons. Your ability to handhold the Rebel T5/EOS 1200D and not see camera shake in the resulting image is determined by the shutter speed you use: the slower the shutter speed, the greater the risk of camera shake. Although the Rebel T5/EOS 1200D kit lens has built-in

IS (Image Stabilization), you will eventually reach a shutter speed that will require the use of a tripod to keep the camera steady during exposure. A very rough rule when handholding a camera is to at least match the shutter speed to the focal length of the lens. So, if the lens is set to 55mm, you'd use a shutter speed of 1/50 sec. or higher, a 200mm lens would require a shutter speed of 1/200 sec. or higher, and so on.

The shutter speed you use is also important if there's movement in the scene you're photographing. There are two options when it comes to recording movement: you can either "freeze" it or you can deliberately blur it.

Freezing movement means using a fast shutter speed—the faster the movement, the faster the shutter speed will need to be. You also have to take into account the distance between you and your moving subject, as the closer the subject is to the camera, the faster the shutter speed will need to be. A subject moving across the image frame will also need a faster shutter speed than a subject moving toward or away from the camera.

Slowing the shutter speed down will make your moving subject appear more blurred and soft. This is not necessarily a bad thing, as a certain amount of softness can help to convey a sense of movement

more effectively than pin-sharp detail. With a sufficiently long shutter speed, a moving subject may even disappear entirely from the image—this can be an effective way to "remove" people from a scene. The slower the shutter speed, the more necessary a tripod or other support will become.

ZOOM

It's not just your subject that can move during an exposure. Turning the zoom ring on a lens during a 1/4 sec. exposure created this effect.

Using Tv mode

1) Turn the mode dial to **Tv**.

2) Turn 🔄 to the right to set a faster shutter speed or to the left to lengthen the shutter speed. As you change the shutter speed, your camera will change the aperture automatically to maintain the same level of exposure overall.

3) Press halfway down on the shutter-release button to take an exposure reading. If the lens' maximum aperture figure blinks in the viewfinder or in Live View, your image will be underexposed. To correct this, you'll need to use a longer shutter speed, increase the ISO, or add more light to the scene.

If the minimum aperture figure for your lens blinks, the image will be overexposed. You will then need to use a faster shutter speed, decrease the ISO, or reduce the amount of light reaching the sensor.

4) Once you're happy with the exposure, press the shutter-release button down halfway; when focus has been achieved, press down fully on the shutter-release button to take the shot.

5) The photograph will be displayed on the rear LCD screen for 2 seconds, unless the review time has been adjusted.

M **Av** Tv P

Aperture priority AE

Adjust aperture to blur backgnd (subjects stand out) or keep foreground and backgnd in focus

Inside every EOS lens is an aperture that can be varied in size to control the amount of light that enters the camera. The most light is let through when the lens is set to its maximum aperture; the least amount of light passes through at minimum aperture.

The aperture also has another, subtler, effect on an image: it controls the amount of acceptable sharpness in the image. As the aperture is made smaller, a zone of sharpness extends out from the focus point. This zone of sharpness is known as "depth of field." Depth of field always extends further back from the focus point than it does in front.

The extent of the achievable depth of field is influenced by three factors. The first is the available aperture range on a lens. The second factor is the focal length of the lens—depth of field is always greater at any given aperture when using a shorter focal length lens than a longer focal

length. The third factor is the camera-to-subject distance, as the closer you focus (the shorter the camera-to-subject distance), the less depth of field you'll be able to achieve, even when using a lens at minimum aperture. This is a particular problem when shooting close-up images using a macro lens.

When you look through the viewfinder or when viewing a Live View image, you are seeing the scene at maximum aperture (and so at minimum depth of field). The Rebel T5/EOS 1200D doesn't have a depth of field preview button, but you can assign this task to the (SET) button (see chapter 3). If you do this, holding down (SET) will close the aperture to the selected value. If you've selected a small aperture, the viewfinder will go dark, but if you wait a few seconds for your eyes to adjust, you should be able to see a difference in overall sharpness. This will give you a more accurate guide to how your final image will look.

In some respects, Live View is a better option though, as the brightness of the screen remains constant, making it easier to see the increase in depth of field.

Using Av mode

1) Turn the mode dial to **Av**.

2) Turn to the right to make the aperture smaller (the minimum aperture on the 18–55mm kit lens is f/22 at 18mm and f/36 at 55mm) or to the left to make it larger (the maximum aperture on the 18–55mm kit lens is f/3.5 at 18mm and f/5.6 at 55mm). As you change the aperture, the camera adjusts the shutter speed automatically to maintain the same level of exposure overall.

3) Press halfway down on the shutter-release button to take an exposure reading. If the shutter speed indicator shows a blinking **30"** either in the viewfinder or on the LCD, your image will be underexposed.

To correct this, you'll need to use a larger aperture, increase the ISO, or add more light to the scene.

If the shutter speed indicator shows a blinking **4000** in the viewfinder or on the LCD, your image will be overexposed. You will either need to use a smaller aperture, decrease the ISO, or use filters to reduce the amount of light reaching the sensor.

4) Once you're happy with the exposure, press lightly halfway down on the shutter-release button again. When focus has been achieved, press down fully on the shutter-release button to take the shot.

5) By default, the captured photograph will be displayed on the LCD for 2 seconds, unless the review time has been adjusted.

OUT OF FOCUS »
Aperture controls depth of field. The longer the lens and the closer your subject is to the camera, the less depth of field is available.

M Av Tv

Manual exposure

Set shutter speed and aperture manually for greater freedom of expression in shots

When you switch to **M** mode, you're in full control of how your images are exposed. This means that it's up to you to set both the shutter speed and the aperture: if you get it wrong, you have no one to blame but yourself!

Although this may sound slightly scary, you do still have the exposure meter in the Rebel T5/EOS 1200D to guide you. Plus, **M** mode is actually very liberating. Because you're in complete control, you can deliberately ignore the camera's meter reading and use an exposure that captures the image precisely as you visualize it. Choosing how an image is exposed is as creative an act as composition; you don't need to be technically correct all the time.

High-key images are those that could be considered overexposed, but for certain subjects a high-key exposure is perfectly valid. High-key images have a light, airy feel with few dark tones and open

shadows. Portraiture—particularly when conveying a romantic feel—works well when a high-key treatment is used.

Low-key images have the opposite feel, with few highlights, and dark, dense shadows. This makes low-key images more dramatic, brooding, and atmospheric.

Unlike the other Creative Zone modes, you can extend the shutter speed beyond 30 seconds using Bulb mode. When the Rebel T5/EOS 1200D is set to Bulb, the camera will continue to expose for as long as the shutter-release button is held down (typically by using a remote release to lock the shutter open). Bulb is found one step beyond the 30" mark when you adjust the shutter speed. During the exposure, the elapsed time is displayed on the LCD.

Bulb is only really necessary when shooting in very low light, such as in dimly lit interiors or at night when shooting cityscapes or star trails. If long exposure noise reduction is switched on (see chapter 3), exposure times will double, making Bulb exposures lengthy affairs. For this reason, it's a good idea to start with a

> **Note:**
> Manual exposure mode is best used with a definite ISO value rather than using Auto ISO.

fully charged battery and keep a spare (or two) handy if you intend to shoot more than a few images.

Using M mode

1) Turn the mode dial to **M**.

2) Turn 🔆 to adjust the shutter speed or hold down 🗑 / Av⭐ and turn 🔆 to set the aperture. The correct exposure is set when the exposure level mark is centered below the standard exposure index in the viewfinder or on the LCD. If the exposure level mark is at the left of the standard exposure index, then underexposure may result (the further left, the greater the

level of underexposure). If the exposure level mark is at the right of the standard exposure index, then overexposure may result (the further right, the greater the level of overexposure).

3) Once you're happy with the exposure, press the shutter-release button down halfway. When focus has been achieved, press down fully on the shutter-release button to take the shot.

4) The photograph will be displayed on the LCD for 2 seconds, unless the default review time has been changed.

CONTROL »
M is the mode to choose if you want complete control over all aspects of exposure. This is particularly important in tricky lighting conditions, when the camera may not make the exposure decisions you'd prefer.

2 » MAKING MOVIES

Every Canon DSLR release since the EOS 5D MkII has been equipped to shoot movies. The Rebel T5/EOS 1200D is no exception. Shooting movies is superficially like shooting still images, but there is a difference. Although it may seem obvious, movies "move." This means when you initially compose a movie shot, you also have to consider how the shot may change over time. Another difference is that you can't compose movies through the viewfinder, so when you switch to movie shooting mode you always have to work in Live View.

› Memory cards

Creating a movie means capturing a continuous stream of digital data. Fortunately, the Rebel T5/EOS 1200D compresses this data, otherwise it couldn't be written to a memory card fast enough and the card would be quickly filled. Movies are compressed by comparing the individual frames within the movie. If there is little or no difference between two or more successive frames the camera doesn't need to save the data for each frame—only the changes, if any, need to be recorded. The more static a movie the more easily it can be compressed.

However, the opposite is also true. The greater the difference between frames, the more data needs to be captured and the lower the compression rate. This means that a movie with lots of movement will take up more room on a memory card than a static one. For this reason, Canon recommends the use of a Class 6 memory card (capable of recording 6 MB/s) or higher when shooting movies.

SPEED **«**
Canon recommends using a Class 6 or higher memory card when you are shooting movies.
© Kingston Technology

Warning!

Do not touch the microphone on the front of the camera during recording, as this will create extraneous noise.

Notes:
The longest movie clip size you can record is 4GB. If a clip exceeds that length during recording, a new clip is started automatically.

The camera will switch off Live View after a period if no controls are pressed. Press ◻ to resume Live View.

H.264

Movies shot with the Rebel T5/EOS 1200D are recorded in MOV format using the H.264 video-encoding standard. This is used in a wide variety of applications from Blu-Ray players to YouTube. MOV is supported by movie-editing software such as Final Cut Express for Mac OS X and Adobe Premiere Elements 9 for Windows and Mac.

Shooting a movie

Unlike taking still images, pressing the shutter-release button doesn't start movie recording. Instead, you need to press ● / ▢. You can still press the shutter-release button—doing so will temporarily pause movie recording to shoot a still image. The pause is approximately 1 second in length.

Starting recording
1) Turn the mode dial to '🎥.

2) Press the shutter-release button halfway to focus. Once the Rebel T5/EOS 1200D starts recording the movie, it will no longer automatically focus. If focus adjustments need to be made during shooting, switch the lens to MF.

3) Press ● / ▢. A red ● mark will be displayed at the top right of the LCD to show that recording has started. The duration of a movie, plus its resolution and frame rate, is shown at the left of the LCD.

4) Press ● / ▢ to stop recording.

› Quick Control

The movie 🅠 screen is controlled in the same way as the 🅠 screen in Live View when shooting still images. Press 🅠 to alter any or all of the following before movie recording: AF method, white balance, Picture Style, Movie recording size, Video snapshot, or Image Quality (still images only).

› Exposure control

When **Movie exposure** on the 📷 menu is set to **Auto**, your Rebel T5/EOS 1200D sets the exposure automatically. The ISO is selected automatically from a range of ISO 100–6400, and the camera also determines the shutter speed and aperture.

However, before and during shooting, you can lock the exposure by pressing ✱ (during shooting, exposure can be unlocked by pressing ⊡). You can also set exposure compensation by holding down 🗑 / Av⊡ and turning 〰. Again, this can be done before and during shooting, but as the noise of 〰 will be picked up by the microphone, it's best done before recording begins.

You have more control over exposure when **Movie exposure** is set to **Manual**, as you can set the ISO, shutter speed, and aperture. ISO is set by pressing ⚡ (flash can't be used when the mode dial is set to 📷), followed by either ◄ / ► or by turning 〰. Highlight the required ISO setting and then press (SET).

The shutter speed is set by turning 〰 (from 1/4000 to 1/60 sec. when using a frame rate of 50 / 60, or 1/4000 to 1/30 sec. when using 24 / 25 / 30).

The aperture is set by holding down 🗑 / Av⊡ and turning 〰.

› LCD information

As with using Live View in other shooting modes, pressing DISP. toggles between screens with different levels of shooting information: use the least cluttered option when initially composing your shot.

The picture displayed on the LCD (both before and during recording) adjusts as you change the following functions: Auto Lighting Optimizer, Picture Style, white balance, Peripheral illumination correction, and exposure compensation.

MOVIE SHOOTING TIPS

Color

You can apply a Picture Style to movies just as you can to a still image. If you want to use your movie straight out of the camera, then choose a Picture Style that is most pleasing. However, if you intend to alter the look of your movie in postproduction (a process known as "grading"), ideally it should be shot with a Picture Style setting with low contrast and low saturation.

Shutter speed

The shutter speed you choose has an impact on the look of your movie. A movie is shot at a certain frame rate (⅓50, ⅓60, ⅓24, ⅓25, or ⅓30, depending on the video resolution and video system). However, the shutter speed you use does not necessarily have to match the frame rate of the movie.

You could, for instance, use a shutter speed of 1/200 sec. If the movie's frame rate is 30 fps, this means that one frame lasting 1/200 sec. is recorded every 1/30 of a second. Using such a fast shutter speed will produce very staccato movie footage. This will be effective when shooting short action sequences, but won't be comfortable to watch for long periods.

Instead, a slight amount of blurring between frames produces footage that is more comfortable to watch. The general rule when selecting a shutter speed is to use one that is roughly twice the chosen frame rate. A shutter speed of 1/60 sec. at ⅓24 / ⅓25 / ⅓30 or 1/125 sec. at ⅓50 / ⅓60 is close to the ideal.

CHOICES «
Whether you shoot movie footage with a muted, low-contrast Picture Style (left) or a more vibrant one (right) will depend on how you intend to use the footage later.

You can view and make simple trimming edits to your movies using the Rebel T5/EOS 1200D.

Playing back a movie

1) Press ▶. Navigate to the movie you wish to view by pressing ◀ / ▶. Movie files are distinguished from still images by the display of **SET** 🎬 at the top left corner of the LCD screen.

2) Press (SET) to display the playback panel when you've found the movie you want to view.

3) The play symbol (▶) is highlighted by default when you first view the playback panel. Press (SET) to play the movie, and again to pause and return to the playback panel. Turn 🎛 to increase or decrease the volume during playback.

4) When the movie finishes, you'll be returned to the first frame of the movie.

› Other playback options

As well as ▶, there are other options on the playback control panel. See the panel below for an explanation of these options.

1) Follow steps 1 to 2 in *Playing back a movie* (left).

2) Press ◀ / ▶ to highlight the desired option on the playback control panel and press (SET).

Movie playback panel	
▶	Movie playback.
I▶	Slow motion; press ◀ / ▶ to decrease/increase speed.
◄◄	Jump back to the first frame of the movie.
◄III	Move back one frame every time (SET) is pressed; hold down (SET) to skip backward.
III►	Move forward one frame every time (SET) is pressed; hold down (SET) to skip forward.
►►I	Jump forward to the last frame of the movie.
✂	Edit movie.
♫	Plays movie accompanied by music copied to the memory card using EOS Utility software.

The Rebel T5/EOS 1200D editing suite

Your Rebel T5/EOS 1200D has a mini editing suite built into it. Although it's not as sophisticated as dedicated editing software, it does allow you to trim movies in-camera if you feel that they're too long. It doesn't allow particularly precise trimming, but it's better than nothing.

Editing movies

1) Follow steps 1 to 2 in *Playing back a movie* (see page opposite).

2) Highlight ✂ on the playback control panel and press ⑤ET.

3) To cut the beginning of the movie, highlight ☐; to cut the end, highlight ☐ and then press ⑤ET. Press ◄ / ► to move the orange trimming point backward or forward through the movie. The light gray portion of the time bar at the top of the LCD shows you how much of the movie

will be left once it's been edited. Press ⑤ET when you're happy with the positioning of the trimming point.

4) Highlight ► and press ⑤ET to view the trimmed movie.

5) If you're happy with the edited movie, select ☐ to save the movie to the memory card. Select **New File** if you want to create a new movie file with edit applied, **Overwrite** if you want to save over the original movie, or **Cancel** to return to the editing screen. Press ⑤ET and follow the instructions on screen.

6) At any point in the editing process, pressing MENU will take you back to the movie playback control panel. If you've set the trimming points, highlight **OK** and press ⑤ET to exit without saving your changes, or **Cancel** to return to the editing screen.

> **Notes:**
> Movies are edited in 1-second increments, so the edit may be less precise than anticipated.
>
> If there's not enough room on the card to save a new movie, **New File** will not be selectable.

3 MENUS

To really get to grips with your Rebel T5/EOS 1200D, you need to delve into its various menus. Although they look daunting initially, the menu screens are grouped into logical categories that are easy to navigate.

The Rebel T5/EOS 1200D's menus allow you to set all of the shooting functions that don't have an allocated button or dial on the body of the camera.

The menus are divided into color-coded sections, each with its own symbol: Shooting ⬛ (including Movie 📷), Playback ▶, Set-up ⚙, and My Menu ★. Each section is sub-divided into a number of separate screens. The number of small squares at the right of the section icon shows you which particular sub-section you're currently viewing.

The number of menu screens available is dependent on the shooting mode you are using. Fewer menu screens are shown when the mode dial is set to a Basic Zone mode—it is only when you select a Creative Zone mode that you have full access to the various menu screens.

One of the keys to using a camera well is to understand exactly what it is doing as you use it. Therefore it's a good idea to work your way through the various menu options, making sure you are familiar with what they do and that they're set correctly for your needs.

LOGIC «
Press MENU to view the menu options. MENU is also used to skip back a step from a sub-menu.

STEAM-POWERED »
Although it appears complex, the menu system has a logic that's easy to follow (with practice).

3

Image quality	RAW+▲L
Beep	Disable
Release shutter without card	
Image review	2 sec.
Peripheral illumin. correct.	
Red-eye reduc.	Enable
Flash control	

Freespace	14.1 GB
Color space	Adobe RGB
WB Shift/Bkt.	0,G2/±0
Live View shoot.	Enable
2 min.	Enable
Disable	On

06/04/2014 11:59:59

Changing menu options

1) Press MENU.

2) Press ◀ / ▶ or turn to jump left or right between the different menu pages. As you jump between the various menu pages, each page's descriptive icon will be highlighted on a tab at the top of the LCD.

3) When you reach the required menu page, press ▲ / ▼ to move up or down the options on that menu page. Press (SET) when the function you wish to alter is highlighted.

4) Highlight one of the options for your chosen function by pressing either ▲ / ▼ for simple menu options or ✛ when there is a series of options arranged around the screen. Press (SET) once more to make your choice. If you press MENU before making your choice, you'll jump back up a level to the previous menu screen without altering the option.

5) When viewing a main menu screen, press MENU (or lightly down on the shutter-release button) to return directly to shooting mode.

> **Notes:**
> Some options require you to confirm your choice before proceeding. This is done by selecting either **OK** to continue or **Cancel** to reject the choice; highlight the required option and press (SET).
>
> By pressing DISP. at any time when viewing menus, you will see a summary screen showing a variety of current camera settings.

MENU SUMMARY

SHOOTING 1 ◻️ (Red)	Options
Image quality	JPEG: ▲L Large Fine; ◢L Large Normal; ◢M Medium Fine; ◢M Medium Normal; ◢S1 Small 1 Fine; ◢S1 Small 1 Normal; S2 Small 2; S3 Small 3
	Raw: Raw RAW*; Raw + JPEG ◢L*
Beep	Enable; Disable
Release shutter without card	Enable; Disable
Image review time	Off; 2 sec.; 4 sec.; 8 sec.; Hold
Peripheral illumination correction	Enable; Disable
Red-eye reduction	Enable; Disable
Flash control*	Flash firing (Enable; Disable); Built-in flash func. setting (Flash mode; Shutter sync.; Flash exp. comp; E-TTL II meter.); External flash func. setting (Speedlite dependent); External flash C.Fn setting (Speedlite dependent); Clear ext. flash C.Fn set.

SHOOTING 2 ◻️ (Red)	Options
Expo. comp./AEB	Exposure compensation (±5 stops in ⅓- or ½-stop increments); AEB (±2 stops)
Auto Lighting Optimizer	Disable; Low; Standard; High
Metering mode	⊡ Evaluative; ⊡ Partial; ▢ Center-weighted average
Custom white balance	Manual setting of white balance
WB Shift/Bkt.	White balance correction; White balance bracketing
Color space	sRGB; Adobe RGB

Picture Style — ⊞A Auto; ⊞S Standard; ⊞P Portrait; ⊞L Landscape; ⊞N Neutral; ⊞F Faithful; ⊞M Monochrome; User Def. 1; User Def. 2; User Def. 3

* Menu settings in gray are not available in the Basic Zone modes

SHOOTING 3 📷 (Red)	Options
Dust Delete Data	Image capture for automatic dust removal in Digital Photo Professional
ISO AUTO	Max.: 400; Max.: 800; Max.: 1600; Max.: 3200; Max.: 6400

SHOOTING 4 📷* (Red)	Options
Live View shooting	Enable; Disable
AF method	FlexiZone-Single; ⓛ Live mode; Quick mode
Grid display	Off; Grid 1 ⊞; Grid 2 ⌗
Aspect ratio	3:2; 4:3; 16:9; 1:1
Metering timer	4 sec.; 8 sec.; 16 sec.; 30 sec.; 1 min.; 10 min.; 30 min.

* In Basic Zone modes, Shooting 4 📷 is renamed Shooting 2 📷

MOVIE 1 🎥 (Red)	Options
Movie exposure	Auto; Manual
AF method	FlexiZone-Single; ⓛ Live mode; Quick mode
AF with shutter button during 🎥	Enable; Disable
🎥 shutter button / AE lock button	AF/AE lock; AE lock/AF; AF/AF lock, no AE Lock; AE/AF, no AE lock
🎥 Highlight tone priority	Enable; Disable

MOVIE 2 🎥 (Red)	Options
Movie rec. size	1920 x 1080 ($\overline{30}$ / $\overline{25}$ / $\overline{24}$); 1280 x 720 ($\overline{60}$ / $\overline{50}$); 640 x 480 ($\overline{30}$ / $\overline{25}$)
Sound recording	Sound recording (Auto; Manual; Disable); Recording level; Wind filter (Enable; Disable)
Metering timer	4 sec.; 16 sec.; 30 sec.; 1 min.; 10 min.; 30 min.
Grid display	Off; Grid 1 ╫; Grid 2 ▦
Video snapshot	Disable; 2 sec. movie; 4 sec. movie; 8 sec. movie
Video system	For NTSC; For PAL

MOVIE 3 🎥 (Red)	Options
Exposure compensation	⅓ -stop increments; ±5 stops
Auto Lighting Optimizer	Disable; Low; Standard; High
Custom White Balance	Manual setting of white balance
Picture Style	🎨A Auto; 🎨S Standard; 🎨P Portrait; 🎨L Landscape; 🎨N Neutral; 🎨F Faithful; 🎨M Monochrome; User Def. 1; User Def. 2; User Def. 3

PLAYBACK 1 ▶ (Blue)	Options
Protect images	Select images; All images in folder; Unprotect all images in folder; All images on card; Unprotect all images on card
Rotate	Rotate images by 90–270° clockwise
Erase images	Select and erase images; All images in folder; All images on card
Print order	Selection of images for printing

Photobook Set-up	Select images; All images in folder; Clear all images in folder; All images on card; Clear all images on card
Creative Filters	Grainy B/W; Soft focus; Fish-eye effect; Toy camera effect; Miniature effect
Resize	Reduce the resolution of compatible images
PLAYBACK 2 ▶ (Blue)	**Options**
Histogram display	Brightness; RGB
Image jump w/	Jump by 1; 10; 100 images; Display by Date; Folder; Movies; Stills; Rating
Slide show	Select images for automatic slide show
Rating	Rate images (Off; 1–5 ★)
Ctrl over HDMI	Enable; Disable
SET UP 1 ♈ (Yellow)	**Options**
Auto power off	30 sec.; 1 min.; 2 min.; 4 min.; 8 min.; 15 min.; Disable
Auto rotate	**On ◘ ▬; On ▬**; Off
Format card	Format memory card
File numbering	Continuous; Auto reset; Manual reset
Select folder	Create and select a folder
Screen color	1 black / 2 light gray / 3 brown / 4 green
Eye-Fi settings	Settings for Eye-Fi card use (only visible when an Eye-Fi card is used)

SET UP 2 ☀ (Yellow)	Options
LCD brightness	Seven levels of brightness
LCD off/on button	Shutter-release button; Shutter/DISP; Remains on
Date/Time/Zone	Sets current date; time; time zone; daylight saving time
Language	English; German; French; Dutch; Danish; Portuguese; Finnish; Italian; Ukrainian; Norwegian; Swedish; Spanish; Greek; Russian; Polish; Czech; Hungarian; Romanian; Turkish; Arabic; Thai; Simplified Chinese; Chinese (traditional); Korean; Japanese
Clean manually	Lifts reflex mirror to allow manual cleaning of sensor
Feature guide	Enable; Disable
GPS device settings	Settings available when GPS unit GP-E2 is fitted
SET UP 3 ☀ (Yellow)	Options
Certification logo display	Displays the logos of the camera's certifications
Custom functions (C. Fn)	C.Fn I: Exposure; C.Fn: II Image; C.Fn III: Autofocus/ Drive; C.Fn IV: Operation/Others
Copyright information	Display copyright info.; Enter author's name; Enter copyright details; Delete copyright information
Clear settings	Clear all camera settings; Clear all Custom Func. (C.Fn)
Firmware Ver.	Currently installed camera firmware version number; Install new camera firmware
MY MENU ★ (Green)	Options
My Menu Settings	Choose your most commonly used menu options for easy accessibility

3 » SHOOTING 1 📷

› Image quality

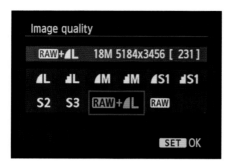

Your Rebel T5/EOS 1200D gives you two basic options when it comes to saving your images: JPEG or Raw. Both have advantages and disadvantages, so there's no right or wrong answer when it comes to choosing which one to use—your choice will largely depend on your style of shooting or how quickly you need your images.

By far the simplest option is JPEG. JPEG images can be used with virtually any software that supports digital still images, including image editors, word processors, and the Internet. When you shoot JPEG, your Rebel T5/EOS 1200D creates a "finished" image that can be used instantly without alteration. To achieve this, the Rebel T5/EOS 1200D applies the settings selected for shooting functions such as white balance and contrast to the image. These settings are permanent and are

said to be "baked" into the image, making them difficult to undo (and impossible if you shoot using a function such as Monochrome). Although this limits your options later, it saves a significant amount of postproduction time.

Another advantage of JPEG is that each image uses far less space on a memory card than an equivalent Raw file. This is due to JPEGs being compressed to save space. Although this sounds useful, the compression is achieved by reducing the fine detail in an image. Fortunately, unless the compression is set to a high level, it's often hard to spot where the loss has occurred unless you look closely at an image at a high magnification (higher levels of compression are typically only possible using software such as Adobe Photoshop—the two compression levels on the Rebel T5/EOS 1200D are relatively low).

JPEG images can be shot at two different quality settings (Fine and Normal) as well as at five different pixel resolutions (Large, Medium, Small 1, Small 2, and

Note:
Image quality can also be set via the Quick Control screen when the mode dial is set to a Creative Zone mode.

Small 3). JPEG Fine will create a higher quality image than Normal, with less loss of detail, but it will take up more memory card space.

Another way to save space on your memory card is to reduce the resolution of your images by using a size other than Large. However, you will find that this limits your printing options.

Compared to a JPEG, a Raw file is a "packet" that contains all the image information captured by the sensor at the moment of exposure. The Raw file is initially tagged with image information based on the shooting functions set at the moment of exposure. However, unlike a JPEG, this information isn't fixed. Consequently, shooting functions such as Picture Style can be undone in postproduction and altered over and over again without any loss of quality. This makes Raw files ideal if you want to experiment with the look of your images.

Quality		Resolution (pixels)	Number of shots (1)	Printable size: cm (2)	Printable size: in. (3)
JPEG	◢L	5184 x 3456	2280	52 x 35	20.7 x 13.8
	◢L		4480		
	◢M	3456 x 2304	4300	35 x 23.2	13.8 x 9.2
	◢M		8400		
	◢S1	2592 x 1728	6700	26.1 x 17.4	10.3 x 6.9
	◢S1		12,720		
	S2	1920 x 1280	11,140	19.3 x 13	7.7 x 5.1
	S3	720 x 480	43,120	7.2 x 4.8	2.9 x 1.9
Raw	RAW	5184 x 3456	580	52 x 35	20.7 x 13.8
Raw + JPEG	–	5184 x 3456	460	52 x 35	20.7 x 13.8

(1) With a 16GB memory card installed. (2) Approximate size when printed at 99 pixels per centimeter. (3) Approximate size when printed at 250 pixels per inch.

One problem with Raw files is that they aren't very useful for general use—you couldn't display a Raw image on a web site, for example. Instead, you can only view and edit Raw files in software designed for that purpose. Your Rebel T5/EOS 1200D is supplied with Digital Photo Professional (DPP), which is a very comprehensive and useful tool. However, there are other options, including third-party products such as Adobe Lightroom and Phase One's Capture One.

Once you've processed your Raw file, you would export the image to a more useful file format, such as JPEG or TIFF. However, all of this will take time, so Raw isn't the option to choose if you need an image immediately. However, if you want the most control over the look of your images, the time required to do justice to Raw files is more than worth it.

Unlike JPEGs, Raw files are always saved at the highest resolution. If you have a sufficiently large memory card, shooting Raw + JPEG ◢L will give you the best of both worlds—a JPEG ready for use straight out of the camera, and a Raw file that can be processed later.

LIGHTROOM ⌄
Editing a Raw file in Adobe Lightroom 5.

Beep

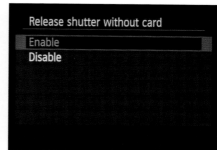

There are a lot of options on the Shooting menu pages that will be set according to personal preference, and **Beep** is one of those. When set to **Enable**, the Rebel T5/EOS 1200D will beep to confirm focus lock and whenever the self-timer is activated. Personally, I find a noisy camera distracting, so this is an option I immediately disable. However, your needs may differ, especially if you like the reassurance of an audible confirmation that focus has been achieved.

Release shutter without card

When **Release shutter without card** is set to **Enable**, you can fire the shutter even if there is no memory card installed in your Rebel T5/EOS 1200D. The image shot will be displayed briefly on the LCD screen, but it will not be saved and therefore will be lost. To prevent this (and it's very easy to forget to fit a memory card into a camera),

set **Release shutter without card** to **Disable**. Now a warning will be displayed on the LCD and in the viewfinder, and the shutter will not fire.

You might think that **Release shutter without card** is a slightly unusual option, but it's possible to shoot without a memory card and still save your images using a technique known as "tethered shooting." This is achieved by connecting your Rebel T5/EOS 1200D to a computer via a USB cable. When shooting in this way, the images are transferred automatically to the computer, for saving to its hard drive.

Tethered shooting is most useful in studio setups, although with a suitable laptop or tablet it's also a feasible option outside. To shoot this way, you will need to install Canon's EOS Utility software, as well as image-editing software such as DPP or Adobe Lightroom to view and process the captured images.

› Image review

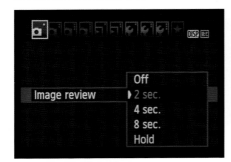

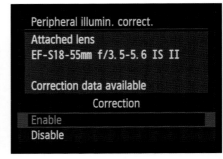

For a brief period after shooting a still image, it will be displayed on the LCD. The default duration for **Image review** is **2 sec.**, but this can be altered to **Off**, **4 sec.**, or **8 sec.** When set to **Hold**, the image will remain on screen until you press any of the controls or until the camera automatically powers down. The LCD screen is one of the biggest drains on the camera's battery, so select a setting that's useful, but also power efficient.

› Peripheral illumin. correct.

The design of any lens is inevitably a compromise between performance and cost. One of those compromises is an effect known as light fall-off, which is seen as the darkening of the corners of an image compared to the center. Most lenses will display a certain amount of light fall-off at maximum aperture, but this is usually reduced as the aperture is stopped down. Unless you're shooting very bright scenes, such as skies or white interiors, light fall-off often isn't too noticeable. In fact, sometimes it's desirable, as some darkening of an image's corners will help to focus attention at the center of an image, which is ideal if this is where your subject is placed.

Fortunately, the amount of light fall-off at the various aperture settings of a specific lens design can be quantified and removed either in postproduction or by enabling **Peripheral illumin. correct**. This requires the profile for the lens fitted to your Rebel T5/EOS 1200D to be installed in the camera—by default, profiles for 27 Canon lenses are installed. You can add or delete lenses using the EOS Utility software, but only Canon lenses are supported (it's unlikely that third-party lenses will ever be added to EOS Utility).

When set to **Enable**, **Peripheral illumin. correct.** automatically lightens

the corners of images according to the lens profile. One downside is the potential for an increase in the visibility of noise in the corners of your images. For this reason, the amount of correction applied is reduced the higher the ISO value you use. If a lens isn't supported, set **Peripheral illumin. correct.** to **Disable**.

Notes:

To change the registered lenses, install EOS Utility and then connect the Rebel T5/EOS 1200D to your computer. When EOS Utility is running, click on **Camera settings/Remote shooting**. When the control panel is displayed on your computer's monitor, click on ◻, followed by **Peripheral illumin. correct**. The full list of Canon lenses is shown in a new window. Check or uncheck lenses as required and then click on **OK**.

Raw files only have the light fall-off correction data appended to the image—it can be removed during postproduction.

Red-eye reduction

See page 167 for details.

Flash control

See page 168 for further details.

Peripheral illumin. correct.:
Default lens set

EF-S 10–22mm f/3.5–4.5 USM
EF 17–40mm f/4 L USM
EF-S 17–85mm f/4–5.6 IS USM
EF-S 18–55mm f/3.5–5.6 IS STM
EF-S 18–135mm f/3.5–5.6 IS
EF-S 18–200mm f/3.5–5.6 IS
EF 24mm f/2.8 IS USM
EF 28–135 f/3.5–5.6 IS USM
EF 28mm f/2.8 IS USM
EF 35mm f/2 IS USM
EF 50mm f/1.8 II
EF-S 55–250mm f/4–5.6 IS STM
EF 70–200mm f/4 L USM
EF 70–300mm f/4–5.6 L IS USM
EF-S 15–85mm f/3.5–5.6 IS USM
EF-S 17–55mm f/2.8 IS USM
EF-S 18–55mm f/3.5–5.6 III
EF-S 18–55mm f/3.5–5.6 IS II
EF-S 18–135mm f/3.5–5.6 IS STM
EF 20mm f/2.8 USM
EF 24–105mm f/4 L IS USM
EF 28mm f/1.8 USM
EF 35mm f/2
EF 40mm f/2.8 STM
EF-S 55–250mm f/4–5.6 IS II
EF 70–200mm f/4 L IS USM
EF 70–300mm f/4–5.6 IS USM

3 » SHOOTING 2 📷

› Exposure compensation/AEB

Exposure compensation allows you to override the suggested exposure, as well as shoot a bracketed sequence of images. See pages 39–40 for details.

› Auto Lighting Optimizer

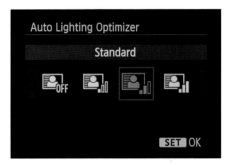

Contrast can be a big problem when you're trying to capture a scene. Sometimes the highlights are too bright in an image; sometimes the shadows are too dark. Auto Lighting Optimizer is Canon's solution to this problem.

If **Auto Lighting Optimizer** is set to any mode other than ⊞**OFF Off**, it will analyze your images as you shoot. If necessary, the shadows will be lightened and the highlights reined in to produce a more balanced looking image. You can control the effect by choosing ⊞**Low**,

⊞ **Standard**, or ⊞ **Strong** (with ⊞ **Strong** applying the most correction to your images).

This may sound good, but Auto Lighting Optimizer isn't perfect. Lightening the shadows can make them more prone to noise (particularly when using ⊞ **Strong**), and if the scene you're shooting is relatively low in contrast, Auto Lighting Optimizer can make your image appear flatter still.

It can also undo slight changes to the exposure that you make using exposure compensation, so with Auto Lighting Optimizer activated you may find you need to dial in a higher exposure compensation value than you would normally. It's also not recommended if you want your subject to be in silhouette when backlit.

› Metering mode

This option lets you set how your Rebel T5/ EOS 1200D meters a scene to determine the correct exposure (see page 38).

> **Note:**
> Auto Lighting Optimizer cannot be used at the same time as Highlight tone priority.

Custom White Balance

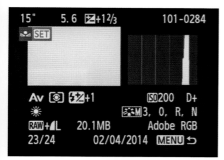

Generally, **AWB** is a convenient way to achieve a pleasing white balance, but like most automated systems it can be fooled into producing an undesirable result. The most common example of a situation when **AWB** trips up is on overcast days, when the light is biased toward blue. **AWB** often doesn't compensate enough for this bias, although switching to **⛅** would cure the problem.

However, a situation that can't easily be cured by a white balance preset is when there is a mix of light sources in a scene, such as daylight and tungsten lighting, for example. In these conditions, the predominant color can fool **AWB** into compensating for it. The solution to this problem (or when you very definitely need accurate colors) is to create a custom white balance.

To set a custom white balance, you must first take a photo of a neutral white surface, so that it fills the viewfinder. The white surface must be lit by the same light as the scene that you're shooting. Switch your lens to MF (it doesn't matter whether the white surface is in focus or not) and adjust the exposure so that the white surface is almost (but not quite) clipping the right edge of the histogram.

Setting a custom white balance
1) Highlight **Custom White Balance** on the **◖◗** menu and press **(SET)**.

2) The image you've just shot should be displayed (press **◄ / ►** if it's not, or if you want to use a different image to create the custom WB). Press **(SET)**.

3) Select **OK** to create the custom white balance, or **Cancel** to return to step 2.

4) Once you've created your custom white balance, you can select it by choosing the **📷** custom white balance preset from the **Q** or screen, or by pressing **▼**/WB.

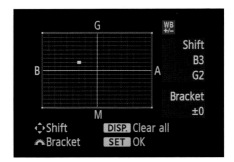

The various white balance presets are a good starting point, but they are slightly blunt instruments. Fortunately, they can be refined using **WB Shift/Bkt.**, which allows you to add more **G** (green), **M** (magenta), **B** (blue), or **A** (amber/red) to the currently selected white balance preset. For extra peace of mind, you can also bracket the white balance, so three shots are taken using different settings.

Setting WB Shift
1) Select **WB Shift/Bkt.**

2) Use ✧ to move the WB adjustment point around the displayed grid. Move the adjustment point to the right to increase the amber bias (making the image warmer), or move it to the left to add more blue (making the image cooler). If you're shooting under fluorescent lighting, you may find that adjusting the green/

magenta bias improves your images. Move the point up and down to add more green or magenta respectively.

3) To set WB bracketing, turn 🎚: turning 🎚 to the left sets the G/M bracketing; turning to the right sets the B/A bracketing. If you choose to bracket WB, the next three shots will use the current WB preset setting followed by either a blue then amber bias or magenta then green bias. The cycle then repeats until WB bracketing is canceled.

4) Press ⓢⓔⓣ to set the WB adjustment and return to the main 📷 menu screen, or press DISP. to clear the WB adjustments and return to step 2.

Note:
When **WB Shift** has been set, ᵂᴮ will be displayed on the viewfinder and on the LCD.

› Color space

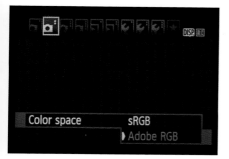

A color space is a mathematical model that allows colors to be represented using numbers. In an RGB color space, numerical values are used to define the red, green, and blue components of a color (red and blue combined would give you magenta, for example). The Rebel T5/EOS 1200D allows you to choose between two RGB color spaces: **Adobe RGB** and **sRGB**.

All color spaces commonly in use today are a subset of an international standard known as the CIE 1931 standard. The CIE standard is a vast color space that encompasses all conceivable colors, including some that can't be perceived by human vision.

Adobe RGB and sRGB are far smaller color spaces that aren't quite so wide in scope: sRGB is approximately 35% of the size of the CIE standard; Adobe RGB is roughly 50%. This means Adobe RGB encompasses a larger and richer range of colors than sRGB, but it is still far smaller than the CIE standard.

You would think that more is better and that setting **Adobe RGB** would be the option to choose. Generally, that's correct, but there are devices—such as printers—that use even smaller color spaces. Internet browsers also prefer images to be sRGB. Therefore, if you plan to print or use your images online without adjustment, **sRGB** is a better option.

Which color space you choose is more important if you use JPEG; Raw files can be tagged with a different color space when they are imported for postproduction.

> **Notes:**
> The first character of the file name of an image captured using the **Adobe RGB** color space is an underscore ("_").
>
> **sRGB** is set automatically when the mode dial is set to a Basic Zone mode.

A world without choice would be dull and monotonous. It's the same with photography. You'd soon get bored if your pictures all had the same colors and levels of contrast. Picture Style gives you more control over how your pictures will look to avoid this tedious state of affairs. There are numerous Picture Style presets to choose from (see the panel below), or you can create your own styles by modifying the parameters of those presets (either in-camera or using EOS Utility).

Choosing a relevant Picture Style is more important when shooting JPEG than Raw, as you can unpick the Picture Style settings in postproduction with the latter.

However, when shooting Raw you'll still see the effects of the current Picture Style in Live View or in playback. This is particularly useful when using the ⊞M Monochrome picture style; you can see what the image looks like in black and white in-camera, but still have a file that includes color information for postproduction work.

Setting a Picture Style

1) Select **Picture Style**.

2) Highlight the required Picture Style by pressing ▲ / ▼. Press (SET) to select the Picture Style and return to the main ◘ menu, or MENU to cancel selection.

Presets	Description
⊞A Automatic	Picture Style is automatically modified by the Rebel T5/EOS 1200D according to the shooting situation.
⊞S Standard	Suitable for general photography; produces images with reasonably saturated colors.
⊞P Portrait	Sharpness is set lower than Standard; colors adjusted to produce sympathetic skin tones.
⊞L Landscape	Greens and blues are more saturated; sharpness increased.
⊞N Neutral	Natural colors with lower saturation and contrast.
⊞F Faithful	Lower saturation still. Faithful produces the most accurate colors of all the presets when shooting under normal daylight conditions.
⊞M Monochrome	Converts images to black and white.
⊞1 User Defined 1–3	–

 Automatic

Standard

Portrait

Landscape

Neutral

Faithful

Detail settings

You don't have to be content with the default settings of the various Picture Styles. A Picture Style is defined by four parameters: ◑ Sharpness, ◐ Contrast, ⊛ Saturation, and ◐ Color Tone (the latter two are replaced by ◐ Filter effect and ⊘ Toning effect when shooting ⬛M).

Each Picture Style can be modified by adjusting one or all of its parameters. To adjust the settings, highlight the Picture Style you wish to alter and then press DISP. Highlight the desired detail setting by using ▲ / ▼ and then press (SET). Press ◄ to decrease the effect of the setting or ► to increase it. Press (SET) when you're happy with your adjustments.

To clear the settings, highlight **Default set.** at the bottom of the screen and press (SET). When you're done, press MENU to return to the main Picture Style screen.

Presets	Description
◑ Sharpness	0: No sharpening
	7: Maximum
	sharpening
◐ Contrast	- Low contrast
	+ High contrast
⊛ Saturation	- Low color saturation
	+ High color
	saturation
◐ Color tone	- Skin tones more red
	+ Skin tones more
	yellow

⬛M Monochrome

The ◐ **Filter effect** and ⊘ **Toning effect** parameters are unique to ⬛M. ◐ mimics the use of colored filters when shooting with black-and-white film (see chapter 6 for more details about why colored filters are—counterintuitively—very important when shooting black-and-white images). Toning effect adds a color wash to your monochrome images. Choose between **N: None**, **S: Sepia**, **B: Blue**, **P: Purple**, and **G: Green**.

Filter effect	Description
N: None	No filter effect applied.
Ye: Yellow	Blues are darkened; greens and yellows are lightened.
Or: Orange	Blues darkened further; yellows and reds are lightened.
R: Red	Blues very dark; reds and oranges are lightened.
G: Green	Purples are darkened; greens are lightened.

User Defined Picture Style

This option allows you to modify up to three Picture Style presets and save the changes as **User Def. 1**, **2**, and **3**. To modify a preset, first highlight **User Def. 1**, **2**, or **3** and then press DISP. Next, highlight **Picture Style** and press (SET). Press ▲ / ▼ to find the Picture Style preset you want to modify, followed by (SET). Highlight and alter the four Picture Style parameters as described previously, then press MENU to return to the main Picture Style menu once you're finished.

There are many good reasons to define your own Picture Style. The first, and arguably most important, is that doing so helps to personalize your images; using the original presets is all very well, but anyone can do that.

If you plan to adjust your images later in postproduction, creating a subdued Picture Style that is low in contrast and saturation is a good idea, particularly if you're shooting JPEG.

This is because it's easier to add contrast and saturation than it is to remove it. This applies most strongly to sharpening, which is almost impossible to remove once it's been applied to an image. If you think you'll want to increase the resolution of an image later on (to make a large print, for example) set the **Sharpness** to **0**. This means you will have to sharpen your images later, but they'll be far easier to resize without a visible drop in quality.

Tip

When you shoot Raw, the image on the LCD uses the currently selected Picture Style. This means that the histogram isn't necessarily accurate. For greater accuracy, create a custom Picture Style that has Contrast and Saturation set at the lowest level. This will make the image appear flat and dull, but it will be a better guide to the file's tonal range.

› Dust Delete Data

Digital sensors and dust were made for each other, as a sensor has an electrical charge that attracts dust to it. Once dust lands on the sensor, you may see it as small black blobs in every image you shoot subsequently.

There are two ways of dealing with dust: you can either physically clean it off the sensor, or you can remove it from the image during postproduction. The former requires the use of cleaning tools, and the technique is described in more detail later in this chapter.

Dust Delete Data is an aid to the postproduction method. **Dust Delete Data** lets you shoot a reference image that's analyzed by your Rebel T5/EOS 1200D to create a map of the location of any dust on the sensor. This information is appended to every subsequent image.

If then you import the image into Digital Photo Professional (see chapter 9), the software can use this data to remove dust automatically from your images. However, it's not foolproof and you may find that important details in your images are removed at the same time. Therefore, it's vital to check your image carefully after the process is complete.

Setting Dust Delete Data

1) Attach a lens with a focal length longer than 50mm, switch it to manual focus, and set the focus at ∞.

2) Press MENU and navigate to ◘. Highlight **Dust Delete Data** and press ⓈⒺⓉ.

3) Select **OK** to continue or **Cancel** to return to the ◘ menu.

4) Aim your camera at a white surface, such as a sheet of paper, from a distance of approximately 12 inches (30cm). The white surface should fill the viewfinder.

5) When **Fully press the shutter button, when ready** is displayed, press the shutter-release button down. Once the image has been captured, it will be processed. When **OK** is displayed, press ⓈⒺⓉ.

› ISO Auto

Dust Delete Data	
Fully press the shutter button, when ready	

6) If the data has not been obtained correctly, follow the instructions on screen and repeat the process.

7) Shoot as normal. Both JPEG and Raw files will have Dust Delete Data attached to them.

8) Switch on your computer, import any photos shot after obtaining Dust Delete Data, and then launch DPP. Select one of the photos in the main DPP window and click on the **Stamp** button. The photo will redraw itself and any dust will be removed using the Dust Delete Data image. Once this process is finished, click on **Apply Dust Delete Data**.

9) Click on **OK** to return to the main DPP window.

When you select **AWB** in any of the Creative Zone modes, the ISO value will change to suit the lighting conditions (the lower the light levels, the higher the ISO value). The ISO chosen will be somewhere in the range of ISO 100–6400.

However, **ISO Auto** allows you to restrict the ISO range your Rebel T5/EOS 1200D chooses from. This helps you to maximize image quality at the increased risk of camera shake if you're shooting with the camera handheld. You can choose between **Max.:400**, **Max.:800**, **Max.:1600, Max.:3200**, and **Max.:6400**.

› Live View shoot.

› Grid display

To use the Rebel T5/EOS 1200D's Live View facility, you must have **Live View shoot.** set to **Enable**. When **Disable** is selected, you can't use Live View and will only be able to use the viewfinder to compose an image (playback of images is unaffected). There's no real advantage to having Live View set to **Disable**, other than that it will stop Live View from being activated if the ◻️ button is accidentally pressed.

› AF method

Sets the AF method when using Live View. See page 54 for details.

The **Grid display** function overlays two different grid types on the LCD when you use Live View. These grids can be used as an aid to composition or as a visual check that elements in the scene are straight relative to the camera.

Grid 1 ⊞ divides the screen into nine equal rectangles through the use of two equally-spaced vertical and two equally-spaced horizontal lines.

Grid 2 ⧉ divides the screen into 24 squares. This is useful when shooting architectural subjects that need to be square to the camera.

Off turns the grid function off entirely.

A grid display is extremely useful when shooting architectural subjects. By aligning the edges of the background buildings with the overlaid grid, I was able to keep everything square to the camera in this shot. This avoids a visual problem known as "converging verticals," where buildings appear to tip forward or backward into the picture.

Settings
> Focal length: 24mm
> Exposure: 3 sec. at f/11
> ISO: 100

The aspect ratio of an image is the ratio of its width to its height. The Rebel T5/EOS 1200D offers the option of creating JPEG images with an aspect ratio of **3:2**, **4:3**, **16:9**, or **1:1**.

When shooting in any aspect ratio other than **3:2**, the full resolution of the sensor is not used, so shooting at **3:2** and cropping in postproduction will achieve the same effect.

This function sets the length of time that AE lock is held after it has been selected: the options are **4 sec.**, **8 sec.**, **16 sec.**, **30 sec.**, **1 min.**, **10 min.**, and **30 min**.

Metering timer is automatically set to **16 sec.** when the mode dial is set to a Basic Zone mode and cannot be altered.

	Aspect ratio and resolution (pixels)			
Image quality	**3:2**	**4:3**	**16:9**	**1:1**
L / RAW	5184 x 3456	4608 x 3456	5184 x 2192	3456 x 3456
M	3456 x 2304	3072 x 2304	3456 x 1944	2304 x 2304
S1	2592 x 1728	2304 x 1728	2592 x 1456	1728 x 1728
S2	1920 x 1280	1696 x 1280	1920 x 1080	1280 x 1280
S3	720 x 480	640 x 480	720 x 405	480 x 480

MOVIE SHOOTING 1

Movie exposure

Movie exposure lets you select whether the exposure for movies is set automatically (**Auto**) or manually (**Manual**). Using **Auto** is by far the easier option, although you are locked out of the creative aspects of exposure control.

AF method

The AF options for movie shooting are set as described on page 54.

AF w/ shutter button during 🎥

Setting **AF w/ shutter button during 🎥** to **Enable** will allow single-shot AF during movie recording. However, this is not recommended—the AF motors in lenses can be very noisy and the microphone in the Rebel T5/EOS 1200D will pick up this

noise. A better option is to set **AF w/ shutter button during 🎥** to **Disable** and, if necessary, focus manually during movie recording.

› 🎥 Shutter/AE lock button

Sets the behavior of the shutter-release button and ✱ button exactly the same as **C.Fn IV-8 Shutter/AE lock button**. See page 132 for details.

› Highlight tone priority

Activates **Highlight tone priority** for movie shooting. This is exactly the same as **C.Fn II-6 Highlight tone priority**. See page 131 for details.

3 » MOVIE SHOOTING 2 📹

› Movie rec. size

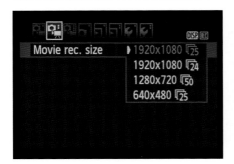

Movie rec. size allows you to set the resolution and frame rate of your movies. The options that are shown will vary depending on whether **Video System** is set to **PAL** or **NTSC.**

› Sound recording

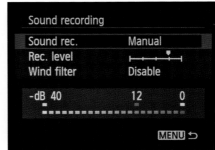

Sound recording gives you control over the recorded volume of your movie's soundtrack. When **Sound rec.** is set to **Auto** the soundtrack volume is adjusted automatically as it's recorded. **Manual** allows you to set the volume level from 1 to 64. After selecting **Manual,** highlight

Resolution (pixels)	
1920 x 1080	Full HD recording with an aspect ratio of 16:9.
1280 x 720	HD recording with an aspect ratio of 16:9.
640 x 480	Standard definition recording with an aspect ratio of 4:3. Suitable for analog TV and Internet use.
Frame rate	
🎞30/ 🎞60	For use in NTSC TV standard areas (North America/Japan). 🎞60 (with its faster frame rate) will allow more scope for slowing down footage during editing.
🎞25/ 🎞50	For use in PAL TV standard areas (Europe/Australia). 🎞50 will allow more scope for slowing down footage during editing.
🎞24	For conversion to motion picture/film standard.

Rec. level, then press (SET) followed by ◄ / ► to set the volume. You should aim to have your peak (or loudest) sound level reach no more than -12 dB (any higher and the recorded sound may be distorted). When **Sound rec.** is set to **Disable**, no sound will be recorded.

When **Wind filter** is set to **Enable**, your Rebel T5/EOS 1200D will eliminate the irritating noise caused by wind blowing across the microphone during sound recording (it works by reducing the bass frequencies in the soundtrack). This achieves a similar effect digitally to fitting a foam windshield on an external microphone. However, it's not perfect and shouldn't be used indoors or in calm conditions; in these situations, set **Wind filter** to **Disable**.

Metering timer

The metering timer options for movie shooting are set in the same way as the options for still image shooting, as described on page 110.

Grid display

Options for displaying a grid on the LCD when shooting movies; set exactly as described on page 108.

› Video snapshot

A video snapshot is a short video clip that can be a **2 sec. movie**, **4 sec. movie**, or **8 sec. movie**. Snapshots are saved in albums, which allows you to group similar snapshots together to be viewed as a continuous sequence.

When you've chosen the clip length press halfway down on the shutter-release button to return to movie shooting. Along the bottom of the LCD is a blue bar. When you press ● / ◻, a clip is recorded at the specified length.

When the clip is finished you have the choice to 🎬 **Save as album** (if this is the first snapshot you've created), 🎬 **Playback video snapshot** (which lets you play back the snapshot you've just created), or 🎬 **Do not save to album** (which erases the snapshot and returns you to movie shooting mode).

The second time you shoot a snapshot, you can 🎬 **Add to album** (which adds the new snapshot to a previously created album) or 🎬 **Save as new album** (which creates a new and separate album to one previously created).

Once you've added several snapshots to an album, you can view them together by pressing ▶. An album is distinguished from a standard movie by the 🎬SET icon at the top left corner of the LCD.

› Video system

There are two main television standards in use around the world. If you want to connect your Rebel T5/EOS 1200D to a TV, you should select the standard relevant for your location: the **NTSC** standard is used in North America and Japan; the **PAL** standard is mainly used in Europe, Russia, and Australia. The choice you make here also determines the frame rates available when selecting options on **Movie rec. size**.

» MOVIE SHOOTING 3 🎬

Duplicates **Exposure comp**, **Auto Lighting Optimizer**, **Custom White Balance**, and **Picture Style** described previously. Settings adjusted on this menu don't affect similar settings chosen for still image shooting.

PLAYBACK 1 ▶

Protect images

This mode allows you to set or unset protection on images to prevent them from being deleted accidentally. See page 59 for more information.

Rotate

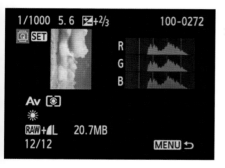

Your Rebel T5/EOS 1200D can sometimes get slightly confused about the orientation it was held in when you took a shot, resulting in images being displayed in the wrong orientation during playback. This often happens when you shoot with the camera pointing straight up or down.

Rotate lets you end the confusion. Once you've selected **Rotate**, press ◄ / ► to find the errant image, and then (SET) when you've found it. The image will rotate 90° clockwise. Press (SET) again to rotate the image a further 180°. Pressing (SET) a third

time restores the image to its original orientation. To rotate additional images press ◄ / ► and repeat the process.

› Erase images

Select and erase unprotected single images, or all images in a folder or on a memory card. See page 58.

› Print order

Sets the print order for your images to determine how they are printed when your Rebel T5/EOS 1200D is connected to a PictBridge printer or when the memory card is taken to a photo lab for image printing. See chapter 9 for details.

Tip

A very effective way of assessing whether the composition of an image has worked is to view it upside down. If the image still "works" when it's the wrong way up, then the composition is successful. If it doesn't, the reason why not is often easier to work out.

3 › Photobook Set-up

One of the big changes brought about by digital photography is the ability to create professional-looking photobooks using your own images. These books can be ordered online from companies such as Blurb and Lulu in any quantity from one copy upward.

Photobook Set-up lets you select up to 998 images for use in a photobook. If you use EOS Utility, you can transfer the selection to your computer, where they will be saved into a dedicated folder. The procedure for choosing images is very similar to choosing images for protection. You can: **Select images**, **All images in folder**, **Clear all in folder**, **All images on card**, and **Clear all on card**.

The key to creating a successful book is in the images you choose. You need to be ruthless when you select your pictures: don't be tempted to add images purely for the purpose of filling out pages.

› Creative Filters

Creative Filters lets you apply simple postproduction effects to your images in-camera. It's not as sophisticated as dedicated software, but it's convenient and it's fun. You can choose from: **Grainy B/W**, **Soft focus**, **Fish-eye effect**, **Toy camera effect**, and **Miniature effect**.

The strength of each effect can be modified, allowing you more scope for personalization. As you're forced to save a new file every time you apply a Creative Filter, your original image always remains safe. If you're shooting Raw, you can also apply Creative Filters, but the results will be saved as JPEG images.

Note:
Raw files cannot be added to a photobook selection.

Effect name	Results	Options
Grainy B/W	Creates a high contrast, grainy, black-and-white image.	Low; Standard; High
Soft focus	Adds a soft-focus glow to an image for a more romantic feel.	Low; Standard; High
Fish-eye effect	Distorts the image so that it looks as if it was shot with a fish-eye lens.	Low; Standard; Strong
Toy camera effect	Adds a vignette around the image and alters the color palette.	Color tone: Cool tone; Standard; Warm tone
Miniature effect	Makes the image look like a miniature model by adjusting the apparent focus.	Move the bar up and down or left and right to set the focus point.

Resize

Resize lets you reduce the pixel resolution of your JPEG images, saving the smaller image as a new file. What you can't do is increase an image's size, although this can be done in postproduction if necessary. The main restriction to **Resize** is that the smaller the original image, the fewer options you have to make it smaller still.

	Sizes available for resizing			
Original size	M	S1	S2	S3
L	Yes	Yes	Yes	Yes
M	–	Yes	Yes	Yes
S1	–	–	Yes	Yes
S2	–	–	–	Yes
S3	–	–	–	–

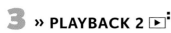
› Histogram display

The Rebel T5/EOS 1200D can display either a **Brightness** or **RGB** histogram when showing detailed shooting information in playback mode (and then both together with the loss of some useful shooting information). Use **Histogram display** to choose which histogram you'd prefer to see with detailed shooting information.

› Image jump w/

Image jump w/ allows you to set how your Rebel T5/EOS 1200D skips through images when turning in single image playback. This option is not very important if you only have a small number of images saved to the memory card, but if you have hundreds (or even thousands) of images on the card, then **Image jump w/** is a useful way to quickly find specific images.

Filtering by an image's rating is particularly useful in this regard if you carefully rate images by type, such as landscape or portrait images, or by project.

Once you've set how you'd like the images to jump, press to enter playback and then turn.

Symbol	Description
⌐1	Display one image at a time.
⌐10	Jump 10 images at a time.
⌐100	Jump 100 images at a time.
⌐◎	Display images by date.
⌐	Display images by folder.
⌐🎬	Display movies only.
⌐◙	Display still images only.
⌐★	Display by rating.

Slide show

Slide show temporarily turns your Rebel T5/EOS 1200D into a digital "slide projector." You can view a slide show of the images on the Rebel T5/EOS 1200D's memory card either on the camera's LCD, or for greater impact, on a TV.

Using Slide show

1) Select **Slide show** and choose 🔁 **All images**. Press ▲ / ▼ to change this to ▦ **Date**, 📁 **Folder**, 🎬 **Movies**, 📷 **Stills**, or ★ **Rating** as required.

If ▦ **Date**, 📁 **Folder**, or ★ **Rating** are highlighted, you can view and alter the options for the function by pressing DISP. There are no options for 🔁 **All images**, 🎬 **Movies**, or 📷 **Stills**. The images that are displayed during the slide show will be dependent on the choices that you make. Press (SET) when you've finished.

2) Select **Set up**. **Display time** will allow you to choose how long each image remains on screen during the slide show. Set **Repeat** to either **Enable** or **Disable**, depending on whether you want your slide show to repeat once it's run through the selected images. **Transition effect** lets you set how one image replaces another during the slide show. Finally, **Background music** allows you to choose what music to play during the slide show. The music must be copied to the memory card using the EOS Utility software provided. Press MENU once you've set all the required options.

3) Select **Start** to begin the slide show. To pause and restart, press (SET). Press MENU to stop the slide show and return to the main slide show screen. If you're playing movies, turn 🎚 to alter the volume.

› Rating

Rating lets you tag individual images with one to five stars (★) or no stars (**Off**, the default setting). This information is embedded in the selected image's metadata and can be used as a filter for **Image jump w/**⚙, **Slide show**, or when the images are on your computer and you're viewing them in DPP.

The obvious way to use **Rating** is to rank your images depending on how successful you think they are. However, **Rating** can be used more subtly than that—you could use it to sort images into categories: 1 ★ for portraits, 2 ★ for landscapes, and so on.

Changing the rating
1) Select **Rating**. Press ◄ / ► to skip through the images on the memory card. To view three images simultaneously, press ▦ / ⊖ ; to view a single image on screen, press ⊕.

2) When you reach an image that you want to rate, use ▲ / ▼ to decrease or increase the rating.

3) When you've finished, press MENU to return to the main ▶ menu screen.

› Ctrl over HDMI

Setting **Ctrl over HDMI** to **Enable** allows you to use your TV's remote control to control certain aspects of the Rebel T5/EOS 1200D's playback functions when it's connected to a TV via an HDMI cable. If your television is not compatible, set this option to **Disable**. See chapter 9 for more details about connecting your Rebel T5/EOS 1200D to a TV.

SET UP 1 ☀

◦ Auto power off

If you don't touch the controls of your Rebel T5/EOS 1200D, eventually it will "fall asleep" to conserve power. There are six options to specify the length of time before this happens: **30 sec., 1 min., 2 min., 4 min., 8 min.,** or **15 min**. You can also **Disable** this function entirely.

When the camera is asleep, it can be woken by lightly pressing the shutter-release button, MENU, DISP., ▶, or ◼. When set to **Disable,** the camera will not power down, although the LCD will still switch off after 30 minutes of inactivity (or if you press DISP.).

Format card

Lets you format your SD memory card so that it's ready for use. See page 33.

› Auto rotate

This option lets you choose whether still images you've shot vertically are rotated or not (movies are never rotated). If you select **On◼▣**, they'll be rotated so that they remain in the correct orientation on the camera's LCD screen and on your computer (once they've been copied there from the memory card).

Selecting **On▣** stops your Rebel T5/EOS 1200D from rotating the images when viewing them on the camera's LCD screen, but it will rotate them when they are copied to your computer.

Finally, **Off** disables rotation both for vertical images displayed on your Rebel T5/EOS 1200D and when the images are viewed on your computer (which means you'll need to rotate the images in postproduction to view them in the correct orientation).

› File numbering

› Select folder

Every time a file is written to the memory card, it's assigned a file name. The last four characters before the file type suffix are numbers—a count of the number of images you've created starting from 0001. If you select **Continuous**, the count continues up to 9999 and then reverts to 0001, no matter how many folders you create or memory cards that you use.

Selecting **Auto reset** forces your Rebel T5/EOS 1200D to reset the count to 0001 every time you create a new folder or swap to an empty memory card.

If you begin a new photography project, and you want to keep the images separate, **Manual reset** may appeal. When this option is selected, a new folder is created on the memory card and the file name count is reset to 0001.

When you shoot a still image or movie, it's stored in a folder on the memory card. When you format a memory card, a new default folder is created automatically. However, you can also create new folders and use those instead of the default.

There are a variety of reasons for doing this. You could, for example, create a new folder for a particular shooting session, which will keep those images separate from all the others on the memory card. When it comes to copying your images to a computer, you would only need to find and copy the images in that folder rather than sorting through irrelevant images.

To create a new folder, choose **Select folder**, followed by **Create folder**. Select **OK** to confirm and create the new folder. Folders created on the Rebel T5/EOS 1200D use a three-number system starting with 100 and continuing up to 999, followed by the word CANON. The

new folder number will be one more than the highest folder number already on the memory card.

To swap between folders, choose **Select folder**, then highlight and select the desired folder name. Until you choose or create a new folder, the Rebel T5/EOS 1200D will save all subsequent images and movies into this folder.

> **Notes:**
> If you create a folder on the memory card when it's connected to your computer, it must use the same naming convention. The five-letter word can only use alphanumeric characters (a–z, A–Z, or 0–9) or an underscore ("_"). No other characters (including "space") are allowed. The new folder must also be within the DCIM folder.
>
> A folder can hold 9999 images. A new folder is created automatically when you reach this number. You can have 999 folders. Once you reach image 9999 in folder 999, however, you won't be able to add any more images to the card even if it's not full.

Eye-Fi settings

Used for Eye-Fi memory card control and only visible when an Eye-Fi card is installed. See chapter 9 for more information.

› Screen color

By default, the background color of the Rebel T5/EOS 1200D's shooting setting and ⚿ screens is black with white text. However, **Screen color** allows you to choose between one of four different colors: **1** (black), **2** (light gray with black text), **3** (brown with white text), or **4** (dark green with mid-green text).

It is very much a personal choice which color you prefer, but if you're shooting in low-light conditions you may find that **4** is the best option, as the subdued color won't affect your night vision as much as the other options (particularly if you also alter **LCD brightness**).

› LCD brightness

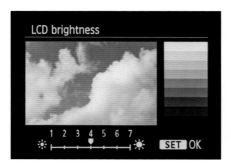

› LCD off/on btn

Viewing a camera's LCD can be tricky in bright light, particularly when the sun is shining on it. Creating a shade with your hands is one solution, although it's only really practical when your Rebel T5/EOS 1200D is mounted on a tripod. Another solution is to temporarily adjust the brightness using **LCD brightness**.

After you've selected **LCD brightness**, press ◄ to darken the LCD screen, or ► to brighten it. Ideally you should be able to distinguish all eight of the gray bars at the right of the screen. Press (SET) when you've adjusted the brightness to the level you desire.

No matter how dark or bright the LCD screen is, do not use the image displayed as a way of assessing exposure. A far more objective method is to use the histograms in Live View or playback.

The shooting settings screen is a useful way to quickly check the current settings of your camera. If **LCD off/on btn** is set to **Shutter btn.** the LCD (and the shooting settings screen) turns off when you press the shutter-release button down halfway and comes back on again when you release the shutter-release button. This is a useful trick, as it's less distracting to have the LCD turned off when you look through the viewfinder.

However, you can go further than this: when **LCD off/on btn** is set to **Shutter/DISP**, the LCD won't turn back on until you press DISP. after releasing the shutter-release button. You can also leave the LCD (and the shooting settings screen) on permanently, even when you press down halfway on the shutter-release button by selecting **Remains on**. This arguably makes

the LCD a visual distraction when looking through the viewfinder, but it does mean that you'll always know what settings are in use, even when the shutter-release button is held down.

Date/Time/Zone

Allows you to set the correct date, time, and time zone, as outlined on page 28.

Language

The Rebel T5/EOS 1200D can display the menu and shooting options in the following languages: English; German; French; Dutch; Danish; Portuguese; Finnish; Italian; Ukrainian; Norwegian; Swedish; Spanish; Greek; Russian; Polish; Czech; Hungarian; Romanian; Turkish; Arabic; Thai; Simplified Chinese; Chinese (traditional); Korean; Japanese. Although it can be fun

to set the language to one other than your own, be careful that you can find this option again to restore the menu system to a more familiar language.

› Clean manually

Dust inevitably will find its way onto the sensor of your Rebel T5/EOS 1200D, no matter how careful you are. Dust is generally seen as small dark blobs on your images, particularly in areas of even tone such as blue sky.

The Rebel T5/EOS 1200D doesn't have an automatic sensor-cleaning mode, so to remove dust from the sensor you will either have to send your camera to an approved Canon Service Center (for a fee), or remove it yourself using **Clean manually** and a cleaning tool.

If you choose to clean the sensor yourself, the simplest method is to use

a blower to blow the dust from the sensor. However, great care must be taken not to touch the surface of the sensor with the tip of the blower, otherwise it might get scratched.

If dust is stuck more firmly to the sensor, then you'll need to use a wet-cleaning system instead. This usually involves brushing a swab moistened with a cleaning agent across the sensor. Most photography stores offer a sensor-cleaning service or will advise on the cleaning system you require.

Tip

Dust becomes more prominent the smaller the aperture you use. Try to use the largest aperture you can and focus precisely, rather than using a small aperture and relying entirely on depth of field.

Manual sensor cleaning

1) Select **Clean manually** followed by **OK**. The mirror will swing out of the way and the shutter open. Remove the lens from your camera.

2) Hold your camera so the front is facing downward. Place the tip of your blower inside the lens mount and squeeze to blow (taking care not to touch the sensor).

3) When you've finished, replace the lens and turn the camera off.

› Feature guide

Setting **Feature guide** to **Enable** displays short (but useful) notes on the LCD. These are simple explanations of the various shooting functions as you select them.

Once you feel confident about using your camera, selecting **Disable** will turn these notes off. This will marginally speed up the operation of your camera and make the menu screens feel less cluttered.

› GPS device settings

Settings available when Canon's optional GP-E2 GPS unit is fitted.

Warning!

Only use a freshly charged battery when cleaning the sensor manually. If in doubt, use the optional ACK-E10 AC adapter to power your camera during the cleaning process.

SET UP 3 𝗬⋮

Certification logo display

This option allows you to view a selection of logos of third-party organizations that approved various aspects of the Rebel T5/EOS 1200D as fit for purpose. This may not be something that particularly interests you, so **Certification logo display** could be an option you look at once and then never again (or simply never look at).

› Custom functions (C.Fn)

Custom functions are very specific aspects of the Rebel T5/EOS 1200D that can be used to tailor the operation of your camera to suit your way of working.

There are 11 custom functions, divided into four groups based on the function type: C.Fn I: Exposure; C.Fn II: Image; C.Fn III: Autofocus/Drive; and C.Fn IV: Operation/Others. Select **Clear Settings** further down the 𝗬⋮ menu if you want to revert to the default settings.

Custom functions only apply to still images and not movie shooting.

C.Fn I: Exposure		📷 shooting
1	Exposure level increments	Yes
2	ISO expansion	Yes
3	Flash sync. speed in Av mode	Yes
C.Fn II: Image		
4	Long exp. noise reduction	Yes
5	High ISO speed noise reduct'n	Yes
6	Highlight tone priority	Yes
C.Fn III: Autofocus/Drive		
7	AF-assist beam firing	With AF Quick
C.Fn IV: Operation/Others		
8	Shutter/AE lock button	Yes
9	Assign (SET) button	Yes (except option 3)
10	Flash button function	Yes
11	LCD display when power ON	–

Setting Custom Functions

1) Select **Custom Functions (C.Fn)**.

2) Press ◄ / ► to skip between the 11 custom function screens. Press ⑤ when you reach the custom function that you want to alter. At the bottom of the LCD, the current custom function settings are displayed below their respective numbers.

3) Press ▲ / ▼ to highlight the desired option followed by ⑤ to select it.

4) Repeat steps 2 and 3 if there are other functions you wish to alter. Otherwise press MENU to return to the main 🎛 screen.

› C.Fn I–1 Exposure level increments

This option allows you to set either **0: 1/3-stop** or **1: 1/2-stop** increments for exposure operations such as shutter speed, exposure compensation, and so on. When set to **1: 1/2-stop**, the exposure controls will be coarser, but setting exposure is speeded up slightly, as there is a smaller range of options to choose from.

› C.Fn I–2 ISO expansion

When **ISO expansion** is set to **1: On**, an extra option, **H**, is added to the ISO selection screen, which is equivalent to ISO 12,800. However, although this may seem a useful option, noise will be very high when **H** is selected. Use it if you desperately need to maintain a certain exposure setting in low light, but if not, it is best avoided. Set **ISO expansion** to **0: Off** to remove **H** from the ISO selection screen. **H** cannot be used when **Highlight tone priority** is enabled.

C.Fn I–3 Flash sync. speed in Av mode

C.Fn I :Exposure ‹ 3 ›
Flash sync. speed in Av mode

0:Auto
1:1/200–1/60sec. auto
2:1/200sec. (fixed)

C.Fn I : 1 2 3 4 5 6 7 8 9 10 11
 0 1 0 2 0 0 0 2 4 0 1

The fastest shutter speed your Rebel T5/ EOS 1200D can use with flash is 1/200 sec., which is known as the "X-sync speed" (there is an exception to this rule—high-speed sync or HSS—which is described in chapter 5).

While 1/200 sec. is the maximum shutter speed that can be used with flash, you can use a slower speed if necessary. If you're shooting in low light, you may find that 1/200 sec. is too fast to record details in the areas not illuminated by flash. Slow sync is the technique of using shutter speeds longer than the X-sync speed to accurately expose parts of a scene lit only by ambient light (typically this would be the background behind your subject). Slow sync is most effective when ambient light is low, but still present. A city at dusk, 20 minutes or so after sunset, is a good example of this type of scene.

However, the lower the ambient light levels, the longer the shutter speed and so the greater the risk of camera shake. This increases the need to use a tripod. **Flash sync. speed in Av mode** lets you change how the Rebel T5/EOS 1200D sets the shutter speed in Av mode when using the slow-speed sync technique. See chapter 5 for more information about using flash.

Option	Result
0: Auto	Any shutter speed between 30 sec. and 1/200 sec. is available for automatic selection to achieve correct exposure for non-flash-lit areas. High-speed sync with a compatible Speedlite is still possible.
1: 1/200–1/60sec. auto	To minimize the risk of camera shake, the Rebel T5/EOS 1200D will only select a shutter speed between 1/60 sec. and 1/200 sec. This may result in underexposed areas not illuminated by flash.
2: 1/200sec. (fixed)	Only the sync speed of 1/200 sec. is available. Non-flash-lit areas may be underexposed, but the risk of camera shake is minimized further.

C.Fn II :Image ◄ 4 ►
Long exp. noise reduction
0:Off
1:Auto
2:On

C.Fn II : 1 2 3 4 5 6 7 8 9 10 11
 0 1 0 2 0 0 0 2 4 0 1

Sensors generate heat; the longer a sensor is active, the more heat builds up. Unfortunately, heat corrupts the image data generated by the sensor, which results in noise appearing in the final image (this is different to high ISO noise). The practical upshot is that the longer the exposure you use, the greater the risk that your image will lose detail because of noise.

Fortunately, there's a surprisingly simple solution that goes a long way toward minimizing noise in long exposures. It goes by the slightly baffling name of "dark-frame subtraction" and relies on the fact that noise patterns in long exposures tend to be consistent over a set period of time

(if you make two long exposures of the same duration, the noise pattern will be the same in both images).

When **Long exp. noise reduction** is set to **2: On** and you make a long exposure (greater than 1 second), the camera makes two exposures. The first, at the selected shutter speed, records the scene as intended, while the second exposure (at exactly the same shutter speed) is made without opening the shutter.

Theoretically, the second exposure should be completely black, but noise will actually lighten areas of this image slightly. The camera can use this tonal variation to work out where noise is occurring and then subtract it from the original exposure (hence dark-frame subtraction).

The downside to this technique is that long exposures double in length, which risks the battery running out before the exposure is complete. A compromise is to set **Long exp. noise reduction** to **1: Auto** so that noise reduction is only performed when necessary. Alternatively, you can turn noise reduction to **0: Off** and deal with long exposure noise in postproduction.

C.Fn II–5 High ISO speed noise reduct'n

Noise in an image can also become a problem when higher ISO settings are used on your Rebel T5/EOS 1200D. **High ISO speed noise reduction** lets you decide whether and by how much your camera tries to tackle high ISO noise.

The greatest amount of noise reduction is applied when this function is set to **2: Strong**. Unfortunately **2: Strong** doesn't just remove noise—it's just as effective at removing some of the fine detail in your images too. **0: Standard** and **1: Low** are a better compromise between noise and loss

> **Note**
> Your camera has more work to do when processing an image with **High ISO speed noise reduct'n** set to **2: Strong**. This will cause a noticeable drop in the burst rate when shooting using the Continuous drive mode.

of detail. Your Rebel T5/EOS 1200D will not perform any noise reduction at all when **Disable** is set, so if you choose this option and there's noise in your images you'll need to tackle it in postproduction.

› C.Fn II–6 Highlight tone priority

High-contrast lighting is often problematic, and usually requires a compromise: you either set the exposure to retain detail in the highlights or in the shadows, but not both. **Highlight tone priority** is Canon's attempt to rectify this problem. When set to **1: Enable, Highlight tone priority** tries its best to ensure that highlights aren't overexposed. When **Highlight tone priority** is active, **D+** is displayed in the viewfinder and on the monitor.

Generally, this system works, but there's always a trade-off with features like this. In this instance, it's the risk of increased noise in the shadow areas. There are also

two important restrictions. The first is that Highlight tone priority reduces the available ISO range to ISO 200–12,800 (up to ISO 6400 for movies). Another is that Auto Lighting Optimizer cannot be used at the same time as Highlight tone priority.

You can use Highlight tone priority when shooting JPEG or Raw, but it's arguably better suited to JPEG, as there's less leeway for recovering highlight detail during postproduction.

When shooting Raw, the effects of Highlight tone priority can be undone during postproduction. If you're shooting Raw, you can achieve the same effect by underexposing your images by 1 stop, and then adjusting the image's tone curve in postproduction to increase the overall exposure without losing highlight detail.

› C.Fn III-7 AF-assist beam firing

When the light level is low and **AF-assist beam firing** is set to **0: Enable**, the built-in flash or attached Speedlite will pulse

light to help the autofocus system. **1: Disable** turns this function off; **2: Enable external flash only** will only use an attached Speedlite; **3: IR AF assist beam only** uses the infra-beam available on certain Speedlites to assist the autofocus.

› C.Fn IV-8 Shutter/ AE lock button

This option sets how focus and exposure are activated or locked using the shutter-release button and ✖ button.

0: AF/AE lock activates metering and autofocus when the shutter-release button is pressed down halfway, with exposure locked by pressing ✖.

When **1: AE lock/AF** is selected, ✖ activates autofocus, and pressing the shutter-release button down halfway activates and locks the exposure.

If you're using AI Servo mode, **2: AF/ AF lock, no AE lock** lets you pause AF by pressing and holding down ✖, with

exposure not set until the shutter-release button is pressed down fully.

3: AE/AF, no AE lock lets you turn AI Servo on or off by repeatedly pressing ✱—exposure is not set until the shutter-release button is pressed down fully.

C.Fn IV-9 Assign ⒮ button

⒮ is a "soft" button that can be assigned to a variety of different functions when you're shooting. The first (and default) option is **0: Normal (disabled)**. Set this way, ⒮ has no function when shooting.

Select **1: Image quality**, however, and you can view the image quality screen by

pressing ⒮, allowing you to swap quickly between JPEG or Raw.

If you're a regular user of flash, you may prefer to select **2: Flash exposure comp.** instead, which displays the flash exposure screen when ⒮ is pressed.

3: LCD monitor On/Off toggles the LCD screen on and off whenever you press ⒮, although arguably this duplicates the DISP. button.

If you're a landscape photographer, you may find **4: Depth-of-field preview** more to your liking. When this option is chosen, pressing ⒮ temporarily closes the aperture in the lens to the selected value (the aperture is normally held open at its maximum value). This allows you to see how the selected aperture affects depth of field, both through the viewfinder and on the LCD screen. The downside is that the viewfinder may darken considerably (you may need to wait a few seconds for your eyes to adjust) and the LCD display may appear grainier than usual. However, this is a small price for a function that lets you preview your final image more closely.

› C.Fn IV–10 Flash button function

› C.Fn IV–11 LCD display when power ON

The flash button is a "soft" button that by default raises the flash when pressed. Set **IV–10 Flash button function** to **1: ISO speed** and the button is assigned to calling up the ISO screen instead. This does mean that you can't raise the flash, but if you rarely use flash (and frequently use Live View), it's worthwhile doing just this. The reason for this is because in Live View the ▲ /ISO button is used to move the AF point around the screen, so it can't be used to set ISO. Usually that can only be done via the **Q** screen: setting **1: ISO speed** offers you another, quicker way to set ISO.

This option sets the status of the LCD when you first switch your camera on. When **0: Display on** is selected, the shooting settings screen is always displayed initially.

However, if you turn off the LCD by pressing DISP., and then turn off the camera with **1: Previous display status** selected, the LCD will stay blank when you turn the camera back on again. You can only view the shooting settings screen by pressing **DISP.** This is a useful, if minor, way to save power.

Copyright information

Copyright laws have been enacted in most countries to protect the rights of anyone who creates something, whether it is a sonnet, a piece of music, or a photograph (though see the note below for exceptions to this rule). The copyright of every image you shoot belongs to you and no one else, so if someone uses one of your images without permission you have the right to request payment (although actually receiving payment is another matter entirely, and it's often not worth the time and effort to pursue minor infractions).

You can stamp your claim on images shot with your Rebel T5/EOS 1200D by automatically adding **Copyright information** to the metadata of your images at the moment of exposure.

A big problem for photographers is the concept of the "orphan" image. These are digital images that apparently belong to no one because information about ownership

has been lost. This can lead to the images being used without attribution and, more importantly, without recompense to the photographer. To avoid this happening to you, it's highly recommended that adding the relevant **Copyright information** is one of the first things you do.

Setting Copyright information
1) Select **Copyright information** and then choose either **Enter author's name** or **Enter copyright details**.

2) On the text entry screen, press Q to jump between the text entry box and the rows of alphanumeric characters below. Press ✛ or turn ⌒ to highlight the required character and then press SET to add it to the text entry box. If you accidentally select the wrong character, press ⬚ / Av⬚ to delete it.

3) Press MENU when you've completed the text entry to save the details and return to the main **Copyright information** menu, or press DISP. to return to the main **Copyright information** screen without saving.

Other Copyright settings

Display copyright info.

Author
David Taylor

Copyright

MENU ↩

Selecting **Display copyright info.** displays the currently set copyright information. If no copyright information is set, the option is grayed out and cannot be selected.

Selecting **Delete copyright information** removes the copyright information set on the camera (but not from the metadata of any images already saved on the memory card). Again, if no copyright information is set, the option is grayed out and cannot be selected.

Notes:
It's likely that you'll set the same information in **Enter author's name** and **Enter copyright details**. However, you can assign copyright in an image (or any created work) to anyone you wish. In this instance, you would set another person's name or even a company (if you were shooting images as an employee) as the copyright owner.

Some social media web sites strip out the copyright information metadata from images when they're uploaded to the site. Adding a subtle copyright watermark to your images when sharing them, therefore, is a safer option if you're worried about them being used without permission.

› Clear settings

Clear settings

Clear all camera settings
Clear all Custom Func. (C.Fn)
Cancel

Choosing this option allows you to either **Clear all camera settings** on your Rebel

T5/EOS 1200D, restoring them to their original factory settings, or **Clear all Custom Func. (C.Fn)** you may have set. Think carefully before you do this, as you cannot undo your decision!

Clearing settings
1) Select **Clear Settings**.

2) Choose **Clear all camera settings** or **Clear all Custom Func. (C.Fn)**. Select **OK** to reset your camera, or **Cancel** to return to the **Clear settings** submenu without clearing the settings.

Firmware Ver.

There's a lot going on inside your Rebel T5/EOS 1200D to keep functions such as the menu system working. This hard work is the sole responsibility of built-in software known as firmware.

This guide was written early in the lifetime of the Rebel T5/EOS 1200D, and

at the time of writing there were no known issues with the camera. However, no camera is completely flawless and over time bugs in the firmware may come to light. If there are problems with the Rebel T5/EOS 1200D's firmware, Canon may well release an update to cure them.

Firmware can also be released to improve a camera in other ways. For example, Canon breathed new life into its EOS 7D model in 2012, simply by overhauling that camera's firmware and adding new features.

Firmware Ver. lets you view the current firmware version number and update the firmware if an update is available. Canon will announce on its web site when a firmware update is available, as well as by email to registered users. This information is also generally relayed via photography news sites, such as www. dpreview.com. Full instructions on how to update your camera will be included with the firmware update. If you're not confident about updating the firmware, it can be updated for you by a Canon Service Center, although you will be charged a fee for the privilege.

Canon will also occasionally release specific updates for lenses—when the lens is attached, you can also update its firmware using this function.

My Menu allows you to compile a list of six of your most commonly used menu settings into one place, so they can be found and altered more conveniently.

Adding options to My Menu
1) Press MENU and navigate to the ★ tab.

2) Select **My Menu settings** followed by **Register to My Menu**.

3) Press ▲ / ▼ to move up and down the function list.

4) Press (SET) when an option you want to add to My Menu is highlighted. Select **OK** to continue or **Cancel** to return to the **Register to My Menu** screen without adding the function. When a function has been added to My Menu, it will be grayed out and can no longer be selected.

5) Continue to add functions as required and then press MENU to return to the **My Menu settings** menu.

Sorting My Menu options
1) Press MENU and navigate to the ★ tab.

2) Select **My Menu settings** followed by **Sort**.

3) Highlight the item that you want to move and press (SET). Press ▲ / ▼ to move the item up and down the list. Press (SET) when you're happy with the position of the selected item in the function list.

4) Repeat step 3 to move other items up or down the list.

5) Press MENU to return to the main My Menu screen.

Deleting My Menu options
1) Press MENU and navigate to the ★ tab.

2) Select **My Menu settings**.

3) To delete individual options from the list, select **Delete item/items**. Highlight the option you want to delete, press (SET), and then select **OK** to delete the option, or press **Cancel** to return to the option list.

4) To delete every option on the list, select **Delete all items** and then choose **OK** to clear the My Menu list. Choose **Cancel** to return to the My Menu screen.

Note:
Select **Enable** on **Display from My Menu** so that My Menu is always the first menu shown when you press the MENU button.

4 LENSES

The kit lens that came with your Rebel T5/1200D is just one of almost 70 lenses produced by Canon, so no matter what your photographic interest, there will be a lens ideally suited to it.

Lenses are important: an inadequate lens will produce disappointing results no matter how good the camera it's attached to. This makes choosing the right lens a slightly daunting task. Fortunately, modern lenses tend not to be truly awful, although some are better than others. The most up-to-date source of information is the Internet, where you will find countless web sites devoted to reviewing lenses. These are worth consulting if you're thinking about buying a new lens.

THIRD-PARTY ⌄
The three main third-party lens manufacturers are Sigma, Tamron, and Tokina. The last is the maker of the 11–16mm f/2.8 lens pictured here.
© Tokina

Canon currently produces nearly 70 different types of lens to satisfy almost any photographic requirement you could think of, and third-party options are also available from manufacturers such as Sigma, Tamron, and Tokina. A big decision to make is whether to stick with Canon lenses or buy a third-party equivalent, and in many ways there is no right or wrong answer. One advantage of sticking with Canon lenses is that you're (almost) guaranteed that they will work with any future EOS DSLR, but third-party lenses often have the advantage of being cheaper—sometimes by a significant margin. There are even some lens types that aren't manufactured by Canon, so are only available from a third-party supplier.

Regardless of your decision, this chapter will cover some of the concepts you'll need to understand to make an informed choice about the lenses you may want to add to your camera bag.

UP CLOSE AND PERSONAL »
Canon's 18–55mm kit lens isn't ideal for shooting close-ups of distant subjects, such as skittish wildlife: this shot required the use of a 300mm telephoto lens.

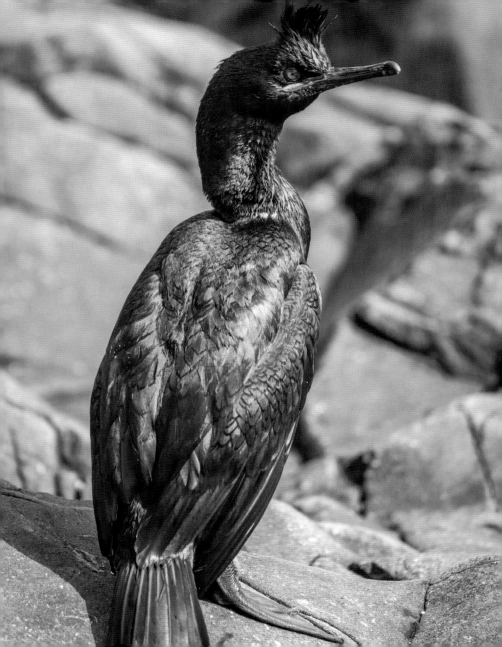

Canon's EOS lenses fall into three groups. The EF-M range is easily discounted (in terms of its use with the Rebel T5/EOS 1200D), as lenses with that designation will only fit Canon's EOS-M series of mirrorless cameras, not EOS DSLR cameras.

The two other lens types are EF and EF-S. The EF range can be further subdivided into "consumer" lenses and top-of-the-range L-series lenses.

EF

The EF lens lineage stretches back to the introduction of the first EOS camera in 1987. This means that there's a wide range of choice, particularly if you're prepared to use discontinued models that are still available secondhand. The Rebel T5/EOS 1200D is compatible with the EF series, although the mounting procedure is slightly different to an EF-S lens (see page 24).

EF-S

EF-S lenses are designed specifically for EOS DSLRs with APS-C sized sensors (such as the Rebel T5/EOS 1200D). They won't physically fit on full-frame cameras, such as the Canon EOS 5D Mk III. This is because the "S" stands for "short back focus," which signifies that the rear element of the lens projects further inside the camera than an EF lens. If you were able to fit an EF-S lens to a full-frame camera, the rear lens element would catch on the reflex mirror as it swung up and down, which would not be good for either the camera or the lens!

The EF-S range is expanding all the time and includes an extremely wide 10–22mm lens as well as longer lenses, such as the popular 55–250mm zoom.

L-series

Canon's L-series lenses are the very best that it makes, which is reflected by the price. Many use expensive technology, such as fluorite glass lens elements and diffraction optics, while some technology, such as Image Stabilization, has filtered down to the "lesser" lenses in the Canon inventory. There are currently no EF-S L-series lenses in production.

ANATOMY OF A LENS

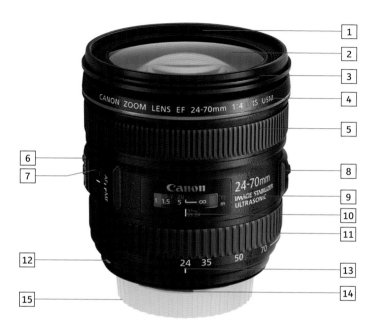

1	Filter ring	**9**	Focus distance scale
2	Lens front element	**10**	Focus index mark
3	Lens hood mount	**11**	Focus ring
4	Lens information	**12**	Lens mount index
5	Focus ring	**13**	Focal length index mark
6	Image Stabilizer switch	**14**	Lens mount
7	AF/MF switch	**15**	Rear lens cap
8	Zoom lock switch		

4 » LENS TECHNOLOGY

There's more to designing and building a lens than meets the eye. Canon employs a number of different technologies in its lenses to maximize image quality and improve aspects such as ergonomics. The following pages form a short guide to some of those technologies.

Diffractive Optics (DO)

DO lenses use specially designed (and expensive) glass elements that allow the lens to be smaller and lighter than an equivalent conventional lens. To date, only two DO lenses have been produced by Canon: a 70–300mm zoom and a 400mm prime. Both can be distinguished by a green band around the lens barrel.

Dust and water resistance (DW-R)

Some of Canon's lenses are fitted with rubber seals around the perimeter of the lens mount. This creates a dustproof, watertight seal when the lens is attached to a camera. DW-R is typically found on L-series lenses.

Fluorine coating

Fluorine is used to provide a micro-thin, anti-static coating on the external glass elements of some Canon lenses. The coating is water repellent and makes cleaning the glass easier.

Fluorite glass

Fluorite glass is unsurpassed as a way of controlling chromatic aberration, and in an ideal world it would be used to produce all lens elements. Unfortunately, it takes four times as long to grind a fluorite glass lens element than one made of standard glass. For this reason, fluorite glass is currently only found on L-series lenses, and then not on every one.

Image Stabilization (IS)

A growing number of Canon lenses is equipped with Image Stabilization (IS). An IS lens can detect the slight movements that naturally occur when handholding a camera. The optical system in the lens is then adjusted to compensate for this movement. The most up-to-date iteration of Canon's IS system—Hybrid IS—can compensate for shutter speeds that are 5-stops slower than would normally cause camera shake. It can also compensate for angular velocity and shift. IS should be turned off when the camera is mounted on a tripod.

Internal focusing

A lens with internal focusing can focus without the need to extend its physical length. A secondary benefit of internal focusing is that the front lens element does not rotate during focusing. This is

particularly useful when using filters that need to be set in a certain orientation.

Stepper Motor (STM)

STM is a type of AF motor developed recently by Canon. An STM is a smoother and quieter, if slightly slower, AF system than USM. This means STM lenses aren't naturally suited to shooting fast-paced sports action, but they are ideal for shooting movies, as their near-silence avoids recording extraneous noise on the soundtrack.

Tripod collar

When a long, heavy lens is mounted to a camera, the center of gravity is shifted forward, away from the camera body. When the camera is attached to a tripod, this places a strain on the lens mount and makes the entire system less stable. Attaching the assembly to the tripod by using a collar around the lens reduces this risk by making the camera/lens combination better balanced.

Ultrasonic Motor (USM)

A USM motor is built into the lens, allowing fast, quiet, and accurate focusing. Canon uses two types of USM—ring-type and micro. The big advantage of the ring-type USM is that it allows full-time manual focusing in autofocus mode.

STABILIZED »
The 18–55mm kit lens features IS, which is particularly useful in dimly lit interiors. For maximum efficiency hold the shutter-release button down halfway for a second or so to allow the IS system to settle.

 » LENS PROPERTIES

› Focal length

The focal length of a lens is the distance (given in millimeters) from the optical center of the lens to the focal plane when a subject at infinity is in focus. The focal plane is shown on the body of the Rebel T5/EOS 1200D as a ⊖ symbol (it can be found just behind the speaker on the top of the camera). If you were to take your Rebel T5/EOS 1200D apart, you would find the sensor inside is aligned with the mark.

Focal length is one of the factors that determines the depth of field at a given aperture. Focal length also partially affects the angle of view of a lens, although this is also affected by the size of the sensor. Lenses can have a fixed focal length (a type of lens referred to as a "prime lens"), or have a variable focal length (known as a "zoom lens").

› Angle of view

The angle (or field) of view of a lens is a measurement, in degrees, of the proportion of a scene that is projected by the lens onto the digital sensor inside the camera. The angle of view can refer to either the horizontal, vertical, or diagonal coverage, but if just one figure is used it's generally safe to assume that it's referring to diagonal coverage.

Short focal length lenses are commonly referred to as "wide-angles." These lenses reduce the size of the image projected onto the sensor, so more of the scene is captured. This means that they have a wide angle of view—hence the name.

Long focal length lenses are known as telephotos. The longer the focal length of a lens, the smaller the angle of view, but the more magnified the image. This is why telephoto lenses appear to bring distant objects closer to you.

WIDE-ANGLE ⌄
When fitted to a Rebel T5/EOS 1200D, Canon's 14mm wide-angle lens would have an angle of view equivalent to a 22mm lens fitted to a full-frame camera.

Crop factor

35mm film is still considered to be the standard reference for defining the angle of view for a lens (although this is referred to as "full-frame" in terms of digital cameras). However, the Rebel T5/EOS 1200D uses an APS-C sized sensor, which is roughly 60% of the size of a full-frame sensor. This means that when a lens is fitted to the camera, a "crop factor" needs to be applied to work out the difference in the angle of view between the two standards.

The size of the sensor in the Rebel T5/EOS 1200D means that the crop factor is 1.6, so the angle of view of a lens on a full-frame camera must be multiplied 1.6x to calculate its angle of view on the Rebel T5/EOS 1200D. The practical upshot of this is that all lenses will appear to have a longer focal length on the Rebel T5/EOS 1200D than on a full-frame camera—a 100mm focal length will have an "effective focal length" of 160mm when the 1.6x crop factor is applied, for example. The advantage of this is that telephoto lenses have more reach, but the downside is that wide-angle lenses won't be quite as wide.

> **Note:**
> Canon's EF-S lenses can only be used on APS-C cameras, such as the Rebel T5/EOS 1200D. Sigma uses the letters DC, Tamron uses Di II, and Tokina uses DX to identify lens ranges designed specifically for crop-sensor cameras.

GREATER REACH »
This image was shot with a full-frame camera using a 135mm lens. If I'd used the same lens on the Rebel T5/EOS 1200D, the angle of view would have been restricted to the area within the orange box, which is equivalent to a 216mm lens on a full-frame camera.

› Primes vs. zooms

Prime lenses have one immediately obvious drawback: you can't simply turn a zoom ring to refine your composition. Instead, prime lenses force you to physically move forward or backward to change your camera-to-subject distance. Although this may seem inconvenient, it is actually one of the appealing characteristics of using a prime lens: because there's more effort involved, the reward of a successful image is sweeter. With practice, it also becomes easier to "see" compositions that suit a particular prime lens. Street photographers who only use prime lenses can work almost instinctively for this reason.

By their very nature, prime lenses are less complicated than zoom lenses (both mechanically and optically). Although modern zooms are generally excellent, they still can't match a good prime for ultimate image quality, and prime lenses generally have faster maximum apertures than zooms as well (the fastest zooms in the Canon range tend to be no faster than f/2.8). A prime with a large maximum aperture is particularly advantageous if you regularly shoot in low-light conditions, or if you like to use minimal depth of field for aesthetic reasons.

However, zoom lenses have one significant advantage: you will need many different prime lenses to cover a decent focal length range, which could easily be covered by one or two zooms.

SUPERZOOM **«**
Canon's 18–200mm zoom lens is what is known as a "superzoom," due to its expansive focal length range (equivalent to 28–320mm on a full-frame camera).

Standard lenses

A standard (or "normal") lens is one that has a focal length that approximately matches the diagonal measurement of the digital sensor in the camera it's fitted to. On a full-frame camera, this is roughly 43mm (although historically 50mm lenses have been regarded as the full-frame standard). The APS-C sensor of the Rebel T5/EOS 1200D is far smaller, however, so a 28mm focal length is closer to the standard lens ideal.

The appeal of standard lenses is that they create images that appear naturalistic, matching the way we see the world. This makes them arguably less capable of dramatic images than either a wide-angle or telephoto lens, but their unfussy nature makes them ideal for a documentary approach to photography.

The Rebel T5/EOS 1200D's 18–55mm kit lens can be set to 28mm (roughly halfway between the 24mm and 35mm markings on the lens barrel). If you prefer prime lenses, then Canon manufactures a number of 28mm lenses, as do third-party companies such as Sigma.

ON THE STREET »
A standard lens is ideal for shooting details and excluding extraneous information.

A wide-angle lens is generally any lens with a wider angle of view than standard. The widest lens most photographers used to own was 28mm, which is equivalent to 18mm once the Rebel T5/EOS 1200D's crop factor has been taken into account. However, wider-angle lenses than this are now quite common: Canon produces a range of very wide-angle lenses, both as primes and zooms, the widest of which is the EF 8–15mm f/4 L USM.

The chief characteristic of wide-angle lenses is that the spatial relationships between elements in a scene become exaggerated. Unless something is very close to the camera, it will appear small and distant in the final image. This means that frequently you need to be very close to your subject for it to appear at a reasonable size in the frame. For portraiture, this isn't ideal, as getting very close to your subject will distort their facial features in a very unflattering way. Wide-angle lenses are useful for showing your subject within the context of their surroundings, however, particularly in compact interiors.

Arguably, the photographers who benefit most from wide-angle lenses are landscape photographers. The exaggeration of spatial relationships often helps to convey a sense of space, although care must be taken to avoid empty looking foregrounds—the idea of getting in close with a wide-angle lens applies equally to landscape photography.

CLOSE　　**«**
To fill the frame using a very wide-angle lens, I had to stand less than a foot away from the hood of the car. Standing further back and using a longer lens could have achieved a more flattering perspective.

Telephoto lenses

Telephoto lenses are those with a longer focal length than standard. Their defining characteristic is that the image on the sensor is magnified, so they appear to bring distant objects closer. This makes longer telephoto lenses popular with wildlife and sports photographers who usually need to keep some distance from their subject.

Because of the Rebel T5/EOS 1200D's 1.6x crop factor, telephoto lenses appear "longer" than they would on a full-frame camera. This is the one major benefit of an APS-C sensor camera: there's less need to buy extremely long focal length lenses. This often makes it cheaper to buy lenses suitable for genres such as wildlife photography. It also means that weight can be saved, which is useful if you need to carry several lenses with you all day.

Another characteristic of telephoto lenses is that depth of field is often limited, particularly when using maximum aperture. However, this is not necessarily a drawback, as keeping your subject sharp with the background out of focus is a good way to simplify a composition and emphasize the subject.

Because of their size and weight, telephoto lenses can be difficult to hold steady. As the image is magnified, any movement will be exaggerated, increasing the risk of camera shake.

Some Canon lenses are equipped with Image Stabilization, which is definitely beneficial for telephotos, although you often pay a premium compared to a non-stabilized equivalent.

PRECISION «
Depth of field restrictions with telephoto lenses mean that focusing has to be very precise. In this case, the focus point was moved to make sure the subject's eyes were sharp.

4 » TELECONVERTERS

A teleconverter (called an "Extender" by Canon) is a specially designed secondary lens that fits between the camera body and the main lens. This increases the focal length of the main lens by a fixed amount. Canon currently makes two teleconverters for the EOS system: the first is a 1.4x teleconverter that increases the focal length by a factor of 1.4; the second is a 2x teleconverter that doubles the focal length of a lens.

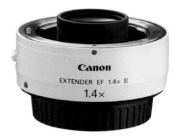

EXTENDER EF 1.4X III ⌃

Teleconverters are a relatively low-cost way of extending the focal range of your lens collection, but they have two significant drawbacks: a reduction in image quality and a dramatic loss of light. The latter drawback effectively makes your lens "slower," darkening the viewfinder and requiring the use of a slower shutter speed (or an increase in the ISO setting). A 1.4x teleconverter loses 1 stop of light, while a 2x teleconverter reduces the amount of light reaching the sensor by 2 stops.

EXTENDER EF 2X III ⌃

Teleconverter	Specifications	Dimensions (diameter x length)	Weight
Extender EF 1.4x III	7 elements / 3 groups	2.8 x 1.1in. 72.0 x 27.2mm	7.9oz. 225g
Extender EF 2x III	9 elements / 5 groups	2.8 x 2.1in. 72.0 x 52.7mm	11.5oz. 325g

A 50mm focal length behaves like a short telephoto on an APS-C camera. When a 50mm lens (or longer) is used with a wide aperture setting, this creates a very narrow slice of sharpness, which is perfect for directing the eye to a specific part of an image.

Settings

> Focal length: 50mm

> Exposure: 1/200 sec. at f/4

> ISO: 1600

» CANON EF/EF-S LENSES

Lens name	Field of view	35mm equivalent	Min. focus distance
EF 8–15mm f/4 L USM	118–83°	12.8–24mm	0.15m
EF-S 10–22mm f/3.5–4.5 USM	96–53°	16–35mm	0.24m
EF 14mm f/2.8 L II USM	81°	22mm	0.2m
EF 15mm f/2.8 Fisheye	–	–	0.2m
EF-S 15–85mm f/3.5–5.6 IS USM	83–18°	22–136mm	0.35m
EF 16–35mm f/2.8 L II USM	69–35°	25–56mm	0.28m
TS-E 17mm f/4 L	76°	27mm	0.25m
EF 17–40mm f/4 L USM	76–37°	27–64mm	0.28m
EF-S 17–55 f/2.8 IS USM	76–27°	27–88mm	0.35m
EF-S 17–85mm f/4–5.6 IS USM	76–18°	27–136mm	0.35m
EF-S 18–55mm f/3.5–5.6 III	73–27°	28–88mm	0.25m
EF-S 18–55mm f/3.5–5.6 IS STM	73–27°	28–88mm	0.25m
EF-S 18–55mm f/3.5–5.6 IS II	73–27°	28–88mm	0.25m
EF-S 18–135mm f/3.5–5.6 IS	73–11°	28–216mm	0.45m
EF-S 18–135mmm f/3.5–5.6 STM	73–11°	28–216mm	0.39m
EF-S 18–200mm f/3.5–5.6 IS	73–7°	28–320mm	0.45m
EF 20mm f/2.8 USM	67°	32mm	0.25m
EF 24mm f/1.4 L II USM	58°	38mm	0.25m
EF 24mm f/2.8	58°	38mm	0.25m
EF 24mm f/2.8 IS USM	58°	38mm	0.2m
EF 24–70mm f/2.8 L USM	58–21°	38–112mm	0.38m
EF 24–70mm f/2.8 L II USM	58–21°	38–112mm	0.38m
EF 24–70mm f/4 L USM	58–21°	38–112mm	0.2m*
TS-E 24mm f/3.5 L	58°	38mm	0.3m
TS-E 24mm f/3.5 L II	58°	38mm	0.3m
EF 24–85mm f/3.5–4.5 USM	58–18°	38–136mm	0.5m
EF 24–105mm f/4 L IS USM	58–14°	38–168mm	0.45m
EF 28mm f/1.8 USM	51°	45mm	0.25m
EF 28mm f/2.8	51°	45mm	0.30m
EF 28mm f/2.8 IS USM	51°	45mm	0.23m
EF 28–80mm f/3.5–5.6 II	51–19°	45–128mm	0.38m
EF 28–90mm f/4–5.6 II USM	51–17°	45–144mm	0.38m

In macro mode at 70mm.

Minimum aperture	Reproduction ratio	Filter size	Dimensions (mm)	Weight (grams)
f/22	1:25	67mm	79 x 83	540
f/22–f/29	1:5.8	77mm	83.5 x 89.8	385
f/22	1:6	rear	80 x 94	645
f/22	1:4.5	rear	73 x 62.2	330
f/22–f/36	1:5	72mm	81.6 x 88	575
f/22	1:4.5	82mm	88.5 x 111.6	635
f/22	1:5.8	n/a	88.9 x 106.9	820
f/22	1:4.2	77mm	83.5 x 96.8	500
f/22	1:5.8	77mm	83.5 x 110.6	645
f/22–f/32	1:5	67mm	78.5 x 92	475
f/22–f/36	1:3	58mm	68.5 x 70	195
f/22–f/38	1:3	58mm	69 x 75.2	205
f/22–f/36	1:3	58mm	68.5 x 70	200
f/22–f/36	1:5	67mm	75.4 x 101	455
f/22–f/38	1:4	67mm	77 x 96	480
f/22–f/36	1:4	72mm	78.6 x 162.5	595
f/22	1:5.8	72mm	77.5 x 70.6	405
f/22	1:6.3	77mm	93.5 x 86.9	650
f/22	1:6.3	58mm	67.5 x 58.5	270
f/22	1:6.3	58mm	68.4 x 55.7	280
f/22	1:3.4	77mm	83.22 x 123.5	950
f/22	1:3.4	82mm	88.5 x 113	805
f/22	1:3.4	77mm	83 x 93	600
f/22	1:7	72mm	78 x 86.7	570
f/22	1:2.9	82mm	78 x 86.7	570
f/22–f/32	1:6	77mm	73 x 69.5	380
f/22	1:4.3	77mm	83.5 x 107	670
f/22	1:5.6	58mm	73.6 x 55.6	310
f/22	1:7.7	52mm	67.4 x 42.5	185
f/22	1:7.7	58mm	68.4 x 51.5	280
f/28–f/39	1:3.8	67mm	67 x 71	220
f/22–f/32	1:3	58mm	67 x 71	190

» **CANON EF/EF-S LENSES**

Lens name	Field of view	35mm equivalent	Min. focus distance
EF 28–90mm f/4–5.6 III	51–17°	45–144mm	0.38m
EF 28–105mm f/3.5–4.5 II USM	51–14°	45–168mm	0.5m
EF 28–105mm f/4.0–5.6 USM	51–14°	45–168mm	0.48m
EF 28–135mm f/3.5–5.6 IS USM	51–11°	45–216mm	0.5m
EF 28–200mm f/3.5–5.6 USM	51–7°	45–320mm	0.45m
EF 28–300mm f/3.5–5.6 L IS USM	51–6°	45–480mm	0.7m
EF 35mm f/1.4 L USM	42°	56mm	0.3m
EF 35mm f/2	42°	56mm	0.25m
EF 40mm f/2.8 STM	37°	64mm	0.3m
TS-E 45mm f/2.8	33°	72mm	0.4m
EF 50mm f/1.2 L USM	30°	80mm	0.45m
EF 50mm f/1.4 USM	30°	80mm	0.45m
EF 50mm f/1.8 II	30°	80mm	0.45m
EF 50mm f/2.5 Compact Macro	30°	80mm	0.23m
EF 55–200mm f/4.5–5.6 II USM	27–7°	88–320mm	1.2m
EF-S 55–250mm f/4–5.6 IS	27–6°	88–400mm	1m
EF-S 55–250mm f/4–5.6 IS STM	27–6°	88–400mm	0.85m
EF-S 60mm f/2.8 Macro USM	25°	96mm	0.2m
MP-E 65mm f/2.8 1–5x Macro	23°	104mm	0.24m
EF 70–200mm f/2.8 L IS II USM*	21–7°	112–320mm	1.2m
EF 70–200mm f/2.8 L USM*	21–7°	112–320mm	1.5m
EF 70–200mm f/4 L IS USM*	21–7°	112–320mm	1.2m
EF 70–200mm f/4 L USM*	21–7°	112–320mm	1.2m
EF 70–300mm f/4.5–5.6 DO IS USM	21–6°	112–480mm	1.4m
EF 70–300mm f/4–5.6 IS USM	21–6°	112–480mm	1.5m
EF 70–300mm f/4–5.6 L IS USM	21–6°	112–480mm	1.2m
EF 75–300mm f/4–5.6 III	20–6°	120–480mm	1.5m
EF 75–300mm f/4–5.6 III USM	20–6°	120–480mm	1.5m
EF 80–200mm f/4.5–5.6 II	19–7°	128–320mm	1.5m
EF 85mm f/1.2 L II USM	18°	136mm	0.95m

Indicates that a lens is compatible with Canon's teleconverters.

Minimum aperture	Reproduction ratio	Filter size	Dimensions (mm)	Weight (grams)
f/22-f/32	1:3	58mm	67 x 71	190
f/22-f/27	1:5.3	58mm	72 x 75	375
f/22-f/32	1:5.3	58mm	67 x 68	210
f/36	1:5.3	72mm	78.4 x 96.8	540
f/22-f/36	1:3.5	72mm	78.4 x 89.6	500
f/40	1:3.3	77mm	92 x 184	1670
f/22	1:5.6	72mm	79 x 86	580
f/22	1:4.3	52mm	67.4 x 42.5	210
f/22	1:5	52mm	68 x 27	130
f/22	1:6.3	72mm	81 x 90.1	645
f/16	1:6.7	72mm	85.8 x 65.5	580
f/22	1:6.7	58mm	73.8 x 50.5	29
f/22	1:6.7	52mm	68.2 x 41	13
f/32	1:2	52mm	67.6 x 63	280
f/22-f/27	1:4.8	77mm	92 x 184	1670
f/22-f/32	1:3	58mm	71 x 109	391
f/22-f/32	1:29	58mm	70 x 111	375
f/32	1:1	52mm	73 x 69.8	335
f/16	5:1	58mm	81 x 98	730
f/32	1:4.8	77mm	89 x 199	1490
f/32	1:4.8	77mm	76 x 193.6	1310
f/32	1:4.8	67mm	76 x 172	760
f/32	1:3.8	67mm	76 x 172	705
f/32-f/38	1:5.3	58mm	82.4 x 99	720
f/32-f/45	1:3.8	58mm	76.5 x 142.8	630
f/32	1:5	67mm	89 x 143	105
f/32-f/45	1:4	58mm	71 x 122	480
f/32-f/45	1:4	58mm	71 x 122	480
f/22-f/27	1:4.8	52mm	69 x 78.5	250
f/16	1:9.1	72mm	91.5 x 84	1025

 » **CANON EF/EF-S LENSES**

Lens name	Field of view	35mm equivalent	Min. focus distance
EF 85mm f/1.8 USM	18°	136mm	0.95m
TS-E 90mm f/2.8	17°	144mm	0.5m
EF 100mm f/2 USM	15°	160mm	0.9m
EF 100mm f/2.8 Macro USM	15°	160mm	0.31m
EF 100mm f/2.8 L Macro IS USM	15°	160mm	0.3m
EF 100–300mm f/4.5–5.6 USM	16–6°	160–480mm	1.5m
EF 100–400mm f/4.5–5.6 L IS USM*	16–3° 5′	160–640mm	1.8m
EF 135mm f/2.8 soft focus	11°	216mm	1.3m
EF 135mm f/2 L USM*	11°	216mm	0.9m
EF 180mm f/3.5 L Macro USM*	8°	288mm	0.48m
EF 200mm f/2 L IS USM*	7°	320mm	1.9m
EF 200mm f/2.8 L II USM*	7°	320mm	1.5m
EF 200–400mm f/4 L IS*	7–3° 5′	320–640mm	1.5m
EF 300mm f/2.8 L IS II USM*	6°	480mm	2m
EF 300mm f/4 L IS USM*	6°	480mm	1.5m
EF 400mm f/2.8 L IS II USM*	3° 5′	640mm	2.7m
EF 400mm f/4 DO IS USM*	3° 5′	640mm	3.5m
EF 400mm f/5.6 L USM*	3° 5′	640mm	3.5m
EF 500mm f/4 L IS USM*	3° 4′	800mm	3.7m
EF 500mm f/4 L IS II USM*	3° 4′	800mm	4.5m
EF 600mm f/4 L IS USM*	2° 34′	960mm	4.5m
EF 600mm f/4 L IS II USM*	2° 34′	960mm	4.5m
EF 800mm f/5.6 L IS USM*	1° 55′	1280mm	6m

Indicates that a lens is compatible with Canon's teleconverters.

+ drop-in filter size

Minimum aperture	Reproduction ratio	Filter size	Dimensions (mm)	Weight (grams)
f/16	1:9.1	72mm	91.5 x 84	1025
f/32	1:3.4	58mm	73.6 x 88	565
f/22	1:7.1	58mm	75 x 73.5	460
f/32	1:1	58mm	79 x 119	600
f/32	1:1	67mm	77.7 x 123	625
f/32-f/38	1:5	58mm	73 x 121.5	540
f/32-f/38	1:5	77mm	92 x 189	1380
f/32	1:8.3	52mm	69.2 x 98.4	390
f/32	1:5.3	72mm	82.5 x 112	750
f/32	1:1	72mm	82.5 x 186.6	1090
f/32	1:8	52mm+	128 x 208	2520
f/32	1:6.3	72mm	83.2 x 136.2	765
f/40	1:4	58mm	73 x 121.5	540
f/32	1:5.5	52mm+	128 x 248	2400
f/32	1:4.2	77mm	90 x 221	1190
f/32	1:5.8	52mm+	163 x 343	3850
f/32	1:8.3	52mm+	128 x 232.7	1940
f/32	1:8.3	77mm	90 x 256.5	1250
f/32	1:8.3	52mm+	146 x 383	3190
f/32	1:6.5	52mm+	168 x 449	3920
f/32	1:8.3	52mm+	168 x 456	5360
f/32	1:8.3	52mm+	168 x 448	3920
f/32	1:7.1	52mm+	163 x 461	4500

5 FLASH

The Rebel T5/EOS 1200D has a built-in, pop-up flash, but it's also fully compatible with Canon's Speedlite flash range and many other third-party flash units.

There are two ways of dealing with low ambient light levels: you can either increase the exposure, or you can add your own light to the scene.

The most common way of adding light is to use flash. Unfortunately, flash has a reputation for being a bit of a dark art, as the technical side of it can appear daunting. Fortunately, it is simpler than you might think, and once a few concepts have been grasped, it's possible to use flash to achieve images that would have been impossible otherwise.

There are two limitations with the Rebel T5/EOS 1200D's built-in flash that you need to be aware of to avoid disappointment. The first limitation is power. The built-in flash is not a particularly powerful light source, which makes its effective range relatively small, particularly in comparison to an external Speedlite.

The second limitation is that the built-in flash is a frontal light. Frontal lighting isn't particularly appealing, as it appears to flatten subjects, making them look less three-dimensional.

This chapter is an introduction to the world of flash, and will demonstrate how taking a few simple steps can improve your flash photography.

BUILT-IN «
The built-in flash is good as a general-purpose fill-in light, but it's not so good for close-up work and can cause hard black shadows behind your subject.

Note:
Canon uses the word Speedlite as a synonym for an external flash, which is the convention we'll use in this book.

OFF-CAMERA »
Using an external flash off-camera gives you the greatest control over the direction of the light.

> Inside a flash

The basic components of a flash are a power source, a capacitor, and an airtight chamber filled with xenon gas. The power source charges up the capacitor, which is discharged when the flash is fired, pulsing an electrical charge into the xenon gas. This charge causes the molecules of gas to release energy in the form of light.

If the flash is fired at full power, the capacitor's entire charge is used and the flash needs to recharge fully before it can be fired again. If the flash is fired at ½ power, only half of the capacitor's charge is used, so the flash will be able to fire twice before it needs to recharge. At ¼ power, the flash can fire four times before needing to recharge, and so on.

The power setting of the flash controls the amount of light released, but it's important to realize that the brightness of the flash is constant. What changes is the length of time that the flash emits light.

At full power, the energy "tap" is turned on until the capacitor is exhausted, resulting in a relatively long flash of light (lasting approximately 1/800 sec.). At ½ power, the energy "tap" is turned off in half that time (approximately 1/1600 sec.), which results in a halving of the light emitted. At ¼ power, the flash duration is halved again and the amount of light emitted is reduced still further. Every halving of power results in less light emitted due to the duration of the flash getting smaller.

> ***Note:***
> Using a lower power setting makes it easier to freeze movement with flash. The downside is that you need to be closer to your subject to illuminate it effectively.

BUILT-IN FLASH «
The Rebel T5/EOS 1200D's built-in flash works on exactly the same principles as a top-of-the-range Speedlite.

Flash exposure

There are two basic ways to determine flash exposure. If you use the built-in flash, the Rebel T5/EOS 1200D will automatically calculate the correct exposure. This is also an option if you are using a Speedlite. To automatically determine the correct flash exposure, Canon uses a proprietary exposure system known as E-TTL II. Generally, this is an accurate system, but it is not foolproof. It can also lead to inconsistent results, with the flash exposure changing between shots depending on the reflectivity of your subjects.

With an external Speedlite, you can also calculate the exposure manually. This is slightly more complicated than using E-TTL II, but it means the results are more predictable and consistent.

When a flash is set to manual, there are two main ways to control its effective distance (the maximum distance at which the flash can illuminate a subject). The first control is the power output of the flash: at ¼ power, the flash is discharged at maximum power; set it to ½ and the power output is halved; set to ¼, it is halved again, and so on.

The second exposure control is the aperture setting: the smaller the aperture used, the shorter the effective range of the flash will be. If a subject is further away

than the effective flash distance for the selected aperture, it will be underexposed, so you would need to use a larger aperture. Alternatively, if your subject is overexposed, this can be remedied by using a smaller aperture.

FLASH ⟩⟩
The recharging—or recycling—time of the built-in flash is reasonably fast, but it's still long enough to noticeably slow down the frame rate when you are shooting continuously.

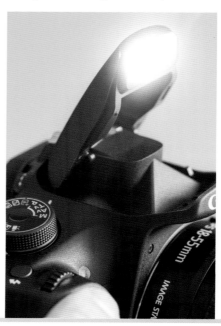

> **Note:**
> The shutter speed has no influence on the flash exposure. However, the shutter speed will affect the exposure of any area of a scene not lit by light from the flash. This is useful for slow-sync exposures, as described later in this chapter.

› Guide number

The power of a flash is referred to as its guide number or GN. The GN determines the effective range of the flash in either meters or feet: the higher the GN, the more powerful the flash is. When the ISO is increased, the GN increases as well, so to avoid confusion ISO 100 is used by camera and flash manufacturers when quoting the GN of a particular model of flash.

The GN can be used to determine the required aperture value for a subject at a given distance, or the effective range of the flash at a specified aperture. The formula to calculate both is respectively:

GN/distance=aperture
GN/aperture=distance

Using the Rebel T5/EOS 1200D's built-in flash as an example (which has a GN of 30.2 feet/9.2 meters at ISO 100), at an aperture setting of f/8 and at ISO 100, the effective flash distance is 3.77 feet (1.15

meters). Doubling the ISO increases the GN 1.4 times, so continuing this example, at an aperture setting of f/8 and ISO 200, the effective flash distance would increase to 5.28 feet (1.61 meters).

> **Note:**
> If a flash is used off-camera (via a cord or using a wireless transmitter), the distance between the flash and the camera is largely irrelevant in terms of determining the correct flash exposure. The GN is always used to calculate the effective distance between the flash and the subject.

THE BUILT-IN FLASH

Compared to most of Canon's Speedlites, the Rebel T5/EOS 1200D's built-in flash is weak, but that's not to say that it doesn't have its uses. There are shooting situations where any flash is better than no flash at all: the built-in flash is particularly useful as a fill-in light when your subject is backlit and otherwise would be silhouetted.

The built-in flash will rise and fire automatically as required when using the Basic Zone modes (with the exception of ⚡). To have complete control of the flash, you'll need to set your Rebel T5/EOS 1200D to one of the Creative Zone modes.

Warning!

If you have a lens hood or filter holder attached to your lens, remove it before you use the built-in flash.

Raising and using the flash

1) Press the ⚡ button behind 🔆 to raise the flash.

2) Press halfway down on the shutter-release button to focus as normal. ⚡ will be displayed at the bottom left corner of the viewfinder (or LCD screen in Live View mode) when the flash is ready for use.

3) The flash needs to recharge after it has fired, so there may be a short delay before the next photo can be shot. During this time, ⚡ **buSY** will be displayed in the viewfinder and **BUSY** ⚡ on the LCD.

4) Press down fully on the shutter-release button to take the photo.

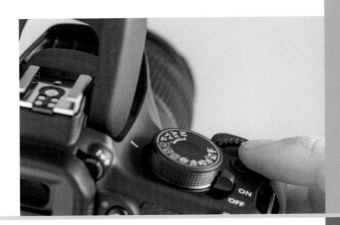

RAISING THE FLASH »
Press ⚡ to raise the flash, but not if you have a Speedlite fitted to the hotshoe!

5 › Built-in flash exposure chart

The effective range of the built-in flash will depend on the ISO that you set and the aperture you are using. This grid will help you determine the appropriate settings in different situations:

ISO	Aperture					
	f/2.8	f/4	f/5.6	f/8	f/11	f/16
100	10.71ft 3.29m	7.5ft 2.3m	5.36ft 1.64m	3.75ft 1.15m	2.73ft 0.84m	1.88ft 0.57m
200	15.15ft 4.65m	10.71ft 3.29m	7.5ft 2.3m	5.3ft 1.64m	3.75ft 1.15m	2.73ft 0.84m
400	21.43ft 6.57m	15.15ft 4.65m	10.71ft 3.29m	7.5ft 2.3m	5.3ft 1.64m	3.73ft 1.15m
800	30.3ft 9.29m	21.43ft 6.57m	15.15ft 4.65m	10.71ft 3.29m	7.5ft 2.3m	5.36ft 1.64m
1600	42.82ft 13.14m	30.3ft 9.29m	21.43ft 6.57m	15.15ft 4.65m	10.71ft 3.29m	7.5ft 2.3m
3200	60.61ft 18.59m	42.86ft 13.14m	30.3ft 9.29m	21.43ft 6.57m	15.15ft 4.65m	10.71ft 3.29m
6400	81.71ft 26.29m	60.61ft 18.59m	42.86ft 13.14m	30.3ft 9.29m	21.43ft 6.57m	15.15ft 4.65m

Red-eye reduc.

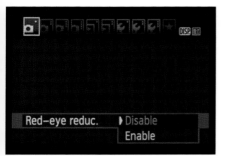

Red-eye occurs when direct flash is used to photograph someone looking directly at the camera (and therefore the flash). It is caused by the light from the flash bouncing straight back out of your subject's eyes, picking up the color of the blood vessels inside the eyes as it does so. The problem is made worse because flash is often used when ambient light levels are low and so the pupils in your subject's eyes will be at their widest.

Red-eye reduc. reduces the problem by activating the red-eye reduction lamp just before the final exposure is made. This causes the pupils of your subject's eyes to contract, reducing the risk of the light from the flash reflecting back out from their eyes.

Using red-eye reduction

1) Press MENU, highlight **Red-eye reduc.** on the ◯ menu, and press (SET).

2) Select **Enable** to switch red-eye reduction on. Press the shutter-release button down lightly to return to shooting mode and raise the built-in flash.

3) Press the shutter-release button down halfway to focus your camera. The orange red-eye reduction lamp should now light. Look through the viewfinder and you will see that a line of bars replaces the exposure scale. Keep your finger on the shutter-release button and the bars will gradually disappear. Press the shutter-release button down fully to take the shot when the last bar disappears.

> ### Tip
>
> *The further the flash is from the lens, the less risk there is of red-eye. This is impossible to change with the built-in flash, but it is possible to take your Speedlite off-camera, either with an extension cable or by using wireless flash. Bounce flash is another way of reducing the risk of red-eye.*

The **Flash control** submenu is the primary way of setting the shooting parameters of the built-in flash and compatible Speedlites (when fitted and switched on). As with red-eye reduction, **Flash control** is found on the 📷 menu.

› Flash firing

Set to **Enable**, the built-in flash or Speedlite will fire when a shot is taken. Set to **Disable**, neither will fire, but the Speedlite's AF assist beam (assuming it has one) will still activate. The AF assist beam is most useful when there is not enough ambient light for effective autofocus.

› Built-in flash func. setting

This menu option allows you to view a submenu where the built-in flash function settings can be adjusted. These include: **Flash mode**, **Shutter sync.**, **Flash exp. comp**, and **E-TTL II meter**, as described in more depth on the following pages.

› External flash func. setting

This option takes you to a submenu where you can change the function settings of a compatible Speedlite with your Rebel T5/EOS 1200D, rather than on the Speedlite itself (when the Speedlite is fitted and switched on). These function settings are described in more detail on page 176.

› External flash C.Fn setting/Clear ext. flash C.Fn set.

These two menu options allow you to set or clear the custom functions of compatible Speedlites using your camera instead of the flash. The available custom functions vary between Speedlite models.

BUILT-IN FLASH FUNCTION SETTINGS

Flash mode

With a Speedlite, you can set the **Flash mode** to either **E-TTL II** metering (the default setting) or to **Manual** flash exposure. Make your choice via **Flash mode** on the **External flash func. setting** screen.

Set to **Manual**, you must determine the flash exposure yourself, taking into account the GN of the flash and the ISO and aperture set on your Rebel T5/EOS 1200D.

If you use the built-in flash, **Flash Mode** is set automatically to **E-TTL II**.

Shutter sync.

In simple terms, the shutter in your Rebel T5/EOS 1200D consists of two light-tight metal curtains, one in front of the other. When you make an exposure, the first (or "front") curtain begins to rise, exposing the sensor to light. Then, after a period of time, the second ("rear") curtain follows, stopping the light reaching the sensor as it does so. The period of time between the first and the second curtain rising is the duration of the shutter speed.

How the shutter works is not that relevant for most photographs, but it is very important when using flash. If **Shutter sync.** is set to **1st curtain**, the flash fires when the first curtain begins to rise (so it fires at the start of the exposure). If the shutter speed is sufficiently long, the subject is "frozen" initially by the flash, but any subsequent movement is recorded as a blur in front of the subject as the camera continues to expose using ambient light.

If **Shutter sync.** is set to **2nd curtain**, the flash is fired when the second curtain begins to rise. The movement of your subject is frozen by the flash at the very end of the exposure. This results in the subject's movement being recorded as a blur behind the subject.

Of the two settings, **2nd curtain** usually appears more natural, but it's worth experimenting with both options to see which effect you prefer.

SYNC

1st curtain sync (below) generally looks less natural than 2nd curtain sync (bottom).

Setting the sync mode

1) Press MENU and select **Flash control**.

2) Select **Built-in flash func. setting** if you're using the built-in flash, or navigate to **External flash func. setting** if you're using an external Speedlite.

3) Select **Shutter sync.** and use ▲ / ▼ to highlight either **1st curtain** or **2nd curtain**. Press (SET) to select the required option. Press MENU to return to the main **Flash control** menu or lightly press the shutter-release button to go directly to shooting mode.

> ### Notes:
> The effects of **Shutter sync.** will only be noticeable if your subject moves across the image: they are not noticeable if your subject is moving toward or away from the camera.
>
> The speed of your subject (and the focal length of your lens) will determine the shutter speed you require. The shutter speed should be long enough for the subject to move from one side of the image space to the other.
>
> Symmetrical subjects (such as a ball, for example) don't work well when experimenting with **Shutter sync.**, as it's almost impossible to work out the original direction of travel!

Flash exposure compensation

Built-in flash func. setting

Flash exp. comp ‑2..1..0..1.:2

MENU ↩

Your Rebel T5/EOS 1200D should correctly calculate the exposure when you use either the built-in flash or an external Speedlite. However, as with non-flash exposure (and all other cameras), the Rebel T5/EOS 1200D can sometimes miscalculate. Fortunately, you can step in and adjust the flash exposure by ±2 stops. Flash exposure can be adjusted in one of two ways:

Notes:
Although you can apply exposure compensation to your flash, you will not be able to increase the effective flash distance for your chosen aperture unless you also increase the ISO.

Depending on the model of flash you are using, you may be able to adjust the flash exposure compensation on a fitted Speedlite.

Method 1
1) In shooting mode, press the Q button.

2) Select ⚡± from the Q menu screen.

3) Turn 🔄 to the left to decrease the power of the flash, or to the right to increase it. ⚡± will be shown in the viewfinder to indicate that flash exposure compensation has been applied.

4) Press down lightly on the shutter-release button to return to shooting mode.

Method 2
1) Highlight **Flash exp. comp.** on the **Built-in flash func. settings** screen and press (SET).

2) Highlight **Flash exp.comp** and press (SET).

3) Press ◀ to decrease the power of the flash or ▶ to increase it.

4) Press (SET) to apply the changes and return to the **Built-in flash func. setting** screen.

Built-in flash func. setting

| E-TTL II meter. | ▶Evaluative |
| | Average |

MENU ↰

E-TTL II stands for "evaluative through-the-lens metering." Flashes were once fitted with sensors that determined the correct exposure, but E-TTL II hands this responsibility to the camera. This makes flash exposure more accurate, particularly if the flash is used off-camera and when filters are used.

The system works by firing two bursts of light from the flash. The first burst is used by the camera to evaluate the flash and ambient light exposure, and then the second burst (which is modified so the subject is correctly exposed) is used to make the exposure. This happens so quickly that you or your subject won't even be aware there were two bursts of flash.

If used with a compatible lens, E-TTL II metering also uses the focus distance as a factor in determining accurate exposure. See the panel opposite for a list of compatible lenses.

The Rebel T5/EOS 1200D provides two methods of determining exposure using E-TTL II metering. The default method is **Evaluative**, which biases the exposure toward the subject (which is typically where the camera would be focused) rather than the background.

The second option—**Average**—does exactly what you'd expect: the required flash exposure is averaged across the entire scene. This increases the chance that a subject close to the flash will be overexposed, but if your lens doesn't supply distance information it may be worth trying both settings to see which you prefer.

Fully E-TTL II compatible lenses that supply distance information

(lenses in gray have been discontinued)

EF-S 10–22mm f/3.5–4.5 USM

EF 14mm f/2.8 L USM

EF 16–35mm f/2.8 L USM

EF 16–35mm f/2.8 L II USM

EF 17–35mm f/2.8 L USM

EF 17–40mm f/4 L USM

EF-S 17–55mm f/2.8 IS USM

EF-S 18–55mm f/3.5–5.6 USM

EF-S 18–55mm f/3.5–5.6

EF-S 18–55mm f/3.5–5.6 II

EF-S 18–55mm f/3.5–5.6 IS

EF 20mm f/2.8 USM

EF 20–35mm f/3.5–4.5 USM

EF 24mm f/1.4 L USM

EF 24–70mm f/2.8 L USM

EF 24–70mm f/2.8 L II USM

EF 24–85mm f/3.5–4.5 USM

EF 24–105mm f/4 L IS USM

EF 28mm f/1.8 USM

EF 28–70mm f/2.8 L USM

EF 28–80mm f/3.5–5.6 USM

EF 28–105mm f/3.5–4.5 USM

EF 28–105mm f/3.5–4.5 II USM

EF 28–105mm f/4–5.6 USM

EF 28–105mm f/4–5.6

EF 28–135mm f/3.5–5.6 IS USM

EF 28–200mm f/3.5–5.6 USM

EF 28–200mm f/3.5–5.6

EF 28–300mm f/3.5–5.6

EF 28–300mm f/3.5–5.6 L IS USM

EF 35mm f/1.4 L USM

EF 35–135mm f/4–5.6 USM

EF 50mm f/1.2 L USM

EF 70–200mm f/2.8 L IS USM

EF 70–200mm f/2.8 L USM

EF 70–200mm f/4 L USM

EF 70–210mm f/3.5–4.5 USM

EF 70–300mm f/4.5–5.6 DO IS USM

EF 70–300 f/4–5.6 IS USM

EF 85mm f/1.2 II L

EF 85mm f/1.8 USM

EF 90–300mm f/4.5–5.6 USM

EF 90–300mm f/4.5–5.6

EF 100mm f/2 USM

EF 100mm f/2.8 Macro USM

EF 100mm f/2.8 Macro L USM

EF 100–300mm f/4.5–5.6 USM

EF 100–400mm f/4.5–5.6 L IS USM

EF 135mm f/2 L USM

EF 180mm f/3.5 L Macro USM

EF 200mm f/2 L IS USM

EF 200mm f/2.8 L USM

EF 200mm f/2.8 L II USM

EF 300mm f/2.8 L IS USM

EF 300mm f/4 L USM

EF 300mm f/4 L IS USM

EF 400mm f/2.8 L IS USM

EF 400mm f/4 DO IS USM

EF 400mm f/5.6 L USM

EF 500mm f/4 L IS USM

EF 600mm f/4 L IS USM

EF 800mm f/5.6 L IS USM

EF 1200mm f/5.6 L USM

5 » FE LOCK

The exposure of both the built-in flash and an external Speedlite can be locked in a similar way to using AE lock (see page 42). To differentiate the two, flash exposure lock is referred to as FE lock.

To set FE lock, your Rebel T5/EOS 1200D first has to fire the flash to determine the correct exposure. This means that FE lock isn't subtle, so it shouldn't be used if you don't want to distract your subject before you shoot.

FE lock is particularly useful when the scene you want to shoot features highly reflective surfaces that normally would cause exposure problems with flash. In this situation, you could aim the flash toward a part of the scene with a more average reflectivity, lock the flash exposure, and then recompose the scene as intended.

Setting FE lock

1) Raise the built-in flash or attach and switch on your Speedlite.

2) Point the camera at your subject and press the shutter-release button down halfway to focus. Check that ⚡ is displayed in the viewfinder.

3) Press �֎ with your thumb. The flash will fire and the exposure details will be recorded. The word **FEL** will be displayed briefly in the viewfinder and ⚡* will replace ⚡. If you press ✷ again, the process will be repeated.

4) Recompose your shot and press the shutter-release button down fully to make the final exposure.

5) FE lock now will be deactivated and normal flash operation will resume.

Notes:
If ⚡ blinks in the viewfinder, your subject distance exceeds the effective flash distance. Either move closer to your subject, use a larger aperture, or increase the ISO.

The term FE lock is often shortened to FEL.

EXTERNAL SPEEDLITES

Although the Rebel T5/EOS 1200D has a built-in flash, it is limited in its uses. Even the lowliest of Canon's Speedlites are better specified and offer greater potential for creative flash techniques (certain Speedlite functions can be set via **Flash control** on the ⬛ menu).

Canon recommends that you do not use third-party flashes with the Rebel T5/EOS 1200D, but companies such as Sigma and Metz produce compatible flash units (although these may be less adjustable via **Flash control** than a Canon Speedlite). As with the built-in flash, the flash sync-speed for external flashes is 1/200 sec., unless the flash is capable of high speed sync.

THIRD-PARTY FLASH　　　　　　　⩔
Although flash hotshoes are a common shape, the electronic connections vary between camera brands. Don't fit third-party flashes unless they are specifically designed for Canon EOS cameras.

Fitting an external flash
1) Make sure that both your Rebel T5/EOS 1200D and Speedlite are switched off.

2) Slide the Speedlite shoe into the hotshoe of the camera. If your Speedlite has a locking collar, press the locking button and slide the collar around until it clicks into the lock position.

3) Turn the Speedlite on first, followed by the Rebel T5/EOS 1200D.

4) A ⚡ symbol will be displayed in the viewfinder of the Rebel T5/EOS 1200D, or on the LCD if you are in Live View.

5) To remove the Speedlite, switch off the Rebel T5/EOS 1200D and Speedlite, and reverse the procedure in step 2.

> *Notes:*
> The settings available on the **Flash control** menu will differ according to the specifications of the Speedlite.
>
> **Flash control** is only displayed when the Rebel T5/EOS 1200D is set to a Creative Zone mode.
>
> The built-in flash is disabled when an external Speedlite is fitted and switched on.

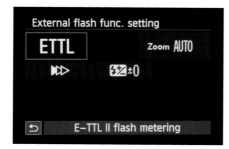

The **External flash func. setting** screen lets you set the shooting functions of compatible Speedlites in-camera rather than on the Speedlite itself. These vary from Speedlite to Speedlite, but here are a few common settings you may encounter:

E-TTL

As with the built-in flash setting screen, this option lets you set whether the flash uses E-TTL II metering or whether the exposure is determined manually.

Zoom

If your flash has a compatible zoom head, selecting **Auto** will ensure that the zoom adjusts to match the focal length of the lens, so you have even coverage across the image frame.

However, you can choose to adjust the focal length of the zoom head on the flash yourself. Usually this would be done if you used a lens that didn't supply the necessary focal length information for **Auto** zoom.

You might also zoom the flash head for creative effect: to focus the light from the Speedlite on your subject and leave the area around the edge of the frame darker, for example.

Flash exposure bracketing

Bracketing with a Speedlite is similar in concept to standard exposure bracketing, but it is only found on high-end Speedlites such as the 600 EX-RT (it's certainly not available when using the built-in flash). Instead of the exposure for the ambient light altering, the output of the Speedlite is varied between shots. As with standard exposure bracketing, flash exposure bracketing can usually be applied in ½-, ⅓-, or 1-stop increments.

SPEEDLITE 90EX

The 90EX is the most recent Speedlite released by Canon. It is also the smallest, lightest, and the least powerful—the GN is roughly similar to the Rebel T5/EOS 1200D's built-in flash. The 90EX was originally designed for Canon's EOS M camera (and is usually bundled with that camera), but it is also compatible with the Rebel T5/EOS 1200D. Unusually for such a low-powered, low-specification Speedlite, it can be used as a master flash to trigger other compatible flashes.

GN
29ft/9m (ISO 100)
Tilt/swivel
No
Focal length coverage
24mm*
AF-assist beam
Yes
Flash metering
E-TTL/E-TTL II
Approximate recycling time
5.5 seconds
Batteries
2 x AAA/LR03
Dimensions (w x h x d)
1.7 x 2 x 2.5in./44 x 52 x 65mm
Weight
1.8oz./50g (without batteries)

*35mm equivalent

Next in terms of size, weight, and power is the 270EX II. It's not a particularly powerful flash, but it's still over twice as powerful as the Rebel T5/EOS 1200D's built-in unit. Although the 270EX II is small, it features a zoom and bounce head, and rapid, near-silent recharging. The 270EX II can be used wirelessly as a slave flash in conjunction with a suitable master Speedlite. However, unlike the 90EX it cannot be used as a master flash to fire other Speedlites.

GN
89ft/27m (ISO 100)
Tilt/swivel
Tilt only
Focal length coverage
28–50mm*
AF-assist beam
Yes
Flash metering
E-TTL/E-TTL II
Approximate recycling time
0.1–3.9 seconds
Batteries
2 x AA/LR6
Dimensions (w x h x d)
2.5 x 2.6 x 3.0in./64 x 65 x 72mm
Weight
5.1oz./155g (without batteries)
Other information
HSS
Included accessories
Soft case, shoe stand, manual

35mm equivalent

The 320EX is a relatively recent addition to the Speedlite range, and is larger and more powerful than the 270EX II. The most distinctive aspect of the 320EX is the built-in LED light in addition to the main flash head. The LED light is there to provide a constant light source when shooting movies. In theory, this is a good idea, but in practice the light isn't that powerful, so your subject needs to be very close to the camera to be illuminated evenly. The 320EX can be used as a slave flash, but it does not have master flash capability.

GN
104ft/32m (ISO 100)
Tilt/swivel
Yes
Focal length coverage
24–50mm*
AF-assist beam
Yes
Flash metering
E-TTL/E-TTL II
Approximate recycling time
0.1–2.3 seconds
Batteries
4 x AA/LR6
Dimensions (w x h x d)
2.75 x 4.5 x 3.09in./70 x 115 x 78.4mm
Weight
9.7oz./275g (without batteries)
Other information
HSS
Included accessories
Soft case, shoe stand, manual

35mm equivalent

The Speedlite 430EX II is the smaller, less powerful sibling of the top-of-the-range 600EX-RT. However, with a GN of 141ft (43m), the 430EX II is far more powerful than the Rebel T5/EOS 1200D's built-in flash and can be fitted to the hotshoe or triggered as a slave flash. The 430EX II allows high speed, 1st curtain, and 2nd curtain flash sync, and has comprehensive exposure compensation options and nine custom functions.

GN
141ft/43m (ISO 100)

Tilt/swivel
Yes

Focal length coverage
14–105mm

AF-assist beam
Yes

Flash metering
E-TTL/E-TTL II

Approximate recycling time
0.1–3.7 seconds

Batteries
4 x AA/LR6

Dimensions (w x h x d)
2.8 x 4.8 x 4.0in./72 x 122 x 101mm

Weight
11.6oz./320g (without batteries)

Other information
HSS, 1st and 2nd curtain sync

Included accessories
Soft case, shoe stand, manual

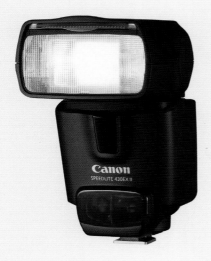

The 600EX-RT is the largest, heaviest, and best-specified Speedlite in the range. It has integrated radio-triggering, as well as infrared wireless flash control, improved weather sealing, high speed synchronization, and 18 custom functions.

However, its size and weight make it a tricky proposition to use fitted to a Rebel T5/EOS 1200D—the combination feels top-heavy, particularly when a small, lightweight lens is used. It is best used as an external flash triggered by a smaller unit such as the 90EX.

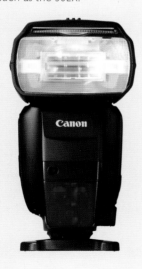

GN
 196.9ft/60m (at ISO 100)
Tilt/swivel
 Yes
Focal length coverage
 14–200mm
AF-assist beam
 Yes
Flash metering
 E-TTL II/E-TTL/TTL/Manual
Approximate recycling time
 0.1–5.5 seconds (0.1–3.3 seconds using quick flash)
Batteries
 4 x AA/LR6
Dimensions (w x h x d)
 3.1 x 5.6 x 4.9in./79.7 x 142.9 x 125.4mm
Weight
 15oz./425g (without batteries)
Other information
 HSS, 1st and 2nd curtain sync
Included accessories
 Soft case, shoe stand, manual, color filters, case, and holder

> Bounce flash

Direct flash is a hard and unflattering light that benefits from being softened. A simple way to soften it is to reflect, or "bounce" the light off another surface before it reaches your subject. This has the effect of increasing the area the light is coming from, which makes it softer.

Bounce flash isn't practical with the built-in flash, but with the exception of the 90EX, all of Canon's Speedlites can be angled in at least one direction. The most common method of bouncing flash is to angle the head of the Speedlite upward, so the light bounces off a ceiling down onto your subject.

One potential problem with bounce flash is that the light will be tinted by the color of the surface you bounce it off, so it is best only to bounce it off a neutral-colored ceiling or wall. Another potential problem is that by bouncing the flash, you increase the distance that the light has to travel to reach your subject. It's all too easy to exceed the effective distance of your flash unless it has a high GN or you use a large aperture and/or high ISO.

BOUNCED ❯❯
The difference between direct flash (left) and bounce flash (right) is often dramatic.

High Speed Sync

If you use flash on a bright day—as a fill-in light to reduce contrast, for example—it's possible that you'll need to use a shutter speed faster than the camera's sync speed. At this point, the built-in flash is no longer useful, as you can't exceed the sync speed.

Some of Canon's high-end Speedlites, however, feature a mode known as High Speed Sync that allows you to use shutter speeds up to 1/4000 sec. (the fastest shutter speed on the Rebel T5/EOS 1200D).

High Speed Sync works by pulsing the Speedlite output to "build up" the flash exposure as the shutter curtains travel across the sensor (effectively turning the flash into a constant light source instead of a single, brief burst of light). The drawback is that the power of the flash is reduced, as the Speedlite has to discharge many times. This limits the effective range, which means that your subject may need to be closer to the camera.

› Off-camera flash

If you take a Speedlite off-camera, you immediately increase the ways in which it can be used creatively. The most important benefit of off-camera flash is that it allows you to control the direction of the light emitted by the flash. This means you can use flash as a sidelight to create interesting shadows, or as a backlight, which works well with translucent subjects.

There are two ways to take a Speedlite off-camera: you can either use an E-TTL cord or you can fire the Speedlite wirelessly. E-TTL cords come in a variety of lengths and are relatively inexpensive. Canon supplies the OC-E3 E-TTL cord, but third-party alternatives are also available. The main problem with a cord connection is that you can't take the Speedlite that far from the camera, unless the cord is long.

An arguably neater solution is to use an optical wireless connection. This requires two Speedlites. One is fitted to the camera (the "master") and the second is positioned off-camera (the "slave"). When the master Speedlite fires, the slave detects this and fires in turn.

The drawback to optical wireless flash is that the two Speedlites need to be able to "see" each other. However, this is a system that works well, and with a compatible Speedlite you can even use E-TTL metering.

6 IN THE FIELD

Although the Rebel T5/EOS 1200D is an entry-level camera, it is more than capable of professional results, with all the features necessary for the creation of any type of photographic imagery. The key is learning to use it well and getting to grips with how it operates.

The Rebel T5/EOS 1200D is a small and light camera, but as long as you don't abuse it, it's capable of withstanding many years of active use. However, that doesn't mean you should be complacent.

Water is probably the greatest enemy of a camera (followed by dropping it), but that shouldn't preclude you from shooting in inclement conditions—with care, it's even possible to shoot in heavy rain. If the camera gets wet, wipe it dry as best you can before covering it up again. Once you're back indoors, check the camera thoroughly, and dry it again if necessary. The lens will also need to be checked. Remove any moisture on the lens' surface with a lint-free lens cloth.

Take special care if you're shooting near saltwater, as salt is very destructive to electronic components (and metal in general). Dry your camera immediately if it is splashed with salt water, and wipe it down again when you get home.

The ambient temperature at which you shoot is a potential source of problems too. Canon recommends 104°F (40°C) as the maximum operating temperature of your Rebel T5/EOS 1200D. Try to avoid using your camera in temperatures hotter than this, or at least keep the camera cool in the shade when it is not in use.

RAIN ⌄
Landscape photography is often at its most appealing when the weather changes. One result is the increased likelihood of rainbows.

SALTY »
Saltwater isn't good for cameras or lenses. When working near the sea, I constantly check them both for splashes.

Cold can affect a camera too. Batteries become far less efficient as the temperature drops, and in extremely cold conditions lubricants in the camera can freeze. When you return indoors, allow your camera to return slowly to room temperature and check that condensation hasn't built up on the lens or LCD screen. Keeping a big packet of silica gel in your camera bag will help to prevent moisture building up.

› Dust

The sensor in the Rebel T5/EOS 1200D doesn't have an automatic cleaning system like other cameras in the EOS range. Dust on the sensor is seen as fuzzy blobs, usually in areas of light, even tone, such as the sky.

Fortunately, dust is usually only seen when small apertures have been used, as depth of field makes it more obvious. Consequently, one way to minimize the appearance of dust is to use the largest aperture you can to achieve the required depth of field.

A fine coating of dust on a lens will increase the risk of flare, so if you're shooting in dusty conditions, keep your Rebel T5/EOS 1200D inside a bag when it is not in use. If you need to change lenses, try to do so as quickly as possible, using your body to shield the camera from any breeze. If you do get dust or sand on the front element of the lens, use a blower to avoid touching (and potentially scratching) the glass.

SAND «
Wind-blown sand can get everywhere. There was a lot of fine sand blowing about when I shot this image, so I avoided changing the lens until I was safely off the beach.

UNDERSTANDING EXPOSURE

The term "exposure" refers to the amount of light allowed to fall onto the sensor (or film) inside a camera to make an image. Exposure is set by three different camera functions: the shutter speed, the aperture, and the ISO. The first two physically determine how much light enters the camera, while the last determines how much light is needed.

Shutter speed is measured in precise fractions of a second: 1/125 sec., 1/250 sec., 1/500 sec., 1/1000 sec., and so on. The difference between each of these

shutter speed values is known as a "stop." A difference of 1 stop represents either a halving of light let into a camera or a doubling. As an example, there's a 1-stop difference between shutter speeds of 1/125 sec. and 1/250 sec. There's also a 1-stop difference between 1/500 sec. and 1/250 sec., and 1/500 sec. and 1/1000 sec.

Changing the shutter speed from 1/250 sec. to 1/125 sec. doubles the time the shutter is open, which doubles the amount of light reaching the sensor. Changing the shutter speed from 1/250 sec. to 1/500 sec. halves the amount of time the shutter's open, so the sensor is exposed to half as much light.

However, to confuse the issue slightly, the Rebel T5/EOS 1200D allows you to adjust the shutter speed in ⅓ -stop increments. In the examples above, 1/160 sec. and 1/200 sec. are the ⅓ -stop values between 1/125 sec. and 1/250 sec., and 1/320 sec. and 1/400 sec. are the shutter speeds that fall between 1/250 sec. and 1/500 sec.

CONTROL «
When you use a Basic Zone mode, the exposure is automatically calculated for you. It's only when you switch to a Creative Zone mode that you have more control over the exposure.

The size of the aperture in the lens is measured in f-stops. The various aperture/f-stop values of a lens describe the diameter of the aperture as a fraction of the focal length. So, the diameter of the aperture at f/2 on a 50mm lens would be 25mm; at f/4, it would be 12.5mm, and so on.

The most commonly found f-stops on a lens, in sequence, are f/2.8, f/4, f/5.6, f/8, f/11, f/16, and f/22, although the maximum and minimum apertures of lenses do vary. As with shutter speeds, each f-stop represents either a doubling or halving of the amount of light let through. So, f/5.6 will allow half as much light to pass

through the lens as f/4, but twice that of f/8. As with shutter speed, the Rebel T5/EOS 1200D allows you to adjust the aperture in ⅓-stop increments.

› Reciprocal relationship

There's a reciprocal relationship between shutter speed, aperture, and ISO: if one is changed, at least one of the other two controls must be altered to maintain the same amount of exposure overall.

As an example, let's assume the camera recommends an exposure of 1/250 sec. at f/8, using an ISO of 400. However, you decide that you would like to use a larger aperture to minimize depth of field and set the aperture to f/4. The difference between f/8 and f/4 is 2 stops, so to maintain the same basic level of exposure you'd either have to reduce the ISO by 2 stops (to ISO 100); increase the shutter speed by 2 stops (to 1/1000 sec.); or split the difference and set the ISO to 200 and the shutter speed to 1/500 sec. (a 1-stop adjustment to each).

CHOICES «
This photograph was taken with a shutter speed of 1/15 sec. and an aperture setting of f/8, at ISO 100. I could have chosen several other shutter speed and aperture combinations to achieve the same exposure overall.

The average ideal

The exposure meter built into the Rebel T5/EOS 1200D is what is known as a "reflective" meter. It measures the amount of light reflected from the scene being metered (as opposed to "incident" light meters that measure the amount of light falling onto a scene).

The exposure suggested by the meter in the Rebel T5/EOS 1200D is based on the assumption that the scene has an average reflectivity. An averagely reflective scene is one where the result would be a midtone if you mixed all the tones in the scene together (from the deepest shadow to the brightest highlight). With all color removed, this midtone would be a gray that is exactly midway between black and white in brightness. This mid-gray is known as "18% gray" because it reflects 18% of the light that falls onto it. Subjects in the real world that are averagely reflective include grass and the bluest part of the sky.

The types of scene that reflective meters have problems with are those with lower or higher reflectivity than average. If a scene is more reflective than average (a good example being a landscape covered in brightly lit snow), the meter will generally underexpose the image. This is because the camera is trying to create an image close to the average ideal. The opposite is true if the scene is less reflective than average: in this situation, the meter will overexpose.

To achieve the correct exposure in these situations, it can be necessary to apply positive or negative exposure compensation respectively.

AVERAGE »
For this shot, the rocks and the grass in the foreground would have been good places to meter from (using Partial metering) to achieve the correct exposure.

When using Evaluative metering, the exposure is biased toward the AF point(s) that achieve focus. This works well when the area you have focused on has an average reflectivity, but a light subject, such as these blossoms, can cause the camera to underexpose (the focus point was placed over the large flower at the right of the image). To avoid underexposure, I applied +1-stop of exposure compensation.

Settings
> Focal length: 55mm
> Exposure: 1/100 sec. at f/5.6
> ISO: 100

HISTOGRAMS

Although the exposure meter in the Rebel T5/EOS 1200D is the primary tool for deciding exposure, there is a second aid that helps you confirm whether exposure is correct: the histogram. A histogram is a graph showing the distribution of tones in an image.

The Rebel T5/EOS 1200D lets you view a histogram on the detailed playback screen after shooting and also on the LCD screen during Live View. Once you've learned to read a histogram, it's a very accurate way of assessing whether an image is exposed correctly, and certainly more precise than judging exposure based on how the image appears on the LCD screen.

The left half of a histogram shows the range of tones in an image that are darker than mid-gray, with black at the extreme left edge. The right half of the histogram shows the tones in an image that are lighter than mid-gray, with white at the extreme right edge. The vertical axis of the histogram shows the number of pixels in an image of a particular tone.

If a histogram is skewed to the left, this may be an indication that the image is underexposed; if it is skewed to the right, the image might be overexposed. If a histogram is squashed against either the left or right edge, it has been clipped, which means there are pure black or pure white pixels in the image respectively. There is no usable image data in those pixels.

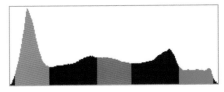

CORRESPONDENCE »
The colored areas of this image's histogram correspond to tonal areas within the boxes drawn on the image.

Assessing exposure isn't the only thing you can do with a histogram. In playback, the Rebel T5/EOS 1200D can display a brightness histogram or three RGB histograms stacked one above the other.

The brightness histogram is the simplest (and is the one shown first when viewing detailed playback and displayed when in Live View). This type of histogram shows the range of tones in the image as if the image were grayscale.

The information conveyed by the RGB histograms is subtler, as the three histograms show the distribution of red, green, and blue that combine to make each pixel in the image. A pure red pixel only has red in it, with no green or blue components. A pure magenta pixel, on the other hand, is an equal mix of red and blue, and a white pixel is an equal mix of red, green, and blue at their maximum values of 255 (black is an entire absence of red, green, and blue).

Normally, this information is too much, and it's easier to understand and read the brightness histogram. However, you can use the RGB histograms to check whether one particular color is overexposed and adjust the exposure accordingly.

The RGB histograms can also indicate if the white balance needs adjusting. To do this, take a photo of a neutral gray surface, so that it fills the entire frame (there's a gray card that can be used for this purpose in the cover of this book). If your white balance setting is correct, the red, green, and blue histograms should be identical. If they're not, the white balance is incorrect.

SKIN TONE «

One subject that looks wrong with an incorrect white balance is the human face, specifically the skin tones. Artificial lighting is a particular weakness of AWB. When shooting portraits under tungsten or fluorescent lighting, it's a good idea to create a custom white balance instead.

If the red histogram is skewed further to the right than the others, for example, the white balance is too warm and should be "cooled down." If the blue histogram is skewed to the right, the white balance is too cool, so it should be "warmed up."

Dynamic range

The dynamic range of a camera is its ability to record usable detail in both the shadows and the highlights. The greater the dynamic range of a camera, the better able it is to cope with high-contrast scenes. The Rebel T5/EOS 1200D is quite respectable in this regard, with a good dynamic range, but there will be occasions when contrast levels are too high.

This occurs when there is an imbalance of light across a scene. When shooting landscape images, for example, the biggest challenge is when there is no direct light on the foreground, but the sky is brightly lit. If you expose for the foreground, the sky will be burnt out, while exposing for the sky means the foreground will be dark and muddy. The solution in this instance is

to use ND graduated filters, which are described in chapter 7.

Backlit scenes present a similar challenge. The choice is usually either to expose for the background (so the subject is in silhouette) or to expose for the subject, so the background is overexposed. An alternative approach is to use a fill-in light, such as flash, or use a reflector to "push" light back toward your subject.

BACKLIT »
This is a "no win" situation without the use of filters, as the intense sunlight shining through the glass roof is far brighter than the foreground. This was the best exposure possible, but even so the brightest area of the roof is burnt out and there's little detail in the darkest shadow.

6 » BLACK-AND-WHITE

Black-and-white photography (called Monochrome in Canon's Picture Styles) was once the only type of photography there was. Although color photography now dominates, shooting black-and-white is still an interesting way of photographing the world with (arguably) a more timeless quality than color.

A monochrome image is composed of shades of gray, from black through to white. The brightness of a particular gray tone in an image is determined by the reflectivity of the subject: the more light the subject reflects, the brighter the gray tone. However, if elements in the scene reflect similar amounts of light (even if they're radically different in color), they will be very similar shades of gray when converted to monochrome. This can lead to images that look "flat."

This can be overcome by using the **Filter effect** options found on the Picture Style screen after highlighting ▓▓M and pressing DISP. Strange as it may seem, colored filters are often necessary when shooting black-and-white images. This is because colored filters block out the colors that are on the opposite side of a standard color wheel to the filter, making them appear darker when they are converted to a gray tone.

For example, a red filter blocks out blue-greens. Using **R: Red** therefore will lighten the gray tones of a red object when it's converted to monochrome, but blue and green objects and areas will be darkened. This helps to separate the tonal values in an image.

Landscape photographers often use yellow, orange, or red filters to darken blue skies (with red having the greatest effect), while portrait photographers are more likely to use green filters, which help with skin tones. If your black-and-white images look flat, it's certainly worth experimenting with the **Filter effect** options.

FLAT «
This is the same scene from page 103, shot using ▓▓M, but with **Filter effect** set to **N: None**. Notice how flat the image looks compared to the color original. On the page opposite is the same scene, shot using the four filter effects: which do you think is most effective?

Ye: Yellow

Or: Orange

R: Red

G: Green

7 ACCESSORIES

If you have a camera, a lens, and a memory card, you can take a photograph, but photographers rarely stop there. It's more common for them to expand their photographic equipment with a variety of different accessories.

› Decisions

There are three types of photographic accessory. The first comprises accessories that are invaluable; for me, tripods fall into this category, followed by filters.

The second type of accessory is useful, but not strictly necessary. Hotshoe spirit levels arguably fall into this category, especially if you're more inclined to take portraits, rather than landscapes, but a reflector will be more useful if you prefer portraiture, for example.

The final type of accessory is fun for a short while, but then is rarely (if ever) used again. This type of accessory usually ends up at the back of drawer, forgotten and unlamented.

The moral is that it pays to be critical when choosing accessories for your camera. This involves being honest with yourself about your way of working and whether your purchase will genuinely enhance your photography or whether it is just a one-day wonder.

LEVEL «
A hotshoe spirit level is used to check how straight a camera is, typically to the horizon. It's most useful when shooting seascapes or architecture, or both!

LOW LIGHT »
In low light, a tripod will help keep images sharp, particularly when using a telephoto lens.

7 » CANON ACCESSORIES

Canon produces a number of accessories for its EOS camera range. The slightly confusing aspect of this is that some accessories will fit all of Canon's recent DSLRs (the GP-E2 falls into this category) while others are only compatible with a limited number of cameras (the AC Adapter Kit ACK-E10, for example).

GPS receiver (GP-E2)

The GP-E2 fits to your Rebel T5/EOS 1200D's hotshoe and records the location information (longitude, latitude, elevation, and direction) of your images to the EXIF metadata. This information can be read by software such as Adobe Lightroom 5, so that your images can be quickly sorted by location and shown on a world map. The GP-E2 will also automatically update the clock in your Rebel T5/EOS 1200D so that it remains accurate.

AC Adapter Kit (ACK-E10)

This replaces the battery in your Rebel T5/EOS 1200D, allowing you to power the camera from a domestic wall socket. If you enjoy showing slide shows through a television, or print directly from your camera, an AC adapter will help to avoid proceedings grinding to a premature halt.

Remote release (RS-60E3)

A remote release allows you to fire the shutter-release button without touching the camera. They're not suitable for all types of photography—you wouldn't use one for sports photography, for example—but they are almost essential if you use a tripod. Canon's RS-60E3 is a remote release that connects to your Rebel T5/EOS 1200D via a short lead.

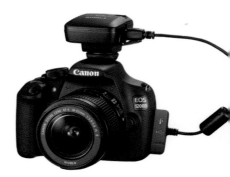

GPS RECEIVER ⌃
Adding GPS capabilities to your Rebel T5/EOS 1200D will allow you to tag your images with location coordinates. This is particularly useful for landscape photography; less so if you mainly shoot portraits indoors.

FILTERS

A filter is a piece of glass, gelatin, or optical resin that's attached in front of the lens to affect the quality of light in some defined way. Filters range from being indispensable (making you wonder how you managed without them) or non-essential (if occasionally fun to use), with effects that range from subtle to garish.

Filters come in one of two forms: circular screw-in filters that physically screw to the front of a lens, and square or rectangular filters that slide into a dedicated holder that's fitted to the lens.

Screw-in filters

Screw-in filters are generally cheaper than filters made for filter holders and are a good way to experiment without spending too much money. The one drawback is that the lenses in your collection may not all have the same filter thread size (the filter thread size is measured in millimeters and is typically found near the front lens element; the filter thread size of the 18–55mm kit lens is 58mm).

If you have a few lenses, this means you may need to buy the same filter several times over. To avoid this, it's often better to buy the biggest filter size possible and then buy step-up rings to convert the filter to your various lenses.

› Filter holders

A filter holder is a plastic device with grooves running down it that allows filters to be slotted in and held in front of a lens. The filter holder is attached to the lens by an adapter ring, and this is the only bit you need to buy for each lens you own (you can use the same filter holder and filters on every lens). This makes filter holders ideal if you plan to expand your lens collection over time.

There are several manufacturers of filter holder systems, including Cokin and Lee Filters. The disadvantage of filter holder systems is that once you've bought a system you may be locked into buying that manufacturer's filters from that point onward, limiting your choice.

Note:
One filter that's useful to fit as a screw-in device is a UV filter. This reduces the effects of ultraviolet light that can cause an outdoor scene to appear overly blue and hazy. However, as there is very little light loss with this filter, it is more commonly used to protect the front of the lens (the theory being that if the lens is dropped, the filter will protect the front glass element from damage).

When light reflects from a non-metallic surface, its rays are scattered randomly. This causes glare on the surface and an apparent reduction in its color saturation. Light that's been scattered in this way has been polarized.

A polarizing filter cuts out this polarized light from every plane but one, restoring saturation and reducing glare. The effect can be seen on surfaces as diverse as water, shiny paint, and even wet or glossy leaves on trees. The effect works best when the camera/polarizer combination is used at 35° to the surface.

The most striking effect of a polarizer is the deepening of blue sky. This effect is strongest when the filter is at 90° to the sun—move the polarizer away from this angle and the effect diminishes (at 180°, a polarizer has no effect on the sky at all). The height of the sun also affects the strength of the polarizing effect.

Polarizing filters are made of glass, mounted in a holder that can be rotated through 360°. This allows the strength of the polarizing effect to be varied. A polarizer is slightly opaque and will reduce the amount of light reaching the sensor. The exposure meter in the Rebel T5/EOS 1200D should automatically compensate when a polarizer is fitted, unless you're shooting in **M** mode (in which case the exposure will need to be altered manually). The amount of compensation required will vary, but 2 stops is a good starting point.

OVERDONE　　　**«**
Deepening a blue sky with a polarizer should be done with care, as on a near-cloudless day it can appear unnatural. It's also not advisable to use a polarizer with a very wide-angle lens, as this can cause unnatural banding in the sky. In this shot, I managed to commit both sins.

TRANSPARENT ⌃

Without a polarizing filter (top), the glare on the water's surface reduces transparency. However, the glare is completely cut out by fitting a polarizer (bottom).

In low-light conditions, you can increase the ISO on your Rebel T5/EOS 1200D if you need extra sensitivity. What's slightly harder to deal with is *too much* light. Even at ISO 100, you'll come across situations where you can't use the desired aperture or shutter speed because it's too bright.

The answer to this problem is to use a neutral density (ND) filter. As the name suggests, an ND filter reduces the amount of light reaching the sensor, without affecting the color of the light (hence "neutral"). A simple analogy is to think of it as sunglasses for your camera.

ND filters are available in a variety of strengths, usually measured in stops (1-stop ND, 2-stop ND, and so on), which refers to how much light they block. When they're fitted, the exposure meter of your Rebel T5/EOS 1200D will compensate automatically for them (you will have to compensate manually for their effect in **M** mode). They're most useful when you want a long shutter speed, but don't want to use a smaller aperture (or if you have already reached the minimum aperture).

A recent development has been the availability of extremely dense ND filters, the most popular being Lee Filter's "Big Stopper"—a 10-stop ND filter that appears to be almost opaque. This filter (and others like it) is generally too dense for the viewfinder AF system to work, although Live View AF is sometimes just about able to manage. Extremely dense ND filters can often turn shutter speeds that should be fractions of a second into whole seconds, or sometimes even whole minutes.

> ### Tip
>
> *Because a polarizer cuts out light, it can also be used as an ND filter.*
>
> *ND filters are often sold using an optical density figure. A 1-stop ND filter has an optical density of 0.3, a 2-stop filter is 0.6, and so on.*

BLACK-AND-WHITE »
Long shutter speeds can produce minimalist images that often suit a black-and-white treatment more than color.

WAVE POWER ⌃
An 8-stop neutral density filter allowed me to
extend the shutter speed from 1/30 sec. (top)
to 8 sec. (bottom).

The graduated ND filter is a cousin of the ND filter, but its defining characteristic is a clear bottom half and a semi-opaque (ND-coated) top half.

Graduated ND filters are generally used when one part of a scene is significantly brighter than another, exceeding the camera's dynamic range and causing overexposure in the brighter area. A typical example is a landscape with a bright sky and dark foreground.

Graduated ND filters are sold in a variety of strengths (most often 1-stop, 2-stops, and 3-stops), and the greater the brightness difference between the two parts of a scene, the stronger the graduated ND you would use.

As well as strength, graduated ND filters are also differentiated by the transition from the clear area to the semi-opaque area, which can be soft, hard, or very hard. Graduated ND filters with a hard transition are easier to position successfully, but are more difficult to use when the difference between the light and the dark areas of a scene isn't perfectly straight.

HOLDER **«**

Graduated ND filters are more effective when used in a filter holder, as this allows you to move the filter up and down (or rotate it) to place the transition point exactly where it's needed.

Some images require the use of several different accessories. This shot was created using a tripod, a polarizing filter, and a 1-stop graduated ND filter.

Settings
> Focal length: 33mm
> Exposure: 1/13 sec. at f/11
> ISO: 100

7 » SUPPORTING THE CAMERA

When shooting fast-paced events, you'd most likely handhold the camera—after all, it's an effective way to quickly react to events and keep your compositional options open. However, if the pace is a little less frenetic and you're working in less than ideal light, you'll benefit from giving your camera more solid support.

TRIPOD ⟨⟩
A Rebel T5/EOS 1200D mounted on a Manfrotto tripod with a (separately purchased) three-way Manfrotto head.

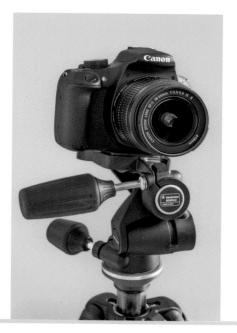

› Tripods

The high ISO capabilities of the Rebel T5/EOS 1200D and the Image Stabilization of the 18–55mm kit lens will allow you to handhold the camera in low-light conditions and still achieve reasonably sharp results. This doesn't mean that tripods are redundant, though.

It is still useful—desirable even—to own a tripod as a photographer. There are many interesting effects that can be achieved by using shutter speeds longer than 1/2 sec., which is far beyond the ability of anyone to handhold their camera. Tripods also force you to slow down and think about your photography—once you've carried a tripod any distance, you're going to make sure you use it to benefit your photography!

When you choose a tripod, it's important to think about factors such as weight and height. If a tripod is too heavy, you'll be less inclined to carry it far, but one that is too light may not provide adequate stability in anything but a light breeze. Carbon fiber tripods are a good compromise between weight and stability, although they are more costly than a plastic or aluminum equivalent.

If possible, buy a tripod that reaches a good height without needing to raise the center column. Ideally this would be one

that reaches eye-level, though the higher a tripod reaches, the bigger and heavier it will be.

Tripods either have an attached head—usually a three-way type—or a screw fitting that allows you to attach a separate head. The latter option is more flexible (but more expensive) and will allow you to choose the head that best suits your needs.

An alternative to a three-way tripod head is a ball head. This type of head is light, but strong, although it can be fiddly if minor positional adjustments are required. Geared heads are easier when it comes to making fine adjustments, but their complexity makes them heavier than the traditional three-way head.

One very useful thing to look out for when buying a tripod head is a quick-release plate. These allow you to quickly mount and dismount a camera from a tripod without unscrewing it each time. The main problem with quick-release plates is that if they're relatively large, they may block the camera's battery cover. Therefore it's worth installing a freshly charged battery and empty memory card before you start a photography session.

QUICK RELEASE »
A tripod (or tripod head) with a quick-release plate makes it much quicker and easier to set up your camera.

› Other supports

A monopod is a lighter alternative to a tripod. They are also less stable, but still better than nothing at all. Some monopods double as walking poles.

If there's a wall to rest your camera on, a beanbag will help to prevent scratches to the base of your camera. It will also absorb small vibrations.

> **Tip**
>
> *If you're using a tripod and your lens has Image Stabilization, be sure to turn the IS off. If not, it may cause slight blur, rather than preventing it.*

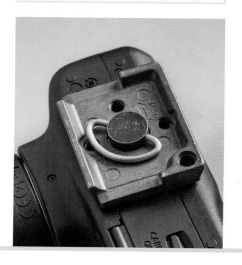

8 MACRO

Macro photography is the art of successfully recording the world of the very small. However, there's a subtle difference between close-up and true macro photography.

When it comes to macro photography, the Rebel T5/EOS 1200D has certain advantages over older DSLRs. The addition of Live View (and the ability to magnify Live View images) makes it easier to check focus before shooting, and the screen is also arguably easier to see than the viewfinder if you're shooting very close to the ground.

However, before we go much further, it's worth pointing out that macro has a very specific meaning when it comes to photography. A true macro lens projects an image onto the sensor that is the same size as (or larger than) the subject. If the image on the sensor is the same size as the subject, the lens is said to have a one-to-one reproduction ratio (shortened to 1:1). A lens with a 2:1 reproduction ratio creates an image that's twice the size of the subject, and so on.

The EF-S 18–55mm lens that's supplied with the Rebel T5/EOS 1200D isn't a true macro lens, but with a minimum focus of 0.82ft (25cm), it still allows you to try close-up photography (which is why 🌷 mode is called Close-up rather than Macro). Fortunately, there are numerous ways of adding a macro capability to your camera, as this chapter will demonstrate.

SMALL «
The world of small things is a fascinating place to explore, to the point that it can become almost addictive.

DETAILS »
Getting in close to a subject allows you to make more abstract, less literal images.

8 » MACRO SOLUTIONS

You don't necessarily need to buy a macro lens to shoot macro imagery. It's possible to extend the focusing capabilities of any lens with the addition of the equipment described here. Although this equipment won't give you the image quality of a true macro lens, these options can provide you with a relatively inexpensive entry to the world of macro photography.

› Close-up attachment lenses

By far the simplest method of adding a macro capability to a lens is to fit a close-up attachment lens. Close-up attachment lenses screw onto the filter thread on the front of the lens to reduce its minimum focusing distance: think of them as magnifying glasses for a lens and you wouldn't be too wide of the mark. They're easy to use because they don't interfere with either the autofocus or exposure system of the camera.

Close-up attachment lenses are available in a variety of strengths, which is indicated by a diopter value: the higher the diopter value, the greater the magnification. It is also possible to stack multiple close-up attachment lenses to increase the strength of magnification, although image quality will drop noticeably. For optimum image quality, it's better to use one close-up attachment lens with a prime lens, rather than a zoom.

Canon currently produces two close-up attachment lenses: a +2 diopter (Type 500D) to fit 52mm, 58mm, 72mm, and 77mm filter threads, and a +4 diopter (Type 250D) to fit 52mm and 58mm filter threads.

CLOSE-UP «
A close-up attachment lens on the Rebel T5/EOS 1200D's kit lens.

Reversing ring

Although it sounds bizarre, if you turn a lens around (so the front element faces the camera), it becomes a macro lens. A reversing ring can be used to hold your lens in the desired back-to-front position. One side of the reversing ring is shaped to fit the lens mount of your camera, while the other side of the ring is threaded so you can screw a lens to the ring using the lens' filter thread (the size of the filter thread determines the type of reversing ring you need to buy).

One big drawback to reversing rings is that they don't usually carry an electronic signal from the lens to the camera. This means that AF is disabled and there's usually no way to set the aperture of the lens. The easiest way to overcome this is to use a manual focus lens with an aperture ring. Before Canon developed the EF standard, Canon SLRs used a lens mount known as the FD mount: FD lenses are in plentiful supply secondhand and can be bought very cheaply.

Set the mode dial on your Rebel T5/ EOS 1200D to **M** once the reversing ring and lens have been fitted to the camera. Then set the shutter speed as normal and adjust the aperture ring until the correct exposure has been obtained.

LENS »
The close-up attachment lens shown on the page opposite produces results far inferior to a macro lens. However, it's cheap, fun to use, and slips into a pocket in my camera bag.

› Extension tubes

› Bellows

Extension tubes (also known as extension rings) are hollow tubes that are fitted between the camera and a lens. This decreases the minimum focusing distance of the lens and increases its magnification. As there is no glass in the extension tube, there is very little loss of image quality.

Extension tubes from third-party manufacturers are often sold in sets of three rings of different lengths. These rings can be detached and used separately, or combined to increase the magnification.

Many cheaper extension tubes lack the electronic connection between the lens and the camera needed for AF and aperture control.

Canon produces two extension tubes: EF 12II and RF/25II. The first extends the lens by 12mm, the second by 25mm. Both extension tubes retain AF and aperture control of the lens.

Kenko, a third-party manufacturer of photographic products, produces a set of lower cost extension tubes that also retain the use of AF and aperture control.

Bellows are similar in concept to extension tubes and work on the same principle. However, bellows can be extended or compressed along a guide rail, so it's easier to set the desired amount of magnification. Once this is achieved, the bellows are locked into position, ready for shooting.

The downside of bellows is that they are heavier and more cumbersome than extension tubes. This is why most bellows systems are used in studios, with the set-up mounted on a tripod. Bellows are also far more expensive than extension tubes.

Canon doesn't make bellows for the EOS system, but compatible systems can be bought from companies such as Novoflex.

KENKO EXTENSION TUBE SET �
Kenko's popular extension tube set provides 68mm of extension when the tubes are combined, or 12mm, 20mm, and 36mm extension when used individually.

TECHNIQUE

Macro photography is deceptively similar to "standard" photography, but it brings several unique challenges that require a certain amount of patience and a definite willingness to solve problems.

Working distance

The working distance is the distance from the lens to the subject that is needed to achieve the required reproduction ratio: the longer the focal length, the greater the working distance. The working distance of a 50mm macro lens is half that of a 100mm lens, for example, and one quarter that of a 200mm lens at a 1:1 reproduction ratio.

The longer the working distance, the further back you can stay from your subject. For some subjects, this is relatively unimportant, but if your subject is likely to be disturbed easily (if it's an insect or animal, for example) a longer working distance is invaluable.

The downside to using a longer focal length macro lens is that they are inevitably heavy and cumbersome to use. They are also far more expensive than macro lenses with a shorter focal length. Choosing a macro lens involves thinking about your budget and what you think your primary subjects are likely to be.

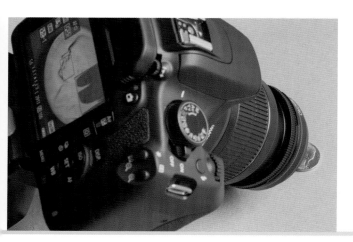

CLOSE TO «
Working distances can be incredibly small when using accessories such as close-up lenses with the kit lens.

One of the biggest problems of shooting macro images is the lack of depth of field. It's often impossible to achieve front-to-back sharpness, even when using the minimum aperture. Choosing the most appropriate point of focus therefore is more important than when shooting "standard" images. With insects or small animals, this would most often be the eye, but for flowers it's more difficult—a good starting point is the tips of the stamens.

If your subject is a flat plane, depth of field is less critical, but it's important to have the subject exactly parallel to the camera—if it's at a slight angle, the subject may not be critically sharp across the entire image.

Live View is particularly useful when shooting macro images. This is partially because the focus point can be moved over a greater area of the image. However, it's chiefly useful for the ability to zoom into the Live View image to check that focus is accurate.

A lack of depth of field is not necessarily a bad thing, though. When looking at an image, we don't like to linger over areas that aren't in focus. If only one part of an image is sharp, the eye will be naturally drawn there.

SHALLOW «
The closer the subject is to the camera, the less depth of field is available at all apertures. If you need a large aperture, you'll have to select the focus point very carefully.

Illuminating your subject

If your subject is moving, you'll need a reasonably fast shutter speed. However, unless you use a high ISO, you'll be forced to use your lens at its maximum aperture, which will reduce the available depth of field to a minimum, making it more difficult to keep your subject in focus.

To overcome this, you can illuminate your subject with a bright light source positioned as close to the subject as possible, but the placement of the light is critical. The built-in flash on your Rebel T5/EOS 1200D isn't suitable for macro photography, as the lens will get in the way and cast a shadow on your subject. A better solution is off-camera flash, using either a cable connection or the Rebel T5/EOS 1200D's wireless flash facility.

Another approach is to use a ring light. These lights "wrap" around the front of the lens, creating a soft and subtle illumination for macro subjects. Canon produces two dedicated macro flashes: the Macro Twin Lite MT-24EX and the recently released Macro Ring Lite MR-14EX II.

If you use one light source, there may be problems with contrast, particularly if it's a point light source such as an off-camera flash. Placing a sheet of white card or a commercial reflector on the opposite side of the subject to the light will help you to throw light back into the shadows and reduce contrast.

Working outdoors can be challenging. The soft light of an overcast day works well for a lot of subjects, particularly softer organic subjects, such as flowers. The light on overcast days will be biased toward blue, so either create a custom WB or use the ☁ preset.

CONTRAST »
Sunlight on a cloudless day is inherently high in contrast. The first image (left) was shot without a reflector, resulting in darker shadows than desired. The image on the right was shot using a reflector out of sight and to the right of the frame to bounce light back into the shadows.

8 » MACRO LENSES

› Canon lenses

Canon currently produces four macro lenses for the EF lens mount and one EF-S lens. All of the lenses have a fixed focal length; all but one offer a 1:1 or better reproduction ratio; and all but one can also be used as conventional lenses for non-macro photography.

The first is an EF-S lens: the 60mm f/2.8 Macro USM. This lens can only be used on cropped-sensor cameras such as the Rebel T5/EOS 1200D. It's unique in that it's Canon's only macro EF-S lens.

The quirkiest (and most difficult to use) of Canon's macro lenses is the MP-E 65mm f/2.8 1–5x Macro. This manual focus lens has a 5:1 reproduction ratio, allowing you to capture macro images that are five times life-size. However, because of its high magnification, it's often easier to mount the lens-camera assembly on a rail system and move the setup backward and forward to achieve critical focus.

There are currently two EF 100mm macro lenses produced by Canon. The first

is relatively old (although still excellent), while the second, newer lens is an L-series lens with built-in Hybrid Image Stabilization. Hybrid IS is designed to be effective when shooting macro, which is something that doesn't strictly apply to Canon's other IS systems.

The largest, heaviest, and most expensive Canon macro lens is the EF 180mm f/3.5 L Macro USM. With the longest working distance of all the Canon macros, this is the perfect lens when working with subjects that benefit from you keeping your distance.

CANON EF 100MM F/2.8 L IS USM ⌄

> **Note:**
> Canon also produces the EF 50mm f/2.5 Compact Macro. Arguably this is not a true macro lens though, as it only has a reproduction ratio of 1:2 (half life size).

Third-party lenses

Canon is not the only manufacturer of macro lenses compatible with the Rebel T5/EOS 1200D. There are many third-party alternatives that are less expensive and sometimes optically the equal of Canon's offerings. The tables below show the current range of lenses produced by Sigma, Tamron, and Tokina for Canon's EF-S lens mount.

Sigma

Lens	Minimum focus distance (cm)	Reproduction ratio size (mm)	Filter thread	Dimensions (diameter x length; mm)	Weight (g)
50mm f/2.8 EX DG	19	1:1	55	71.4 x 66.5	320
70mm f/2.8 EX DG	25	1:1	62	76 x 95	527
105mm f/2.8 APO EX DG OS HSM	31	1:1	62	78.3 x 126.4	725
150mm f/2.8 EX DG OS HSM	38	1:1	72	79.6 x 150	1150

Tamron

Lens	Minimum focus distance (cm)	Reproduction ratio size (mm)	Filter thread	Dimensions (diameter x length; mm)	Weight (g)
60mm f/2 Di II LD SP AF	23	1:1	55	73 x 80	390
90mm SP f/2.8 SP Di	29	1:1	55	71.5 x 97	405
180mm f/3.5 SP Di	47	1:1	72	84.8 x 165.7	920

Tokina

Lens	Minimum focus distance (cm)	Reproduction ratio size (mm)	Filter thread	Dimensions (diameter x length; mm)	Weight (g)
35mm f/2.8 AT-X PRO	14	1:1	52	73.2 x 60.4	340
100mm f/2.8 AT-X	30	1:1	55	73 x 95.1	540

A limited depth of field and a moving subject make a difficult combination to deal with: it won't take much movement for your subject to drift out of focus. If wind is the problem, try to shelter the subject with your body or a sheet of card. You can also use the Rebel T5/EOS 1200D's Continuous shooting and AI Servo modes to expose a number of frames and edit the sequence later, deleting those images that don't have critical sharpness.

Settings
> Focal length: 55mm
> Exposure: 1/320 sec. at f/5.6
> ISO: 400

Museums are great places to find interesting details to photograph, but if your subject is in a display case, glass can be a problem. Glass will pick up reflections from ambient light, causing glare and reflections. The solution is to press your lens against the glass to cut out those reflections. This should be done gently, though, especially with the 18–55mm kit lens, as the front element rotates as it focuses.

Settings
> Focal length: 39mm
> Exposure: 1/5 sec. at f/5
> ISO: 800

9 CONNECTION

If you want to make the most of your EOS Rebel T5/1200D, ultimately you'll need to connect it (or the memory card) to an external digital device such as a computer, printer, or even a television. This will enable you to archive, review, edit, and print your images.

› Color calibration

Your Rebel T5/EOS 1200D is the first link in a digital chain that ultimately will lead to your images being viewed on a computer monitor or as a print. Like all chains, it's only as strong as its weakest link, and one potential source of weakness is color: specifically, making sure that the colors captured in your image are accurate when viewed on screen or on a sheet of paper. The main way to keep everything in check is known as calibration, which starts with your computer's monitor.

Colors on a monitor drift over time. To keep colors accurate, you need to calibrate the monitor at regular intervals. Hardware monitor color calibrators are readily available from most good retail and online electronics stores. Good image-editing software will use the monitor profile created by the calibrator to ensure that you're viewing accurate colors on screen.

To make prints from your images you'll also need an accurate profile for the particular type of paper you want to use with the printer (a profile is produced by a printer calibrator, which is a separate device to a monitor calibrator). Accurate profiles ensure that an image's colors are correctly reproduced. Most paper manufacturers supply generic profiles for their papers for popular printers, but a specially created profile for your personal printer and paper combination will be far more accurate.

ACCURACY «
Achieving accurate colors in a print means matching the profile to the exact type of paper you use.

COLOR »
Printers tend to struggle more with highly saturated colors. Sometimes it is necessary to rein in an image's vividness to achieve a satisfactory print.

Your Rebel T5/EOS 1200D is bundled with a disk of computer programs, which can be used alone or in conjunction with third-party software such as Adobe Photoshop. Unfortunately, there's not enough space in this book to provide an in-depth guide to all this software, but Canon supplies comprehensive manuals in PDF format on the disk that came with your Rebel T5/EOS 1200D. To install the software, follow the instructions below.

If using Windows:

1) Log on as normal (or as Administrator if required to do so to install software).

2) Insert the Canon CD-ROM disk into the CD-ROM drive.

3) The Canon software installation screen should appear automatically. Follow the instructions on screen to select your geographical region, country, and preferred language. Then, either click on **Easy Installation** to automatically install all the software, or click on **Custom Installation** to select which of the programs you want to install. Follow the instructions on screen to continue.

4) When the installation is complete, click on **Finish** and remove the CD-ROM.

Warning!

The software is only compatible with Windows 8, Windows 7, Vista, and XP (SP3), plus Intel Mac OS X 10.6–10.8.

Uninstall any previous versions of ZoomBrowser or ImageBrowser from your computer before installing the new applications.

Don't connect your camera to your computer before you've installed the applications.

WEB SITE **«**

Canon's various image applications—including updates—are available on the company web site for your region.

If using Mac OS X:

1) Log on as normal (or as Administrator if required to do so to install software).

2) Insert the Canon CD-ROM disk into the CD-ROM drive.

3) Double-click on the CD-ROM icon on your Mac's desktop.

4) Double-click on **Setup**. The Canon software installation screen should now appear. Follow the instructions on screen to select your geographical region, country, and preferred language. Then, either click on **Easy Installation** to automatically install all the software, or click on **Custom Installation** to select which of the programs you want to install. Follow the instructions shown on screen to continue.

5) When the installation is complete, click on **Restart** to reboot your Mac.

6) Remove the CD-ROM.

7) The installed software can now be found in the Applications folder of your Mac's hard drive.

Notes:
The latest iMacs don't have optical drives. This means you'll need to download and install the software from your local Canon web site or purchase an external optical drive.

You can also register for CANON iMAGE GATEWAY during installation. This is a free service that allows you to post your images and videos online for other members to view. As well as this facility, there are technique articles to read and benefits such as free shipping when products are bought through the Canon online store.

INSTALLATION ⌄
Installing Canon's software on an Apple Mac.

Digital Photo Professional

DPP is most useful for editing your Rebel T5/EOS 1200D's Raw files and then saving them as JPEGs or TIFFs for use in other non-Raw applications, or transferring them directly to Adobe Photoshop. If you've set **Dust Delete Data** (see chapter 3), you can also use DPP to automatically clone out dust spots.

ImageBrowser EX

ImageBrowser EX is used to sort the images on your Window's PC or Mac. The simple interface allows you to quickly copy, duplicate, move, rename, and delete your images and movie files. You can also rate them using a star system or join the online CANON iMAGE GATEWAY to post your images for others to view.

EOS Utility

This nifty utility enables you to import your images from your Rebel T5/EOS 1200D onto your computer, or organize the images on the memory card. It can also be used to capture images directly onto your computer when your camera is tethered (see page 226).

Picture Style Editor

Picture Style Editor allows you to edit and save personalized Picture Styles, and then copy them to your Rebel T5/EOS 1200D for use when shooting JPEGs.

PhotoStitch

PhotoStitch does exactly as its name suggests: it stitches photos together automatically. Specifically, it stitches short sequences shot horizontally or vertically to create a long, panoramic image. This is a more convoluted process than simply cropping a single image to a panoramic shape, but it does mean you can create large, high-resolution images.

PANORAMIC «
Canon's PhotoStitch software.

CONNECTING TO A PC

There are two ways to transfer the images saved to the memory card in your Rebel T5/EOS 1200D. You can either remove the memory card and plug it into a card reader attached to your PC (or into the SD card slot on your PC if it has one), or you can connect your Rebel T5/EOS 1200D directly to your computer via a USB cable.

The latter option has some additional benefits: as well as transferring images, you can shoot remotely (saving the images directly to your PC) and you can apply changes to your camera, such as adding custom Picture Styles created using Picture Style Editor.

Connecting to a PC via a USB cable
1) Attach the USB cable to the A/V OUT DIGITAL connector underneath the terminal cover on your camera.

2) Insert the other end of the USB cable into a free USB 2.0 (or higher) port on your computer.

3) Turn on your Rebel T5/EOS 1200D.

4) On Windows PCs, click on **Download Images From EOS Camera using Canon EOS Utility**. Canon EOS Utility should now launch automatically. Check **Always do this for this device** if you want to make this a default action when you connect your Rebel T5/EOS 1200D.

5) On Mac OS X, Canon EOS Utility should run automatically when your camera is connected to your computer.

6) Follow the instructions on screen.

7) Quit Canon EOS Utility when you are finished, turn off your Rebel T5/EOS 1200D, and unplug it from your computer.

> ### Warning!
> *Before connecting your Rebel T5/ EOS 1200D to your computer, install the Canon software. Ensure that your camera is switched off and that the battery is fully charged.*

 » TETHERED SHOOTING

When your Rebel T5/EOS 1200D is connected to a PC via a USB cable, you can use the computer's hard drive as a memory card. This is achieved with a technique known as "tethered shooting."

Tethered shooting allows you to view a Live View image on your PC's monitor, make adjustments, and then shoot: the resulting image is then transferred directly to your computer.

The drawback is that you're limited to shooting within a USB cable's length of the computer. This makes the technique more difficult away from the studio, although not impossible with a suitable laptop. Tethered shooting requires EOS Utility.

Enabling tethered shooting

1) Connect your Rebel T5/EOS 1200D to your computer as described on the previous page.

2) Launch EOS Utility (if it doesn't launch automatically) and click on **Camera Setting/Remote Shooting**.

3) Click **Preferences** and select **Destination Folder** from the tab (Windows) or pop-up menu (Mac) at the top of the dialog box. Select the folder that you want your images to be saved to. Alter the other settings as desired.

4) Select **Linked Software** from the tab (Windows) or pop-up menu (Mac) at the top of the dialog box. Select the software that you want to use to edit the images.

5) Click **OK** to continue.

6) Click on the **Live View shoot...** button to see the camera's output on your computer screen.

7) Alter settings such as **White Balance** and **Focus** (found at the right and below the Live View window) as required.

8) Click on the software shutter-release button to capture the image.

9) When you're done, disconnect your Rebel T5/EOS 1200D from your computer as described on the previous page.

TETHERED **«**
When tethered, EOS Utility mimics the various controls of your Rebel T5/EOS 1200D.

EYE-FI

Eye-Fi is a third-party SD memory card with a built-in Wi-Fi transmitter. This allows you to transfer files wirelessly between your Rebel T5/EOS 1200D and a Wi-Fi enabled PC or hosting service. To set up the Eye-Fi card, check the manual that came with your card before use. For more information about Eye-Fi, go to www.eye.fi.

Enabling Eye-Fi
1) Press MENU and select **Eye-Fi settings** from the ♥ menu.

2) Select **Eye-Fi trans.** and set it to **Enable**. When **Eye-Fi trans.** is set to **Disable**, the Eye-Fi card will not transmit your files automatically, and 🛜 will be shown on the shooting settings screen.

3) Shoot a picture. The Eye-Fi symbol turns from a gray 🛜 to one of the icons listed below. When an image has been transferred

Displayed symbol	Status
🛜 [GRAY]	Not connected
🛜 [BLINKING]	Connecting
🛜 [SOLID WHITE]	Connection to access point established
🛜 (↑)	Transferring

to your computer, 📷 will be displayed on the shooting information screen.

Checking an Eye-Fi connection
1) Press MENU and select **Eye-Fi settings** from the ♥ menu.

2) Select **Connection info** to display the connection information screen.

3) Press MENU to return to the main Eye-Fi Settings menu.

> **Notes:**
> File transfer speeds using an Eye-Fi card are dependent on the speed of your wireless connection.
>
> The battery in your Rebel T5/EOS 1200D may be depleted more quickly than usual when using an Eye-Fi card to regularly transmit images.
>
> Eye-Fi settings only appear on the ♥ menu when an Eye-Fi card is installed.
>
> Ensure that the write-protect tab on the Eye-Fi card is set to "unlocked."
>
> **Auto power off** is disabled during file transfer.

9 » CONNECTING TO A TV

Transferring images to a PC is all very well, but it's not a particularly sociable way of sharing your images with family and friends. An arguably better way is to connect your Rebel T5/EOS 1200D to an HDTV and show a slide show of your work that way. The Type C mini-pin HDMI cable needed to connect the camera to an HDTV set is not supplied in the box, but these can be readily found at good consumer electronics stores.

Connecting to an HDTV

1) Ensure that both your Rebel T5/EOS 1200D and TV are switched off.

2) Open the Rebel T5/EOS 1200D's terminal cover and connect the HDMI cable plug to the HDMI OUT port.

3) Plug the other end of the HDMI cable into a free slot on your TV.

4) Turn on your TV and switch to the correct channel for external devices.

5) Turn on your camera and press ▶ to view your images on the HDTV. Press DISP. to change the display format if necessary.

6) When you are finished, turn off the camera and TV before disconnecting the HDMI cable.

› HDMI TV remote control

If your TV is compatible with the HDMI CEC standard, you can use the TV's remote to control the playback function on your Rebel T5/EOS 1200D.

1) Follow steps 1 to 5 (left) to connect your Rebel T5/EOS 1200D to an HDTV.

2) Use the remote control's ◄ / ► buttons to select the desired option displayed on the TV. If you select **Return** and then press **Enter**, you'll be able to use the remote's ◄ / ► buttons to skip through images on your Rebel T5/EOS 1200D.

Menu options

↰	Return	
⊞	9-image index	
▸🖳	Play movie	
◈	Slide show	
INFO.	Show image shooting information	
⟳	Rotate	

Note:
Set **Ctrl over HDMI** on ▸ to **Enable** if you want to use your HDTV's remote to control your camera.



CONNECTING TO A PRINTER

There's something very satisfying about making a print from an image you've shot. There are two ways to achieve this using your Rebel T5/EOS 1200D: you can either connect the camera directly to a printer, or you can tag DPOF printing instructions to images on the memory card.

If you choose the latter option, you can print those images by plugging the card into a compatible printer or taking the card to a photo lab for printing there.

PictBridge

If your printer is PictBridge () compatible, you can connect your camera to it via a USB cable. The advantage of this method over DPOF is that PictBridge supports the printing of both Raw and JPEG images—DPOF only supports JPEG.

Connecting to a printer

1) Check that the camera battery is fully charged before beginning to print.

2) Ensure that both the camera and printer are switched off. Insert the memory card of images you want to print into the Rebel T5/EOS 1200D if it's not already installed.

3) Open the Rebel T5/EOS 1200D's terminal cover and connect the supplied USB cable to the AV OUT / DIGITAL port.

4) Connect the cable to the printer, following the instructions in the manual supplied with the printer.

5) Turn on the printer, followed by the camera, and press ►. The PictBridge icon will be displayed at the top left corner of the LCD screen to show that the connection has been made successfully.

6) Press ◄ / ► to find the image you want to print and then press (SET).

7) The print options screen will now appear (see following page). Set the required options, highlight **Print**, and press (SET) once more. Printing should now begin.

8) Repeat steps 6 and 7 (above) to print additional images.

9) Turn off the Rebel T5/EOS 1200D and printer, and disconnect the USB cable.

Printing effect	Description
⌂ On	Print will be made using the printer's standard setup.
⌂ Off	No automatic correction applied.
⌂ Vivid	Greens and blues are more saturated.
⌂ NR	Image noise reduction is applied before printing.
B/W B/W	Black-and-white image is printed with pure blacks.
B/W Cool tone	Black-and-white image is printed with bluish tone.
B/W Warm tone	Black-and-white image is printed with yellowish tone.
📷 Natural	Prints an image with natural colors.
📷 Natural M	Finer control over colors than Natural.
Default	Printer dependant. See your printer manual for details.
🕰	Choose between overlaying the date, file number, or both on the print.
🗐	Number of copies: Specify the number of prints to be made.
Cropping	Allows you to trim and rotate your image before printing.

Paper settings	Description
Paper size	Select the size of the paper loaded in the printer.
Paper type	Select the paper type.
Page layout	Select how the image will look on the printed page.

Page layout	Description
Bordered	The print will be made with white borders around the edge of the paper.
Borderless	The print will go to the edge of the page if your printer supports this facility.
Bordered 🔢	Shooting information will be imprinted on the border on prints measuring 9 x 13cm or larger.
XX-up	Print 2, 4, 8, 9, 16, or 20 image thumbnails on A4 paper.
20-up 🔢 35-up 🎞	20 or 35 images will be printed as thumbnails on A4 or Letter sized paper. 20-up 🔢 will have the shooting information added.
Default	Prints at your printer's standard settings.

› DPOF

If you've shot JPEGs, an alternative way to prepare them for printing is to use DPOF (or Digital Print Order Format). DPOF lets you add printing instructions to images on your Rebel T5/EOS 1200D's memory card. These instructions can be read and followed by a compatible printer or by a photographic printing service.

Instructions can include which images to print, how many of each image to print, and whether the shooting date or the file name should be overlaid on the image.

Once DPOF instructions have been added to your chosen images, you either plug the memory card directly into a compatible printer or take it to your chosen photographic printing service.

Setting DPOF
1) Press MENU, navigate to ▣, and select **Print order**.

2) Select **Set up**.

3) Set the **Print type** (select **Standard** for a normal print, **Index** for a sheet of thumbnails, or **Both**).

4) Set **Date** to **On** if you want the date to be imprinted on your prints, or **Off** if you don't want the date added.

5) Set **File no.** to **On** if you want the image file number added to your prints, or **Off** if you don't.

6) Press MENU to return to the Print order menu screen.

Marking all images in a folder for printing

1) Open the **Print order** screen and select **By** .

2) Select **Mark all in folder** and then choose the desired folder. Select **OK** to continue, and a print order for one copy of each compatible image in the folder will be set. Alternatively, select **Cancel** to return to the **Select folder** screen.

3) To clear the print order, select **Clear all in folder** and then select the desired folder. Choose **OK** to continue, or **Cancel** to return to the **Select folder** screen.

Marking all images on the card for printing

1) Open the **Print order** screen and choose **All image**.

2) Select **Mark all on card** and choose **OK** to continue. A print order for one copy of each compatible image on the memory card will be set. Alternatively, select **Cancel** to return to the **All image** screen.

3) To clear the print order, select **Clear all on card**. Select **OK** to clear all the DPOF instructions from the memory, or **Cancel** to return to the **All image** screen.

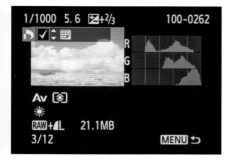

```
1/1000 5.6 ⚡+²/₃          100-0262
R
G
B
Av ⊙
☀
RAW+4L  21.1MB
3/12                      MENU ↰
```

Print ordering individual images

1) On the **Print order** screen, choose **Sel. Image**.

2) Press ◀ / ▶ to skip between images on the memory card (or jump through the images by turning ⌒). To view three images on screen at once, press ▚▚ / Q (to restore single-image view, press ⊕Q).

3) If you selected **Standard** when setting **Print type** (when following the instructions on the page opposite), press ▲ / ▼ to set the number of prints to be made from the currently displayed image.

4) If you selected **Index,** press (SET) to add the currently displayed image to the DPOF instructions to be printed in index form. A ✓ in the box next to the ↰ icon indicates that the image has been selected. If you choose an image by mistake, press (SET) to deselect it.

5) Repeat steps 2–4 to select additional images and then press MENU to return to the main **Print order** menu screen.

Direct printing

If your Rebel T5/EOS 1200D is connected to a PictBridge printer, select **Print** on the **Print order** menu screen. Follow the instructions on screen and the printer will print according to the DPOF instructions you've set.

» GLOSSARY

Aberration An imperfection in a photograph, usually caused by the optics of a lens.

AEL *(automatic exposure lock)* A camera control that locks in the exposure value, allowing a scene to be recomposed.

Angle of view The area of a scene that a lens takes in, measured in degrees.

Aperture The opening in a camera lens through which light passes to expose the sensor. The relative size of the aperture is denoted by f-stops.

Autofocus (AF) A reliable through-the-lens focusing system allowing accurate focus without the photographer manually turning the lens.

Bracketing Taking a series of identical pictures, changing only the exposure, usually in ⅓-, ½-, or 1-stop increments.

Buffer The in-camera memory of a digital camera.

Center-weighted metering A metering pattern that determines the exposure by placing importance on the lightmeter reading at the center of the frame.

Chromatic aberration The inability of a lens to bring spectrum colors into focus at a single point.

CMOS *(Complementary Metal Oxide Semiconductor)* A type of imaging sensor, consisting of a grid of light-sensitive cells. The more cells, the greater the number of pixels and the higher the resolution of the final image.

Codec A piece of software that is able to interpret and decode a digital file such as Raw.

Color temperature The color of a light source expressed in degrees Kelvin (K).

Compression The process by which digital files are reduced in size.

Contrast The range between the highlight and shadow areas of a photo, or a marked difference in illumination between colors or adjacent areas.

Depth of field *(DOF)* The amount of a photograph that appears acceptably sharp. This is controlled primarily by the aperture: the smaller the aperture, the greater the depth of field.

Diopter Unit expressing the power of a lens.

dpi *(dots per inch)* Measure of the resolution of a printer or scanner. The more dots per inch, the higher the resolution.

Dynamic range The ability of the camera's sensor to capture a full range of shadows and highlights.

Evaluative metering A metering system where light reflected from several subject areas is calculated based on algorithms.

Exposure The amount of light allowed to hit the digital sensor, controlled by aperture, shutter speed, and ISO. Also, the act of taking a photograph, as in "making an exposure."

Exposure compensation A control that allows intentional over- or underexposure.

Fill-in flash Flash combined with daylight in an exposure. Used with naturally backlit or harshly side-lit or top-lit subjects to prevent silhouettes forming, or to add extra light to the shadow areas of a well-lit scene.

Filter A piece of colored or coated glass, or plastic, placed in front of the lens.

Focal length The distance, usually in millimeters, from the optical center point of a lens to its focal point.

fps *(frames per second)* A measure of the time needed for a digital camera to process one photograph and be ready to shoot the next.

f-stop Number assigned to a particular lens aperture. Wide apertures are denoted by small numbers (such as f/1.8 and f/2.8), while small apertures are denoted by large numbers (such as f/16 and f/22).

HDR *(High Dynamic Range)* A technique that increases the dynamic range of a photograph by merging several shots taken with different exposure settings.

Histogram A graph representing the distribution of tones in a photograph.

Hotshoe An accessory shoe with electrical contacts that allows synchronization between a camera and a flash.

Hotspot A light area with a loss of detail in the highlights. This is a common problem in flash photography.

Incident-light reading Meter reading based on the amount of light falling onto the subject.

Interpolation A method of increasing the file size of a digital photograph by adding pixels, thereby increasing its resolution.

ISO The sensitivity of the digital sensor measured in terms equivalent to the ISO rating of a film.

JPEG *(Joint Photographic Experts Group)* JPEG compression can reduce file sizes to about 5% of their original size, but uses a lossy compression system that degrades image quality.

LCD *(Liquid crystal display)* The flat screen on a digital camera that allows the user to preview digital photographs.

Macro A term used to describe close focusing and the close-focusing ability of a lens.

Megapixel One million pixels is equal to one megapixel.

Memory card A removable storage device for digital cameras.

Noise Interference visible in a digital image caused by stray electrical signals during exposure.

PictBridge The industry standard for sending information directly from a camera to a printer, without the need for a computer.

Pixel Short for "picture element"—the smallest bit of information in a digital photograph.

Predictive autofocus An AF system that can continuously track a moving subject.

Raw The file format in which the raw data from the sensor is stored without permanent alteration being made.

Red-eye reduction A system that causes the pupils of a subject's eyes to shrink, by shining a light prior to taking the main flash picture.

Remote switch A device used to trigger the shutter of the camera from a distance, to help minimize camera shake. Also known as a "cable release" or "remote release."

Resolution The number of pixels used to capture or display a photo.

RGB *(red, green, blue)* Computers and other digital devices understand color information as combinations of red, green, and blue.

Rule of thirds A rule of composition that places the key elements of a picture at points along imagined lines that divide the frame into thirds, both vertically and horizontally.

Shutter The mechanism that controls the amount of light reaching the sensor, by opening and closing.

Soft proofing Using software to mimic on screen how an image will look once output to another imaging device. Typically this will be a printer.

Spot metering A metering pattern that places importance on the intensity of light reflected by a very small portion of the scene, either at the center of the frame or linked to a focus point.

Teleconverter A supplementary lens that is fitted between the camera body and lens, increasing its effective focal length.

Telephoto A lens with a large focal length and a narrow angle of view.

TIFF *(Tagged Image File Format)* A universal file format supported by virtually all relevant software applications. TIFFs are uncompressed digital files.

TTL *(through the lens)* **metering** A metering system built into the camera that measures light passing through the lens at the time of shooting.

USB *(universal serial bus)* A data transfer standard, used by most cameras when connecting to a computer.

Viewfinder An optical system used for composing and sometimes for focusing the subject.

White balance A function that allows the correct color balance to be recorded for any given lighting situation.

Wide-angle lens A lens with a short focal length and, consequently, a wide angle of view.

USEFUL WEB SITES

CANON

Canon Worldwide
www.canon.com

Canon US
www.usa.canon.com

Canon UK
www.canon.co.uk

Canon Europe
www.canon-europe.com

Canon Middle East
www.canon-me.com

Canon Oceania
www.canon.com.au

GENERAL

David Taylor
Landscape and travel photography
www.davidtaylorphotography.co.uk

Digital Photography Review
Camera and lens review site
www.dpreview.com

Photonet
Photography Discussion Forum
www.photo.net

EQUIPMENT

Adobe
Image-editing software (Photoshop,
Photoshop Elements, and Lightroom)
www.adobe.com

Apple
Hardware and software manufacturer
www.apple.com/uk

PHOTOGRAPHY PUBLICATIONS

Photography books & Expanded Camera Guides
www.ammonitepress.com

Black & White Photography magazine
Outdoor Photography magazine
www.thegmcgroup.com

» INDEX

CANON REBEL T5/EOS 1200D

THE EXPANDED GUIDE

FRONT OF CAMERA

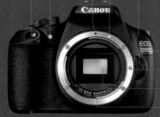

BACK OF CAMERA

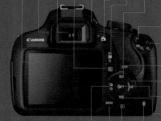

1 Shutter-release button

2 Red-eye reduction / Self-timer light

3 EF lens mount index

4 EF-S lens mount index

5 Microphone

6 Lens release button

7 Lens locking pin

8 Reflex mirror

9 Lens electrical contacts

10 LCD monitor

11 Viewfinder eyecup

12 Viewfinder eyepiece

13 Quick Control button

14 Diopter adjustment knob

15 Live View / Movie shooting button

16 Aperture / Exposure compensation / Erase image button

17 ▲ / ISO selection button

18 AE/FE lock / Index / Reduce button

19 AF point selection / Magnify button

20 Display button

21 ▶ / AF mode selection button

22 (SET) button

23 ▼ / White balance selection button

24 Access lamp

25 Playback button

26 MENU button

27 ◀ / Drive mode selection button

TOP OF CAMERA

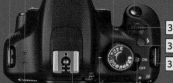

| 28 | 29 | 30 | | 31 | 32 |
| | | | 33 | 34 | 35 |

| 39 | | 38 | 37 | | 36 |

BOTTOM OF CAMERA

| 44 | 45 | 46 | 47 |

LEFT SIDE

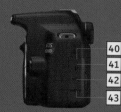

| 40 |
| 41 |
| 42 |
| 43 |

RIGHT SIDE

| 48 |

28	Strap mount	**39**	Focal plane indicator
29	Speaker	**40**	Terminal cover
30	Built-in flash	**41**	Remote control terminal
31	Mode dial	**42**	Digital terminal
32	Shutter-release button	**43**	HDMI mini out terminal
33	Main dial	**44**	Serial number / Information panel
34	Flash button	**45**	Tripod socket
35	Strap mount	**46**	Battery / Memory card cover
36	On/Off switch	**47**	Battery / Memory card cover lock
37	Mode dial index mark	**48**	DC cord hole
38	Hotshoe		